PHOTOSHOP
for Artists

PHOTOSHOP
for Artists

A Complete Guide for Fine Artists, Photographers, and Printmakers

SYLVIE COVEY

WATSON
GUPTILL

Watson-Guptill Publications
New York

Sylvie Covey, *Imagine a Land 3* (detail), digital mural

WATSON-GUPTILL is a registered trademark, and the WG
and Horse designs are trademarks of Random House, Inc.

The photo-etching *Performances of the Heart* was printed
(in black & white) in *Linea*, Vol. 6, No. 2, Winter 2003.
The digital prints *Into the Sea 4b*, *Imagine a Land 3*, and
Wyoming 1 were printed in *Linea*, Vol. 14, No 2, Fall 2010.

Library of Congress Cataloging-in-Publication Data
Covey, Sylvie.
 Photoshop for artists / Sylvie Covey.
 p. cm.
 Includes bibliographical references and index.
1. Digital art—Technique. 2. Adobe Photoshop. I. Title.
 N7433.8.C69 2012
 776—dc23 2011038161

ISBN 978-0-8230-0671-7
eISBN 978-0-8230-0672-4

Printed in China

10 9 8 7 6 5 4 3 2 1

First Edition

Acknowledgments

There are many to thank for this book, first of all Candace Raney, executive editor at Watson-Guptill, who had the foresight to seek me out and understood the potential of this book, and a special thanks to the artist Nuri Taub, who many years ago encouraged me to take my first Photoshop class at the Fashion Institute of Technology. Many thanks to the Random House team, particularly Patrick Barb.

Finally, I thank my friends and family who have encouraged me and gave me moral support, and I am particularly deeply grateful to the contributing artists who have generously shared their artwork for this endeavor.

Contents

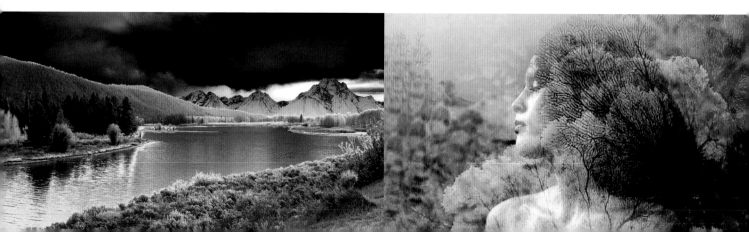

Preface

The process of making art is a continuous learning experience. As a printmaker, photographer, and painter, I am always fascinated by combining mediums and techniques—perhaps, it is an attempt to celebrate, transcend, or reverse the conventions of visual languages. In today's world, we artists want to embrace new technologies, while still holding onto and combining them with more traditional methods of making art.

New techniques keep on evolving. In the past, I used to print on film and make multiple exposures in a darkroom by sandwiching negatives in slide holders and I used liquid photo emulsions and chemistry on huge canvases and papers. I also printed collotypes with gelatin and cyanotypes with the sun and used tea and coffee—as well as many other more toxic chemicals—for toning. I was driven to learn all the languages of light and darkness.

When I discovered Photoshop, however, my life began anew with colors. I believe that although we artists want to fly with new wings, see with new eyes, and hear new sounds, we still need somehow to produce a tangible testimony of what we see, hear, and feel. Combining old and new technologies allows this tangible world to exist in whole new dimensions of expression.

Today, creating images digitally means that the possibilities for outputting them are infinite; it is the ultimate freedom. We still use our hands, our eyes, and our hearts, but with different tools, on different surfaces, and through different scales. There is no limit to what we can do.

Sylvie Covey, *Imagine a Land 5b* (detail), digital print

Introduction

I have been a printmaker my whole life, from my beginning years in France until today, and for the last twenty years I have been working on combining photography with printmaking. I have been teaching printmaking since 1995 at the Art Students League of New York, since 1998 at the Art Center of Northern New Jersey, and since 2001 at the Fashion Institute of Technology in New York City. Writing a technical book was always on my mind, because I specialized in all of the processes related to combining photo techniques with printmaking. Later, when I started teaching Photoshop, I realized there was an even greater need to write a book for artists wanting to learn Photoshop from the point of view of a fine artist.

Photoshop has unlimited tools, and artists of all media can grow by learning to use these tools as a new way to produce art. This book is intended for professional artists (painters, photographers, and printmakers) who wish to discover digital techniques to achieve a wide variety of creative imagery.

This book is relevant both for beginners and advanced artists, because it is conceived as a series of step-by-step, easy-to-understand visual tutorials for a number of art methods. These tutorials were created on a Mac computer, but work just as well on a PC.

In the computer world, I can relate to the anxiety anyone may feel by not fully grasping a Photoshop method or function, and this is why I chose to write this book using step-by-step visual tutorials. I also chose to write the tutorials without shortcuts, repeating even simple steps word for word.

Teaching Photoshop taught me not to expect the same from each artist, but to be ready for anything. Repeating directions will burn them in your memory. I believe an artist who learns a new medium can make it his or her own. Teaching students, but also many different professional artists, over the years and understanding their interests determined the choice of tutorials in this book.

Photoshop for Artists addresses all of the special effects relevant to artists, and shows how to achieve a specific image with a specific technique. It also allows an artist to take ideas from the tutorials and apply them to his or her own work and imagery.

Following an initial part that introduces key terms and concepts related to

Sylvie Covey, *Into the Sea 4b*, digital print on canvas

Photoshop, *Photoshop for Artists* breaks Photoshop usage into three additional major parts, the first one addressing fine artists, the second photographers, and the third printmakers, although each part bears relevance to all artists.

The book comprises twenty-eight tutorials: nine tutorials for fine artists to draw and paint digitally and fourteen tutorials for photographers. Finally, the third part of the book contains five tutorials for printmakers wishing to combine printmaking techniques with digital photography via Photoshop.

Over the years Adobe has developed many versions of its Photoshop application, which is now part of the Adobe Creative Suite. Each new version presents a few new tools or enhancements. The tutorials for this book were written using the Creative Suite 4 (CS4) version of Photoshop, but they can be applied to older or newer versions of the program. It is recommended to use CS4, CS5, or the latest version. These tutorials should apply to any Photoshop upgrades. The CS5 version includes, among other enhancements, improved Selecting and Masking, an Automated Lens Enhancement Correction, and a Content-aware Filling & Healing Brush.

Aside from the step-by-step visual tutorials, I have included some of my work and examples of other artists' works that I found relevant to the tutorials. Throughout my career as an artist and educator, it has been, and still is, a privilege to meet and learn from many talented artists. I am happy to share some of their artwork in this book along with my own work, and to provide contact information and websites for these artists. All the artists in this book are professionals who have improved or transformed their art by learning Photoshop from an artist's perspective.

ABOVE Dan Williams,
Global Output, digital print

RIGHT Janet Millstein,
The Dao Man, photolithograph,
16 x 12 inches

PART ONE

Understanding the Vocabulary and Logic of Photoshop

The first thing you should know about Adobe Photoshop is that it is crucial to learn its vocabulary. Words like *Toolbox, Tool Options Bar, Window menu, palettes, brush lists,* and *icons* sound like a foreign language to the uninitiated. Those words are extremely important, because they identify each area you want to reach on your Photoshop screen workspace. For this reason, the next sections of Workspace Overview and Digital Basics are important to read and remember.

You should also remind yourself *not* to panic when you are stuck. Be calm. The answer is right there. You will be able to reach it when you read and are able to identify the vocabulary. Look carefully, and find that little arrow in the upper right of the particular window palette you are in; it will open lists of more options. I find that everyone misses those little arrows and freaks out when first learning Photoshop.

After a while, logic will kick in, and you will only need to look in the right place to find the answer, so take the time to learn the Photoshop language, become familiar with the options the little arrows in the upper right give you, and get accustomed to the workspace.

Another important tip: *Always* have your Layers palette open and visible. The Layers palette shows what is going on in your file while you are working on it.

Don't give up. Think of this as a great learning experience. Success will come eventually. Photoshop is only a tool for your artistry, but it is a *great* tool to have and master.

Sylvie Covey, *Imagine a Land 5C,* digital print, 60 x 120 inches

Workspace Overview

The Photoshop workspace consists of the menus, tools, options bars, image windows, and palette wells. Your choice of workspace will define which windows are automatically opened, for example the Essentials workspace will open the Color, Adjustment, and Layer windows with the Application bar giving you their tools and options. The Basic workspace will only display the icons of each palette.

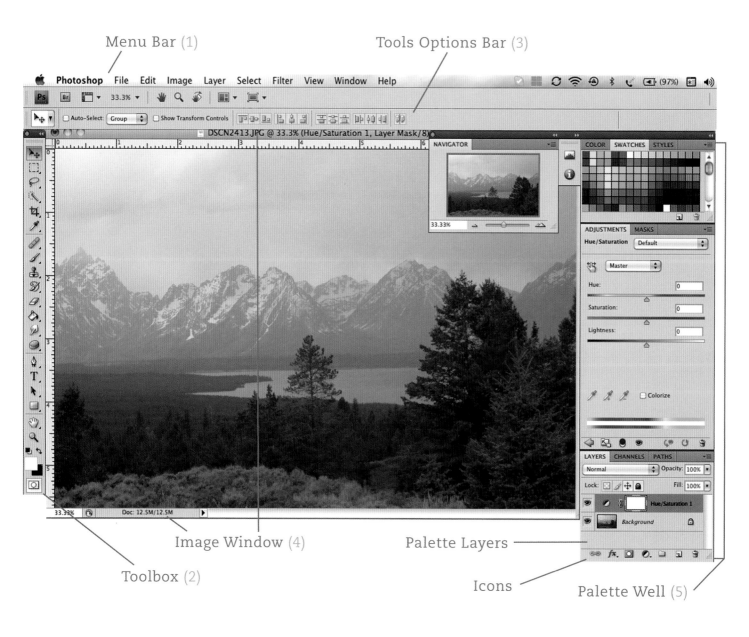

Menu Bar (1)

Tools Options Bar (3)

Image Window (4)

Palette Layers

Toolbox (2)

Icons

Palette Well (5)

THE MENU BAR (1)

The Menu Bar at the top of the screen accesses the main commands, with each command subdivided into major categories. Click on each menu category to access the commands in the section. To display a specific Option palette, open the Window menu and check the desired option.

Photoshop	**File** Edit Image Layer Select Filt
New...	⌘N
Open...	⌘O
Browse in Bridge...	⌥⌘O
Open As Smart Object...	
Open Recent	▶
Share My Screen...	
Device Central...	
Close	⌘W
Close All	⌥⌘W
Close and Go To Bridge...	⇧⌘W
Save	⌘S
Save As...	⇧⌘S
Check In...	
Save for Web & Devices...	⌥⇧⌘S
Revert	F12
Place...	
Import	▶
Export	▶
Automate	▶
Scripts	▶
File Info...	⌥⇧⌘I
Page Setup...	⇧⌘P
Print...	⌘P
Print One Copy	⌥⇧⌘P

Rectangular Marquee Tool M
Elliptical Marquee Tool M
Single Row Marquee Tool
Single Column Marquee Tool

Brush Tool B
Pencil Tool B
Color Replacement Tool B

THE TOOLBOX (2)

The Toolbox displays a variety of icons, each one representing an image-editing tool. Choose and click on a tool in the Tools palette to select it. Leave the cursor over the tool to read the name of the tool. Some tools are stacked in groups. A small, black arrow in the bottom right of the toolbox will indicate additional tools that are hidden behind it. To access the stack, click and drag the mouse to the right of the uppermost tool for a second. The Toolbox also displays the current foreground and background colors.

THE TOOL OPTIONS BAR (3)

When a tool is selected, the Tool Options Bar gives access to the specifications and controls of that particular tool. The Tool Options Bar changes with each tool.

THE IMAGE WINDOW (4)

The Image window in Standard Screen mode indicates the entire file name, magnification, color mode, and document size.

THE PALETTE WELL (5)

Palettes are small windows that give you control and provide information during the process of editing an image. Palettes can be accessed from the Window menu or by clicking on their icons or tabs.

Icons ——————

SET PREFERENCES

Photoshop's Preferences dialog box lets you change default settings and customize how the program looks. From the Photoshop menu choose **Preferences** > **General** to display the general options. Review all your options. For example, below General, click on **Cursors** to select a cursor type to use for the painting tools.

SELECT A WORKSPACE

From the pull-down menu in the upper right of the screen, select the workspace appropriate for your work. For example, if you are planning to paint digitally, choose **Painting**; but if you are doing a little bit of everything, choose **Essentials**. The workspace you have chosen will automatically open the appropriate window palettes you will need the most. You can switch your workspace anytime you wish.

Digital Basics

Computers require that any image—whether it is a drawing, painting, or a photograph—be translated into numbers. But computers use binary numbers, or *binary digits* (zeros and ones).

A byte is often a computer's smallest addressable memory unit. Most computers today process information in 8-bit units, called "bytes." Computers can also process information in multiple units, such as 16, 32, or 64 bits at a time. For this reason, computer images are called "digital images."

A digital image is made of *pixels*, with primary and secondary colors of light mixed through *channels*. There are different *image modes* used for the intended output, and both the *size* and *resolution* of the image determine its quality. An *image format* is chosen according to its purpose, for example mailing or printing an image file.

PIXELS

The structure of a digital image file consists of pixels, or little solid-color squares positioned horizontally and vertically to form a grid. To create the illusion of curved lines in an image, pixels are displayed so small that we cannot see them with our naked eye. It is easy to get confused by the terms "pixels" and "dots per inch," or "dpi." Pixels are the true dimensions of an image, and the term dpi refers only to a file header sent to any output device. Printers typically output at 300 dpi. Whatever the output resolution is, the image retains the same amount of pixels.

CHANNELS AND MODES

The primary colors of light are red, green, and blue. By mixing these three colors in different amounts, all the colors of the rainbow can be created. All color variations can be captured and stored in three separate component parts of a digital file. These component parts are called the Red, Green, and Blue channels.

The most common type of image mode is the RGB Color mode (red, green, blue). This is the mode used on monitors and screens. In Photoshop, the colored RGB channels provide three sets of information regarding color. When color from one channel is present, a primary color is created. When information from two channels is present, a secondary color is displayed. Secondary colors are created by mixing two primaries, and they are called cyan, magenta, yellow (CMY). Color information about an image can also be stored using the secondary colors (mixing two secondary colors creates a primary color) plus black (K). Images using this system are in the CMYK Color mode. This mode is used for printing.

PHOTOSHOP FOR ARTISTS

FILE SIZE AND RESOLUTION

The size of an image file determines the amount of memory a computer uses to store it. The image size is the actual size in inches and also in pixel size, or "ppi" (pixels per square inch). You can access the Image Size window from the Image menu through **Image > Image Size**.

The term *resolution* refers to the number of pixels that describe an image and that establish its detail. Pixel dimensions, or the number of pixels along the width and height of an image, determine an image's resolution. To ensure the highest quality of a printed image, the image resolution should be at least 300 ppi.

Adjusting the resolution changes the number of pixels in an image, so the on-screen image becomes larger or smaller while the print size stays the same.

IMAGE QUALITY

To determine the printed size of a Photoshop image, you can divide the on-screen size by the resolution. For example, if you have an image with an on-screen width of 480 pixels and a resolution of 120 pixels per square inch, the printed width will be 4 inches. You can select the Resample Image option, if it is not already selected, to adjust the number of pixels in your image and keep the print dimensions fixed. This will reduce the image quality. The Constrain Proportions option, if checked, locks the image's width and the height to change proportionally. For example, if you are working on a photograph of a person and the Constrain Proportions is unchecked, reducing the height alone will make that person look fat because the width will stay the same while the height is reduced. However, if Constrain Proportions is checked, changing the height will automatically adjust the width proportionally.

Note: Sometimes it is useful to uncheck Constrain Proportions when you are working on a landscape or an abstract image, where disproportion is not as important as in figure photography.

Because resolution is linked to quality, the greater an image's resolution is, the smaller the pixels are and the sharper the appearance of the image will be to the naked eye.

FILE FORMATS

The main formats for saving a file are:

Photoshop Document (.PSD): This is Photoshop's default file format. It saves all the information for postcamera work. Other Adobe applications, such as Adobe Illustrator, Adobe InDesign, and Adobe GoLive, can directly import PSD files, which preserve many Photoshop features.

RAW (.DNG): Camera Raw and Digital Negative. This format contains the raw image data from a digital camera. It is meant to be an industry-wide standard format for digital cameras and provides a compatible archival format.

JPEG (.JPEG): Joint Photographic Experts Group. This format is used to display photographs and continuous-tone RGB images on the Web. JPEG-formatted images retain all color information, but they compress the file size by selectively discarding data. The larger the compression, the lower the quality of the image—and vice-versa.

TIFF (.TIFF): Tagged Image File Format. This format is used to exchange files between applications and computer platforms. Because this format is supported by all image-editing programs as well as paint and page layout applications—in addition to being accepted by all desktop scanners—I usually recommend saving one version of an image as a TIFF.

To send an image electronically, it is best to save it in RGB mode and change the format to a JPEG and to reduce the image resolution to 72 dpi. Reducing the size in inches is also a good idea. Although reducing the image resolution and size in inches will make the image unfit for quality printing, this option is necessary to send images by e-mail. An image sent by e-mail should be no more than 1 megabyte. This practice also protects an artist's copyright.

SAVING A FILE

Most files from a camera are in the JPEG format, but working from a JPEG and altering the file creates compression and loss of information. It is best to change the format of your file to a Photoshop format before working on it. The PSD format, which is native to Photoshop and a widely used format, stores an image with support for most imaging options available in Photoshop, including layers with masks, text, clipping paths, color spaces and more. There are several other Photoshop formats available besides PSD, which by contrast restrict content to provide predictable functionality. For example, EPS (Encapsulated PostScript) is a language file format that can contain

PHOTOSHOP FOR ARTISTS

both vector and bitmap graphics, and is used to transfer PostScipt-language artwork between applications. When opening an ESP file containing vector graphics, Photoshop rasterizes the image, converting the vector graphics to pixels.

An image in the PSD format is limited to a maximum of height and width of 30,000 pixels, but there is also an extended version, PSB format (Photoshop Big), known as "large document format" within Photoshop, which can hold images of up to 300,000 pixels.

However, for fine artists I suggest saving your working files as PSD files, with all layers intact. When you are ready to print the file, you should make an image duplicate [Image > Duplicate], then flatten the image [Layer > Flatten], then save it as a TIFF file to print [File > Save As > TIFF]. TIFF is recognized anywhere and is uncompressed, meaning all the file information is saved.

While working on an image, save your work *often* in PSD format to preserve all your layers [File > Save As > Format > Photoshop]. Always preserve your original work as a PSD file in case you want to go back to it.

CAPTURING AN IMAGE

An image can be transferred directly from a digital camera to your computer using a card reader. If you are working on a Mac, it can also be imported through iPhoto or any other image browser. Images are usually saved in the camera as either JPEG or RAW files. Some cameras do not have the RAW files option, which is an uncompressed format. Images captured from a camera in the JPEG format should be taken at the *highest* quality camera settings to ensure optimum editing flexibility with Photoshop and outputting options. Images can also be scanned. To ensure quality, it is best to choose the highest resolution from the outputting device.

DOWNLOADING PICTURES FROM A DIGITAL CAMERA

The easiest method for downloading pictures is to plug your camera, using the cord that came with it, into your computer via a USB port. If you are using a Mac, the iPhoto application will open automatically. If you are using a PC, your PC photo/media application will open and offer you options to view or copy/import your images. Import the photos to your computer and save them in your photo albums. If you are working on a Mac, you can create albums with the iPhoto application. Once your images are downloaded from your camera, to rework images with Photoshop, simply drag them from the album onto your desktop, open Photoshop, and go to File > Open. Find your desktop in the Open window, select your image, and then click Open.

SCANNING AN IMAGE

To scan an image, place the photo in the scanner. Switch on the scanner and let it warm up. When scanning, there are three particular areas you need to pay attention to: (1) resolution, (2) color depth, and (3) descreening. In general, the rule is that you should scan with at least twice the resolution of your intended output. Most printers work best at 300 dpi, so scan at 600 dpi and downsize later.

Color depth is measured in bits. In your scanner's options, you should see 1-bit (black and white), 8-bit (grayscale or limited color), and 24-bit (full color). Choose 24-bit for photos, even if the photo is black and white, to capture as much color and tonal information as you can.

If your scanner comes with a descreen option, make sure to use it. This will help to reduce the dot pattern visible when scanning printed material. To start scanning, on your scanner choose the photo setting or **Custom > 600 Resolution** and then click on the **Start Scanning** option.

Note: You can also choose a higher resolution for large-format images if your scanner permits it. A "repro-quality" desktop scanner offers resolution of 1200 ppi to 2400 ppi. Scanning at a high resolution will slow the action of scanning, but it will produce a higher quality image if you are planning on producing large-size work.

When the scanning is done, open your image in Photoshop [**File** > **Open** > **(select your image)** > **Open**]. You can also begin by launching your scanning software directly through Photoshop [**File** > **Import** > **(select your scanner)** > **(select your image)**]. Set the correct color depth and enable the **Descreen** option. Be sure to set the scan dpi to double what your final image will be.

PHOTOSHOP FOR ARTISTS

SCANNING AN OBJECT

You can create works of art by placing objects on a flatbed scanner and scanning them. Images rendered from a scanner can be a lot larger and more detailed than from a photo taken with a digital camera. They can be compared to macrophotography (photography at a very close-up range with very sharp details). You can scan objects at incredibly high resolutions to achieve really high levels of detail. A scanner's light is not directional but uniform. Although the depth of field offered by a flatbed scanner is somewhat limited, there is a three-dimensional quality that makes scanned objects pop out and stand on their own.

Scanning creates a very unusual view of an object and isolates it with a clean background. Manipulations with Photoshop will add to this creative technique. All kinds of objects can be scanned, especially natural materials such as flowers and leaves. Avoid touching the glass, as the oil on your skin will create smears. After opening a scanned image in Photoshop, use the Crop tool to choose the amount of image you wish to retain. In the photo below, I cropped out some dark area on the left.

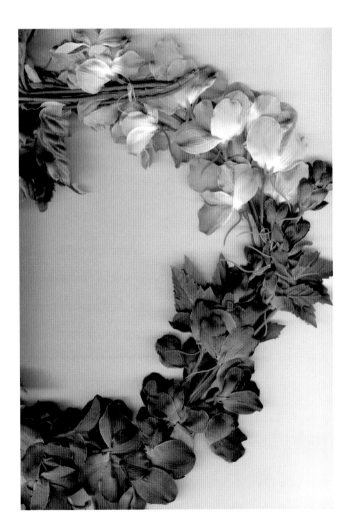

Mastering Photoshop's Tools for Artists

Painting with Photoshop means selecting an area on a created digital canvas and using the various tools available in the toolbox and filling these areas with color. There are several ways to select a color: the Color Swatches, the Color Picker, or the libraries of available Color palettes. The Eyedropper Tool is a very handy way to select a color in an opened image, which is particularly important when you need to pick and match a color from an existing image. To apply colors, several tools and various options are offered in Photoshop, such as the Paint Bucket Tool, the Gradient Tool, and the many brush choices in the Brushes library. Patterns and textures are also listed in the Brush Tool and Paint Bucket Tool libraries.

SELECTIVE TOOLS: LASSOS AND MARQUEES

Selective tools, such as the Rectangular Marquee Tool, the Elliptical Marquee Tool, the Lasso Tool, the Magic Wand Tool, and the Quick Selection Tool, are designed to select pixels contained in an area. Once selected, the area can be filled with color, pattern, or texture.

COLOR

Color in Photoshop can be accessed through the Color Swatches window or through the Color Picker window. Note that there are many additional Color Swatches palettes available from the Swatches palette window and that there are additional color libraries available through the Color Picker window. Click on the little arrow in the upper right of the window you are working on, to access these additional palettes.

Most important, any color from a photograph can also be reproduced with the Eyedropper Tool. Using the Eyedropper Tool on any spot in a color image will bring the specific color to the foreground at the bottom of the toolbox. Once a color is selected as the foreground, it can be painted on with any of the brush tools. The Eyedropper Tool is a crucial tool when working with color photographs. It matches colors already present and retrieves colors created.

PAINT BUCKET AND GRADIENT TOOL

The Paint Bucket Tool and the Gradient Tool are used to fill a selected area with colors, patterns, or textures. These tools will not work if an area is not selected with one of the selective tools mentioned earlier. The Edit > Fill command can also be used to fill a layer with color, pattern, or texture. The blending mode of a layer can also be changed from the Fill command window.

BRUSHES

Many tools are called "brushes," such as the Clone Tool, the Healing Brush Tool, and the Eraser Tool, but for now we will look closely at the Brush Tool. Photoshop offers a huge amount of brushes, but most users never go beyond the basic list. However, there are libraries full of wonderful brushes and textures that can be applied to your work. At first choose the Brush Tool from the Toolbox. Then in the Tool Options Bar (with the Brush Tool selected) under the Menu Bar, the first brush icon opens the Tool Preset Picker, while the second brush icon opens the Brush Preset Picker.

Click on the arrow at the upper right of the Brush Preset Picker window to reveal a menu of Brush libraries that can be viewed as thumbnails or lists, either small or large. The Brush Preset Picker also shows the Master Diameter and Hardness sliders of the selected brush. Clicking on the arrow to the right of the Master Diameter slider opens the Brushes library.

Choosing a different list of brushes will open a dialog box that asks you to either replace or append the current brushes with the new list. Choosing **Append** will add the new list of brushes to the current one, while choosing **Replace > OK** will replace them. To go back to the default brushes, choose **Reset Brushes** from the list and click **OK**.

To change the size and hardness of the brush, move the **Master Diameter** and **Hardness** sliders accordingly. You can also type a pixel amount for the diameter and hardness percentage.

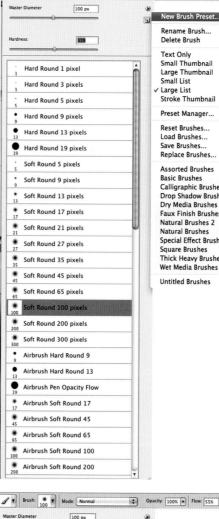

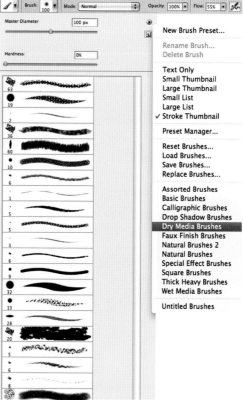

PHOTOSHOP FOR ARTISTS

Selecting **Painting** as a workspace will automatically open the Brush Presets window with the Color and Layers windows. You can also access the Brushes Presets window from the Window menu by checking **Brushes**. You can change and adjust the presets of a brush by clicking on the name of the preset. Clicking on the checkmarks will only make that preset available or unavailable. Clicking on the name will open the settings window on the right of the presets list.

Click on **Brush Tip Shape** to choose your brush tip and to change its size. Use the **Angle** and **Roundness** values to angle your brush and shape it. Click on the word **Texture** to open the Pattern swatches and pick a texture from the Artists Surfaces selection. From the Dynamics option, you can make the opacity and size respond to the pressure applied on a stylus by setting Control to **Pen Pressure**.

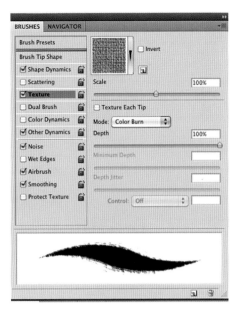

Making Your Own Brushes.

You can easily create your own brushes. Open a new file and pick a couple of interesting brushes to make your own marks. Select the marked area with the **Lasso Tool** or the **Rectangular Marquee Tool**, and then from the Edit menu, choose **Define Brush Preset**. A dialog box will appear asking you to give your new brush a name. Choose a descriptive name. Your new brush will now be listed at the end of your current brush list. You can save this brush and find it later by choosing **Load Brushes** from your Brushes library.

You can also easily create an endless number of brushes with patterns and textures with **Edit > Define Brush Preset** and **Edit > Define Pattern**. The new brush must be selected with a selective tool in order to be defined. Name your new brush and it will appear at the bottom of your current brush list.

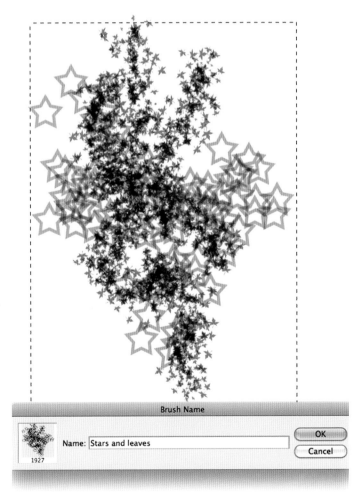

PATTERNS AND TEXTURES

Photoshop offers a large number of patterns and textures to work with. The Patterns and Textures libraries can be accessed as tools from the Paint Bucket Tool when choosing Pattern in the Tool Options Bar, or from the Pattern Stamp Tool in the Tool Options Bar. They can also be accessed as layers from the Edit > Fill menu (when the Fill window opens, choose **Pattern** in the Contents) or from Layer > New Fill Layer > Pattern.

You can create your own pattern just as you can create your own brushes. Select your newly created pattern with a selective tool and then from the Edit menu choose **Define Pattern**. Name your new pattern and it will appear at the bottom of your current pattern list.

Note: Edit > Fill > Pattern offers options to change the blending mode and opacity of the pattern, and Layer > New Fill Layer > Pattern offers all those options with the scale option. I find it is important to be able to change the scale of a pattern. The higher the scale percentage, the less repetition of the pattern.

Because the Pattern Stamp Tool is also a brush, patterns and textures can be painted with any brush size and setting, rather than just being filled in an area, so the Pattern Stamp Tool offers more control and many more creative options than the Paint Bucket Tool.

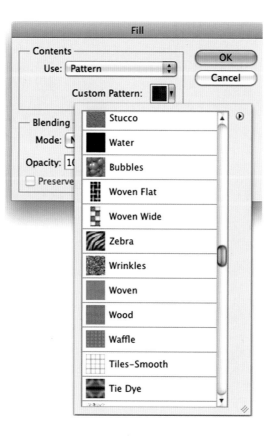

PHOTOSHOP FOR ARTISTS

Ann Winston Brown, *Stairs*, digital lithographic print

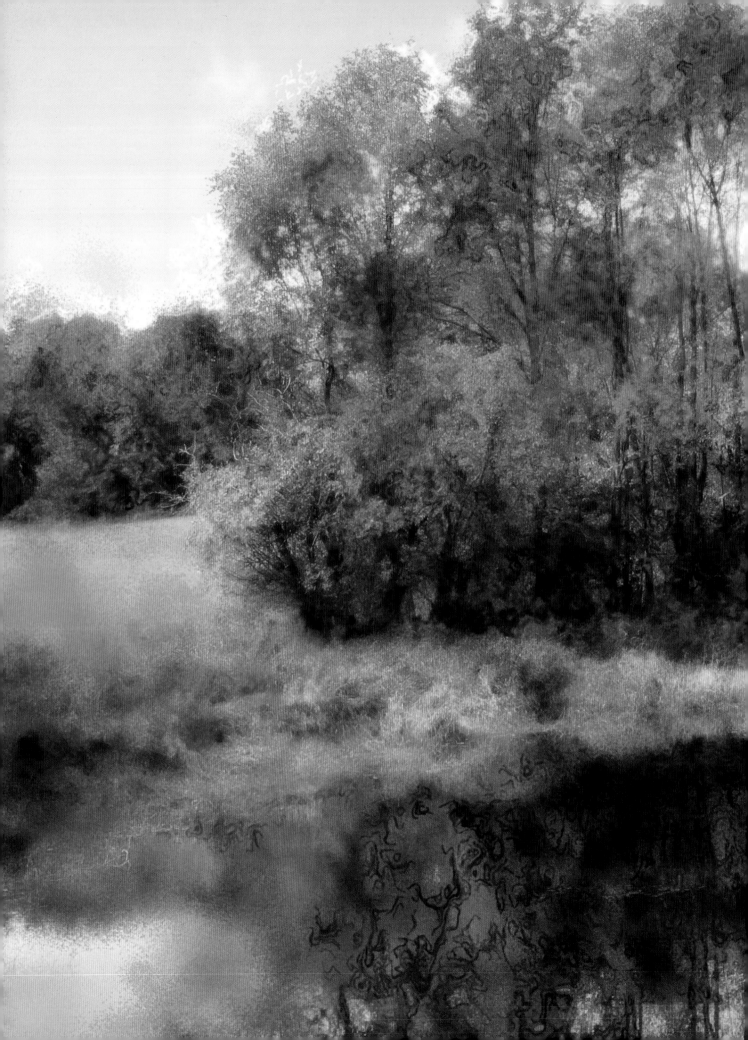

PART TWO

Tutorials for Drawing and Painting Digitally

For a painter, Photoshop is an entry into a new world of color and textures that are applied through the mind and eyes of the artist using the touch of a keyboard instead of a paint brush—without getting his or her hands dirty. The composition and building of a layered digital drawing or painting could be compared to the Renaissance painting technique of layering colored glaze onto an egg tempera–based surface.

Sylvie Covey, *Autumn Pond*,
digital painting

Drawing Digitally

This tutorial presents four methods for drawing in Photoshop.

FREE-HAND PORTRAIT DRAWING WITH A PHOTOSHOP GRID

Many beginners try too hard to outline everything. A successful drawing contains indications and information within the shapes of lines, tones, and textures. Well-drawn information often comes from within the subtleties of tones rather than from an outline. In this method we will create a free-hand tonal portrait sketch from a reference photograph. The use of a stylus is recommended for hand-drawing digitally.

The *grid technique* is a traditional way of reproducing an image used by artists for centuries. The basic principle consists of dividing a surface image into equal parts and working on each part as a whole. A divided part is smaller and easier to see and tackle. The grid technique is also very helpful to create the initial sketch of the important parts of a composition and for reproducing an image at a different scale. We will use a Photoshop grid as an overlay on both the reference photo and the drawing surface itself. The grid on both will help position the various elements of the portrait more accurately.

Drawing on a gray background with very realistic Photoshop brushes will allow us to keep all our options open for adding darker or lighter tones. We will start from a midtone surface and digitally use the natural media feel of centuries-old drawing tools. Photoshop offers many wonderful ways to re-create this traditional drawing method. New York artist, illustrator, and author Moira Fain turned this photo portrait into a digital hand-drawing using this method.

START IMAGE Photographer Unknown, *Shaun Covey*, digital print

1 **Make a Grid.** Open a photo portrait in Photoshop [**File** > **Open** > **(select your file)**]. From the Image menu, go to **Image Size** and resize your image so that it can be equally divided into a 2-inch grid (for example, 12 x 18 inches). From the View menu go to **View** > **Show** > **Grid**. Then from the Photoshop menu choose **Photoshop** > **Preferences** > **Guides, Grid & Slices**. When the window opens, type **2** in the Grid section for Gridline Every and set it in inches. Click **OK**. Your image is now covered with a 2-inch grid.

2 **Create a Gray Background.** From the Image menu choose **Image** > **Duplicate**. Choose a light gray color for the foreground swatch. Go to **Edit** > **Fill,** and in the Fill window choose **Foreground** for Contents. Your duplicate image is now the exact size of the reference photo portrait and also bears the grid.

3 Prepare the Drawing Tool.

In Photoshop many tools are called brushes, and in this method we will draw with a "brush" to render the pencil effect of a free-hand drawing on paper. Select the **Brush Tool** from the Toolbox. In the Brush Picker of the Tool Options Bar click the list menu (click on the arrow in the right of the upper window) and find the **Pastel Medium Tip** brush from the **Dry Media Brushes** menu.

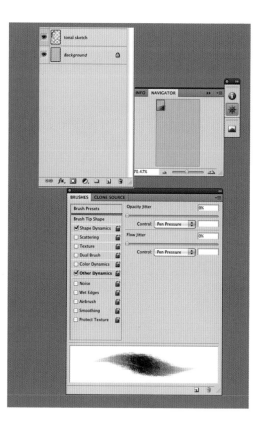

To set the size and opacity dynamics, from the Window menu choose **Brushes** to display the Brushes palette. In the Shape Dynamics option, set the **Size Jitter** to 10% and **Minimum Diameter** to 25% and the Control to **Pen Pressure**. In the Other Dynamics option, set both the Opacity and Flow jitters to **Pen Control** and click **OK**, ignoring the rest of the options.

PHOTOSHOP FOR ARTISTS

4 **Draw Digitally.** In this method we will only use black and white to draw, and each tonal range will be on a separate layer. Create a new layer [Layer > New > Layer] and name it "Tonal Sketch." Set the foreground color to black. Start by sketching the main shadow areas onto the new layer with your brush at **50%** Opacity.

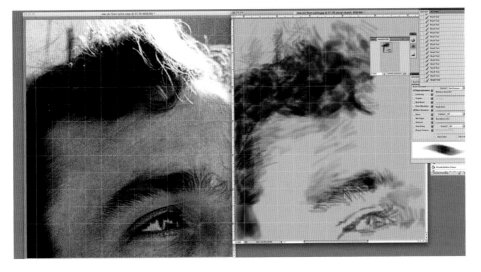

Use the grid as a guide for composing your image. At this point, you only need a few indications to position the main masses of light and dark. At this stage the use of the hatching technique is preferrable rather than an outline. Hatching is criss-crossing a surface in order to create a tone. Think of blocks of tones rather than outlines.

5 Adjust Your Brush Size. Change the size of your
brush as needed by moving the Master Diameter slider at the top of the Brush Picker window. You can also type a pixel number to increase or decrease the size of your brush. For now, work with a brush Size between **100** and **150** pixels.

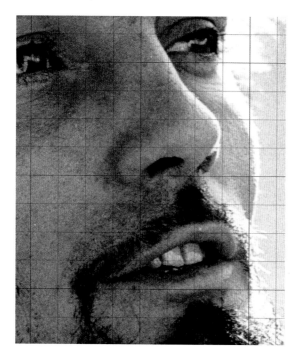

6 Lay Out the Dark Areas.
Create a new layer [**Layer > New > Layer**] and name it "First Darks." It is important to be aware of the direction of light in your image. Use lots of loose brushstrokes in various directions and concentrate on the dark masses. The tones build up slowly with overlaying strokes because the brush Opacity is at **50%** or lower. You should also vary the pressure of your stylus. The gray background will serve as midtones for now.

7 Start on the Highlights. From the Layer menu
choose **Layer** > **New** > **Layer** to create a new layer and name it
"Highlights." Switch the foreground color to white in the Toolbox. Start
establishing your highlights on the new layer with gentle, white strokes.

Note: To switch from the foreground to the background in the Toolbox, click
on the curved, little arrow at the right of the small black-and-white swatches
at the bottom of the toolbox. Clicking on the smaller swatches will switch
from color to black and white.

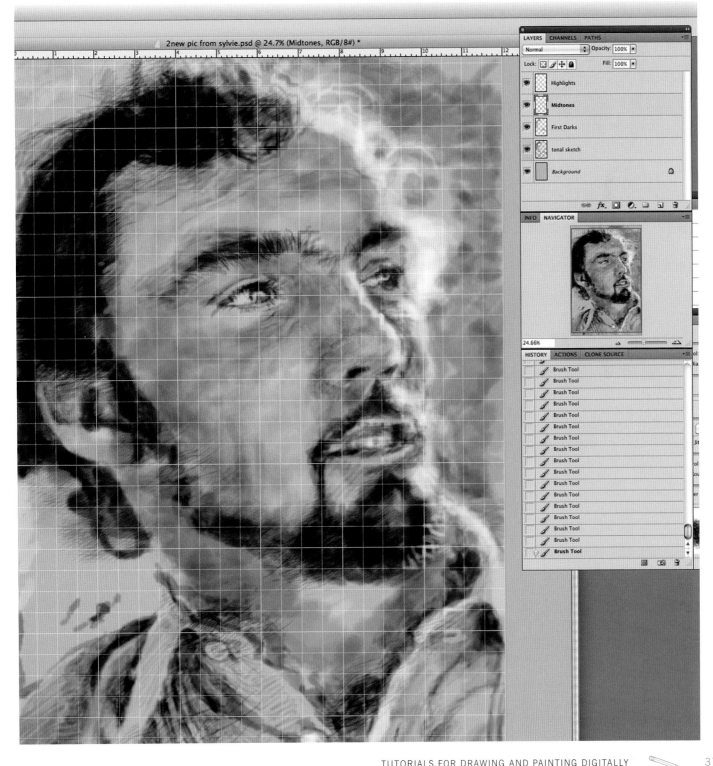

8 Add Some Midtones.

Create a new layer [**Layer > New > Layer**] and drag it above the "First Darks" layer. Name the new layer "Midtones." The layers stack now starts at the bottom with the "Background" layer, then "Tonal Sketch," then "First Darks," then "Midtones," then ending with the "Highlights" layer on top. Reduce your brush Opacity to **25%** and switch the foreground color to black. Gently brush in transitional tones between the highlights and shadows.

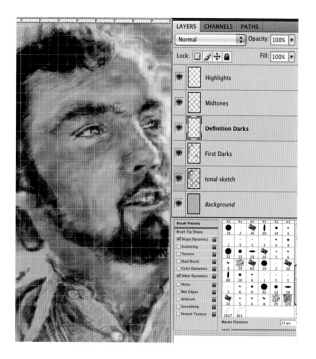

9 Add More Definition.

It is time to look at the drawing as a whole image. From the View menu select **Show > Grid** to uncheck and erase the grid. Create a new layer [**Layer > New > Layer**], drag it above the "First Darks" layer in the layers stack and name it "Definition Darks." Reduce your brush to a much smaller size with the Master Diameter slider in the Brush Picker window. With the **Brush Tool** selected from the Tool Options Bar, increase the Opacity to around **50%** and start sketching the details. Work with small strokes to reinforce and define the image. You can also use the Eraser Tool from the Toolbox to lift subtle areas of light in the darks layers. This close-up to the right shows where the Eraser Tool was used to accentuate the light on the background of the subject, next to the head and on the nose.

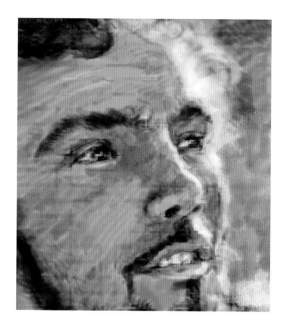

10 **Create Highlights.** Activate the "Highlights" layer and use a very small-sized brush with white as the foreground color to add highlights to the eyes and hair. For larger areas use the hatching technique to create light and texture.

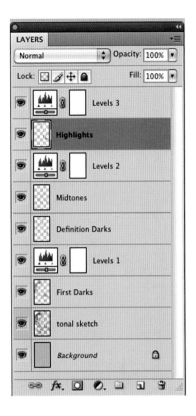

11 **Add Final Details.** Select the **Smudge Tool** from the Toolbox and smudge out the rough areas and the leftover marks from the grid. Save your image in a PSD format to keep all the layers intact. Make a duplicate image [**Image** > **Duplicate**], flatten the duplicate's layers [**Layer** > **Flatten**], and save the duplicate as a TIFF file to print.

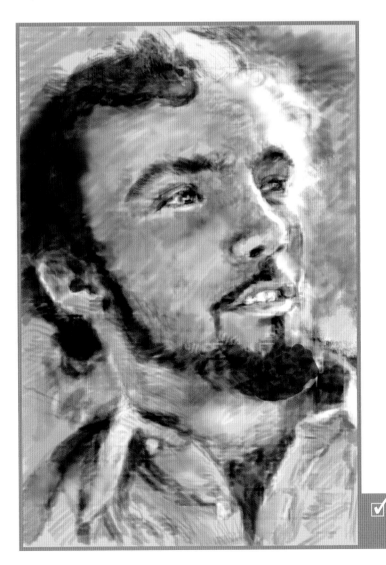

☑ the final

Moira Fain, *Portrait of Shan*, digital drawing

FREE-HAND CHARCOAL DRAWING IN PHOTOSHOP

Early mankind made charcoal from burnt twigs and hardwood to draw on cave walls. One of the simplest mediums, charcoal was—and continues to be today—a favorite and effective tool for producing charismatic and expressive drawings. When drawing with charcoal, an accumulation of carbon dust is deposited onto the paper's surface. There is a gritty quality to this medium that can be contrasted with soft and smudged areas, producing a mysterious and appealing result.

Charcoal can be classified as either soft, medium, or hard. Soft charcoal produces darker grays than hard charcoal. Charred wood produces very subtle tints of color that change in tonal density. Although charcoal art is mainly black and white, very dark reds, blues, and browns can be used in place of black for shadows.

When working with real charcoal, a fixative must be sprayed onto the finished image to minimize any smearing; however, in this drawing method smudging is digital. I will use a photograph as a reference and convert it into a charcoal drawing using Photoshop's brushes, filters, and layer masks. I will also create a paper color and style it with the feel of old parchment.

1 **Choose a Subject.** Select a photograph that you want to change into a charcoal drawing and open it in Photoshop. I chose a picture of lilies from my garden.

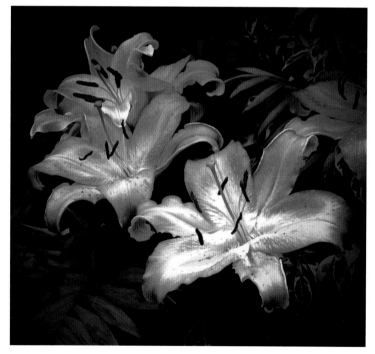

START IMAGE Sylvie Covey, *Lilies*, digital photograph

2 Create a Paper Color.

Next, create a new layer. From the Layer menu choose **Layer > New > Layer** and name it "Paper." From the Window menu, open either the Color or Swatches window (in the Windows pull-down menu, check **Swatches** or **Color**) and choose a color for your charcoal paper. It could be an antique, warm, light yellow that has an old parchment look or a colder blue-gray. Choose anything but white. Select your color by clicking on it with your cursor and make sure that it automatically becomes your Foreground Color at the bottom of the Toolbox.

Note: Placing your cursor on the Color Swatches or Color Picker automatically makes it work as the Eyedropper Tool, which is there for selecting your color as a foreground color.

With the "Paper" layer active, choose **Fill** and choose **Foreground Color** from the Contents Dialog box.

3 Create a Line Drawing.

Duplicate the "Background" layer [**Layer > Duplicate Layer**] and drag it to the top of the layers stack. From the Filter menu choose **Filter > Stylize > Glowing Edges**. Manipulate the Glowing Edges sliders to your liking. We want the line to be narrow, bright, and very smooth. Photoshop users may use other filters to create a line drawing, such as the **Filter > Stylize > Find Edges**. However, that filter does not offer sliders to adjust the line quality. The Glowing Edges filter offers more quality control to the size and characteristics of its edges.

To convert this neon-filtered image into a black-and-white drawing, go to **Image > Adjustments > Invert** and then to **Image > Adjustments > Desaturate**.

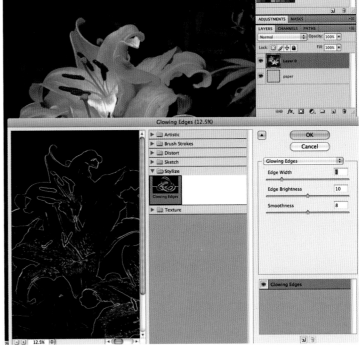

4 Create a Grainy Charcoal Effect. Set the

Blend Mode of the drawing layer to **Multiply**. This blending mode makes the white disappear. The drawing now shows onto the colored paper.

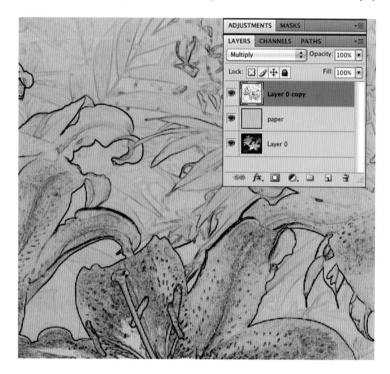

Duplicate the "Background" layer once more [**Layer > Duplicate Layer**] and drag this new layer to the top of the layers stack. From the Image menu, choose **Image > Adjustments > Desaturate** to make the layer black and white. Add some contrast with an S-shape curve adjustment [**Image > Adjustments > Curves**]. Click on the upper right part of the line and raise it slightly. Then click on the lower left part of the line and lower it to create an S-shape.

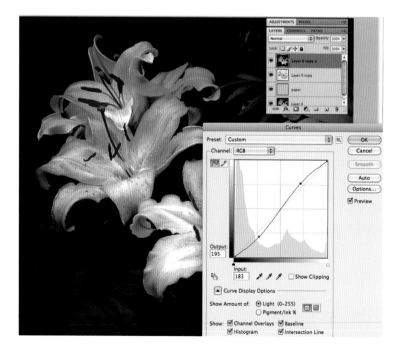

PHOTOSHOP FOR ARTISTS

Charcoal has a grainy quality, which we want to re-create. With this black-and-white layer active, go to **Filter > Noise > Add Noise**. Check **Monochromatic** and **Gaussian** Distribution and give it an Amount of about **20%**. The Noise filters add or remove noise, or pixels, with randomly distributed color levels. This helps blend a selection to the surrounding pixels. Noise filters can create unusual textures and also remove dust and scratches.

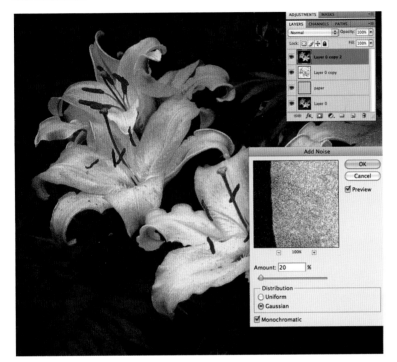

5 **Draw a Mask.** Photoshop masks are used to isolate and hide parts of an image. When a selection is made, the area *not* selected is masked, or protected. Masks can be used for editing tasks such as filter effects or color changes within the selected areas. From the Layers menu, the Layer Mask option offers Reveal All or Hide All settings. A key concept to remember when masking is that black hides, and white reveals. Masking is important to understand, because it does not erase or cut pixel information; it only masks the information. Those masked pixels are always there to be retrieved if needed. Remember, the Eraser Tool erases similarly to how a surgeon works with a scalpel, but a mask can always be worked on and pixels can always be revived.

When starting to work with masks it is crucial to check the Layers palette to see whether the layer image or the mask is active. An active element will have a white border around its thumbnail. Click on the intended icon to be sure it is activated. With the top layer active, go to **Layer > Layer Mask > Hide All**. Choose the **Brush Tool** from the Toolbox.

Note: When drawing or painting on a layer mask, it is important to remember to activate the mask thumbnail by clicking on it and to always use white as foreground color on a black mask, and black as foreground color on a white mask.

With the mask thumbnail active and white selected as the foreground color, draw with white on your image. Notice that your mask in the Layers window will show the white paint on top of the black mask. Start at the center of your image and leave some areas untouched to let the paper's texture show. Wisely use your drawing skills and artistic judgment to draw.

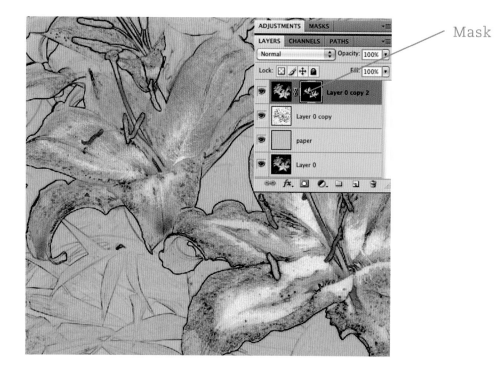

Mask

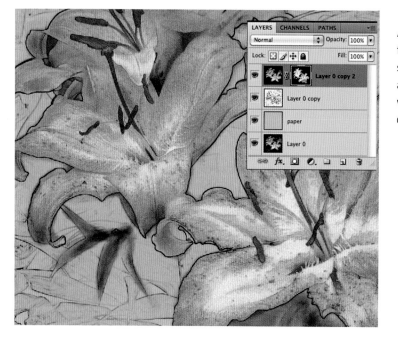

Adjust the opacity of your brush as needed in the Tool Options Bar under the menus, and switch the foreground color to black to correct any painting mistakes. Continue painting with white to further your composition, but concentrate on the center of the image.

6 Create a Paper Texture.
Activate the "Paper" layer and go to **Layer > New Fill Layer > Pattern**. Click **OK** to create a Pattern Fill Adjustment layer. See Patterns and Textures on pages 28–29 for more information about patterns. Click on the arrow next to the pattern swatch to open the Patterns library list. From the Grayscale Paper library, experiment with different patterns like **Parchment** or **Charcoal Flecks**. Increase the Scale to more than **1000%** for Parchment and **600%** for Charcoal Flecks to hide pattern repetition and then click **OK**.

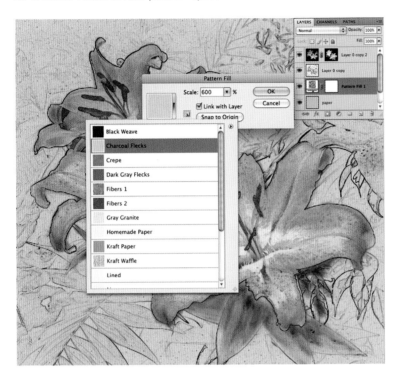

7 Use a Blending Mode.
Change the Blend Mode of the "Pattern Fill" layer to **Multiply**. The color of the paper now reappears.

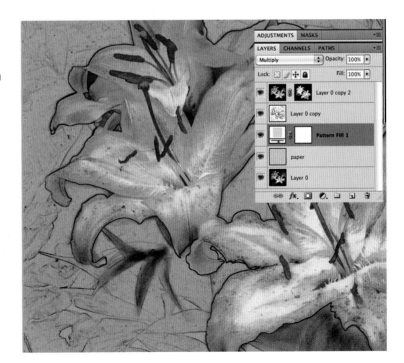

8 Create Softer Edges.

Create Softer Edges. Save a copy of your image in a PSD format [**File** > **Save As** > **Format** > **Photoshop**]. You now need to flatten your image to continue working on it [**Layer** > **Flatten**].

To work on the edges, you must first create a new white layer under the layer image. First double-click on the "Background" layer and convert it to "Layer 0." This will enable you to move the layer to the layers stack, since a "Background" layer cannot be moved. Create a new layer [**Layer** > **New** > **Layer**], and from the Edit menu choose **Fill**. In the Fill window choose **Fill with White**. Drag the white layer ("Layer 1") under the "Layer 0."

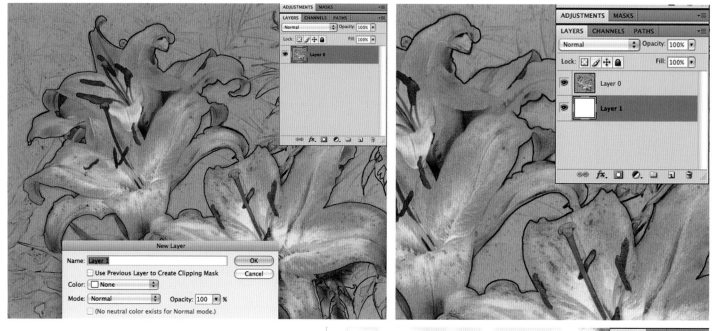

Activate "Layer 0," and from the Layer menu choose **Layer** > **Layer Mask** > **Reveal All**. Choose a rough brush, such as the **Stipple** brush at around 250 pixels, and lower its Opacity to **50%** in the Tool Options Bar. Activate the mask thumbnail and start painting the edges of your paper with black as the foreground color.

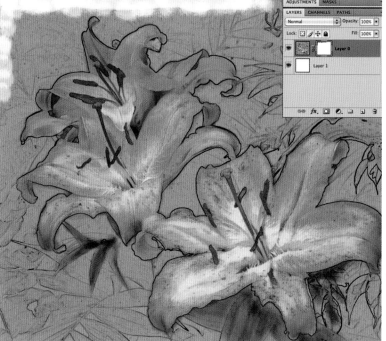

9 Create an Antique Effect. Duplicate "Layer 0"
[Layer > Duplicate Layer] and change the Blend Mode of the new
layer to Multiply. Continue painting on the edges in the mask until you are
satisfied. Adjust the Opacity to around 70%. Flatten and save your work
as a TIFF file to print.

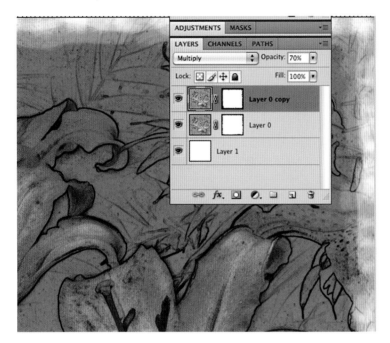

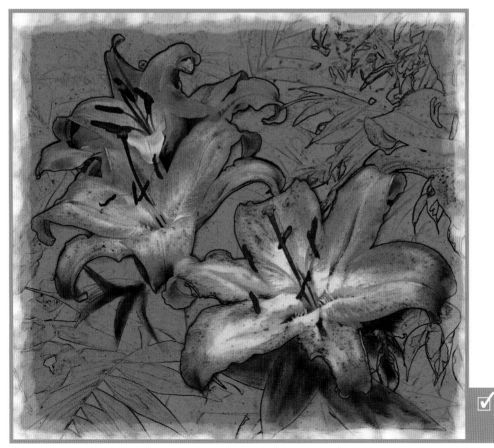

DRAWING WITH FILTERS

Unlike the previous methods, drawing with filters does not require traditional drawing skills, because a filter is not used as a free-hand brush but is applied on a entire layer of the image. In this exercise the artistic skills reside in the optical decisions when setting the control options of a particular filter.

Drawing with a Colored Pencil Filter
The Filter menu opens a number of Filter libraries. In this first example I chose the **Colored Pencil** filter from the **Filter > Artistic** library, because its control options fit well with my image. Open an image in Photoshop. In the Layer window, double-click on the "Background" layer and convert it to "Layer 0." Duplicate the layer [**Layer > Duplicate Layer**].

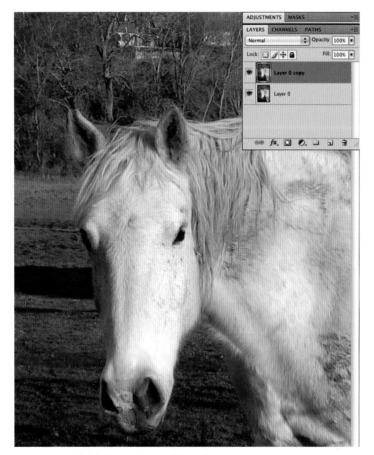

START IMAGE Sylvie Covey, *Horse*, digital print

1 Create a Paper Layer. From the
Layer menu go to New Fill Layer > Pattern.

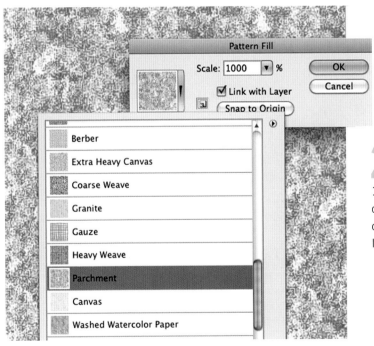

2 Choose a Pattern. When the Pattern
Fill window opens, set the Scale to maximum
1000% and click on the arrow in the Pattern swatch to
open the Pattern lists. Experiment with the many paper
options. I chose **Parchment** from the Grayscale Paper
library.

3 Change the Opacity Layer and the Blend Mode.
In the Layers window, lower the Pattern Fill layer Opacity to **50%**. Drag "Layer 0 Copy" to the top of the layers stack and change its Blend Mode to **Overlay**.

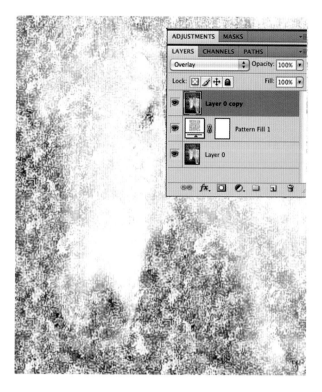

4 Use a Colored Pencil Filter.
Activate "Layer 0" by choosing **Artistic > Colored Pencil** from the Filter menu. Set the Pencil Width to around **24**, the Stroke Pressure to **4**, and the Paper Brightness to **50**.

Note: These settings were appropriate with my image, but they should be adjusted according to your image's needs.

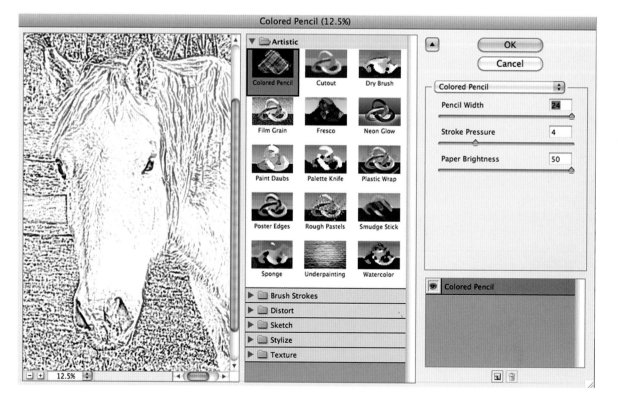

PHOTOSHOP FOR ARTISTS

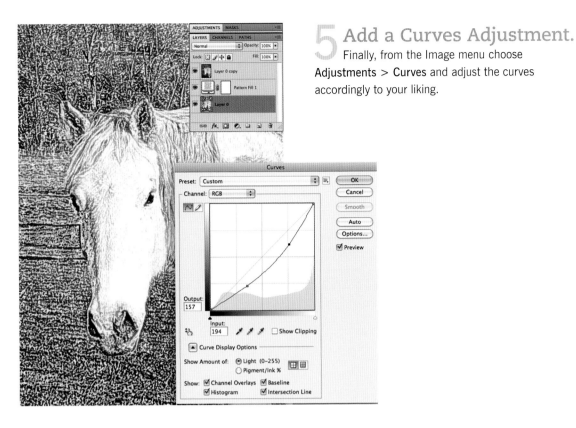

5 Add a Curves Adjustment.

Finally, from the Image menu choose
Adjustments > Curves and adjust the curves
accordingly to your liking.

6 Save Your File.

Save your file in a PSD format [**File > Save
As > Format > Photoshop**] and then from the Layer menu flatten your
image [**Layer > Flatten**]. Save it again as a TIFF to print.

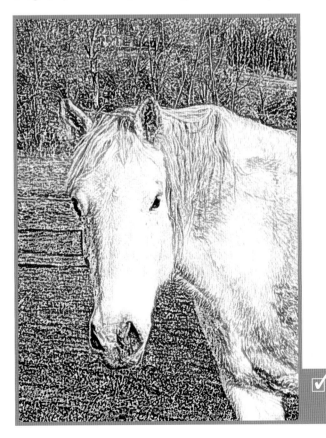

☑ the final

Sylvie Covey, *Colored Horse,*
digital drawing

PEN AND INK DRAWING WITH PATTERNS

The use of patterns was covered on pages 28–29. In this drawing method I chose patterns resembling a crosshatch drawing technique for a graphic effect. Some of the patterns you might want to look at include Strings, Fractures, Ant Farm, Bark, and Weave 1.

1 Choose a Subject. Open an image in Photoshop. Double-click on the "Background" layer to make it "Layer 0." I chose a photograph I took of a goat in Upstate New York.

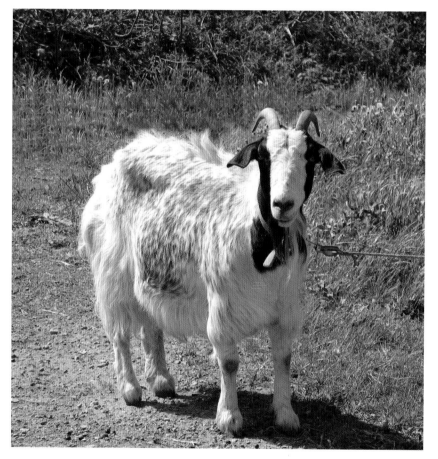

START IMAGE Sylvie Covey, *Goat*, digital print

PHOTOSHOP FOR ARTISTS

2 Turn Your Image into Black and White.

Duplicate "Layer 0." From the Layer menu go to **Layer > Duplicate Layer.** Then, from the Layer menu again, go to **New Adjustment Layer > Black & White.**

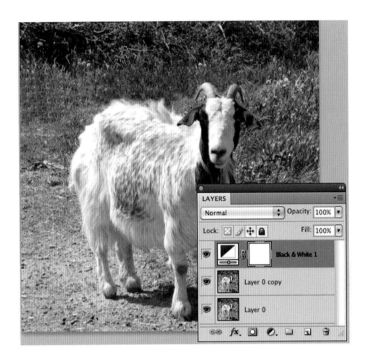

3 Select an Area.

Choose the **Magic Wand Tool** from the Toolbox and set a low Tolerance (**10 to 15**) in the Tool Options Bar. If the Magic Wand Tool is not right for your image, switch to the **Magnetic Lasso Tool.** The Magnetic Lasso Tool actively searches the edges of an object, snapping the selection like a magnet. In order to separate objects, it looks for differences in color and brightness. Select an area of your image to fill with a pattern.

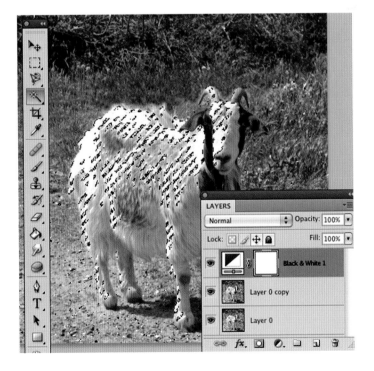

4 Choose and Apply a Pattern.

From the Layer menu choose **New Fill Layer > Pattern**. In the Pattern Fill window click on the arrow next to the pattern swatch to open the patterns list. Choose a pattern and adjust the Scale percentage accordingly. Click **OK** to apply the pattern.

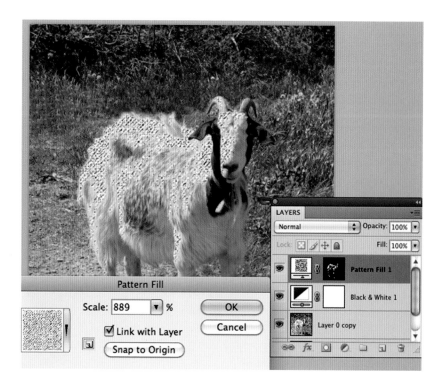

5 Apply Another Pattern.

Activate the "Layer 0 Copy 2." Select another area of the image with your **Magic Wand Tool** or with the **Quick Selection Tool**. From the Layer menu again, choose **New Fill Layer > Pattern**. Choose a different pattern from the list and change the scale percentage. Move the "Pattern Fill 2" layer to the top of the layers stack and change the Blend Mode of the layer to **Multiply**.

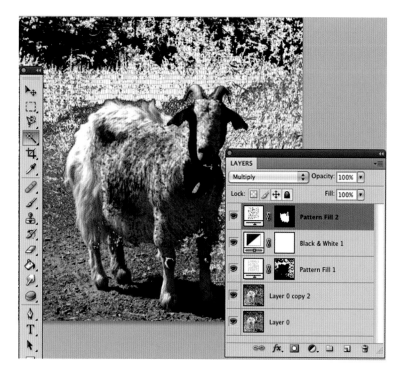

PHOTOSHOP FOR ARTISTS

6 **Add More Patterns with Different Blending Modes.** Activate the "Layer 0 Copy 2" again and select another area of your image with the **Magic Wand Tool.** Add another New Fill Layer pattern [**Layer** > **New Fill Layer** > **Pattern**]. Choose different patterns to add graphic effects to your image. Bring this Pattern Fill layer to the top of the layers stack and change the layer's Blend Mode to **Overlay**. Your final image is a combination of multiple patterns that give very graphic effects and transform your photo into a crosshatch drawing.

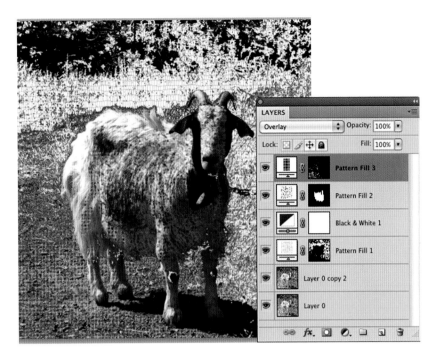

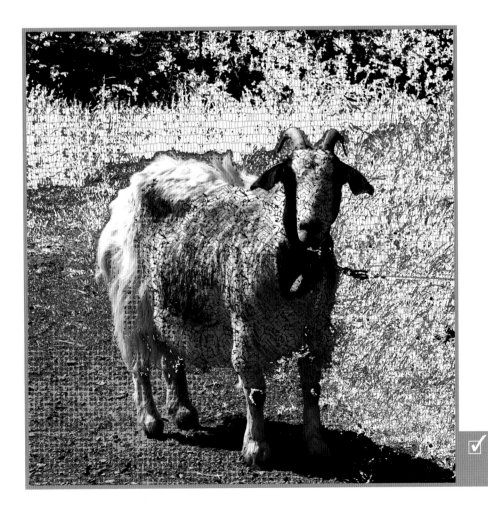

☑ the final

Sylvie Covey, *Goat II*, digital drawing

Painting Abstract Compositions

In this tutorial we will use the Rectangular Marquee Tool, the Elliptical Marquee Tool, the Lasso Tool, and Polygonal Lasso Tool to select areas to be filled with color using the Paint Bucket Tool. Each selection and color is made on a separate layer to ensure more control during final editing. Each selection can be moved using the Move Tool. Each layer's opacity can be adjusted, in addition to the order of layers in the Layers palette. Here is a great example of an abstract composition by New York artist John Salvi.

EXAMPLE John Salvi, *Melt Down*, digital print

1 Create and Name a New File and Choose Its Size.

In Photoshop, create a new file [File > New] and name the file "Abstract Painting" in the New file window. Type the Width and Height in inches (for example, 8 inches and 10 inches, respectively). Choose 300 for the Resolution, RGB Color for the Color Mode, and select White for the Background Contents. The bit depth specifies the maximum number of colors that can be used (8 bit is good for this project). Click OK.

New		
Name: Abstract Painting		OK
Preset: Custom		Cancel
Size:		Save Preset...
Width: 8	inches	Delete Preset...
Height: 10	inches	
Resolution: 300	pixels/inch	Device Central...
Color Mode: RGB Color	8 bit	
Background Contents: White		
▼ Advanced		Image Size: 20.6M

2 Open the Layers and Swatches Windows, Make Rectangular Selections, and Fill Them with Color.

From the Window menu, click on **Layers** > **Swatches** to open the Layers and Swatches windows. You can also access these windows from the icons panel on the right of your screen when you are in the Basic workspace. Select the **Rectangular Marquee Tool** from the Toolbox and make a rectangular selection on the canvas. Click on one area in your canvas and drag the cursor diagonally across; then release the cursor. The rectangular selection appears. (It looks like little marching ants.) Choose a color from the Swatches palette by clicking on it. The color is now your foreground color and appears as a swatch at the bottom of your toolbox. Select the **Paint Bucket Tool** from the Toolbox. Then click inside the rectangular selection to fill it with your chosen color. From the Layer menu go to **Layer** > **New** > **Layer** to make a new layer for the next color.

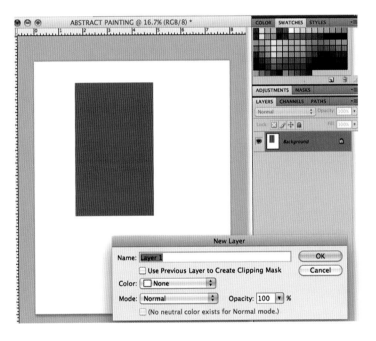

3 Make Multiple Selections of Interactive Shapes.

With the selective marquee tools, like the **Rectangular Marquee Tool** or the **Elliptical Marquee Tool,** you can create a selection with a predefined shape, and you can combine multiple selections in many different ways. The key to doing this lies in the Selection Options at the top left of the Tool Options Bar. First, make a selection active; then choose the buttons **Add to Selection** or **Subtract from Selection**. (You can even choose just the intersecting area.)

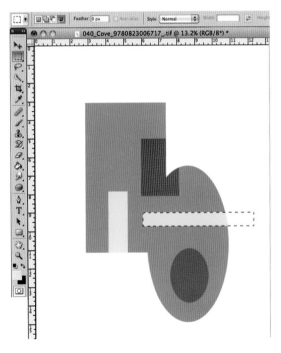

4 Use the Polygonal Lasso Tool to Create Your Own Shapes.

Select the **Polygonal Lasso Tool** from the Toolbox and make a geometrical straight edges selection on the new layer by clicking, dragging, and releasing the cursor around a geometrical shape. Choose a different color from the Color Swatches window and use the **Paint Bucket Tool** to fill the selection. Repeat this process several times, making sure you create a new layer for each color [**Layer > New > Layer**]. Adjust the opacity of each layer in the Layers palette to let the underneath colors show through.

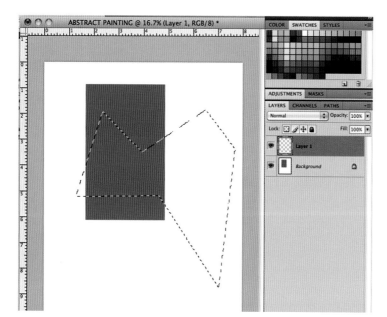

PHOTOSHOP FOR ARTISTS

5 Draw Irregular Free-hand Shapes. Choose
the regular **Lasso Tool** to make a curve selection with irregular edges,
and continue to build your painting with new layers and new colors, adjusting
the opacity accordingly.

Note: If you have started making a selection with one of the lasso tools and
want to start again, hit the Esc (Escape) key on the keyboard to delete it and
start again.

6 Experiment with Changing the Order
of Layers. Use the **Rectangular
Marquee Tool** again to fill a new selection
with a color; then duplicate the layer [**Layer
> Duplicate Layer**] and use the **Move
Tool** to move the selection of the duplicate
layer. Drag the duplicate down to the stack
of layers and observe how it changes its
appearance without reducing its opacity.

7 Create a Key Line Frame.

To create a key line frame over the whole image, use the **Rectangular Marquee Tool** to make a selection. From the Edit menu choose **Stroke**. In the Stroke window, enter a pixel number to determine the thickness of your line. Choose a color from the Color Picker (double-click on the color swatch to open the Color Picker). Next, choose the Location of the stroke (Inside, Center, or Outside) and click **OK**.

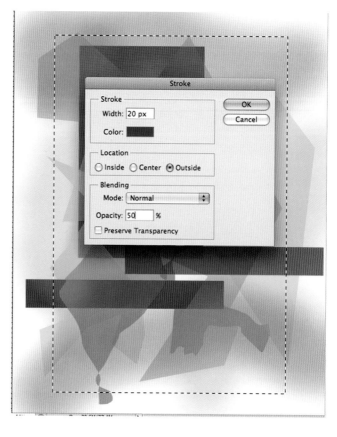

8 Add a Color Wash to Some Areas.

Finally, choose a large, soft brush at a low opacity on a new layer to give a wash to the areas that are not filled with color. Experiment with dragging the layers up and down the layers stack and observe how it affects the appearance of the image. Play with the order of layers in the stack until the image looks satisfying to your taste.

9 **Save Your File.** Save your image in a PSD format to keep all the layers intact [**File** > **Save As** > **Format** > **Photoshop**]. From the Layer menu, flatten your image [**Layer** > **Flatten**] and save it again in a TIFF format to print [**File** > **Save As** > **Format** > **TIFF**].

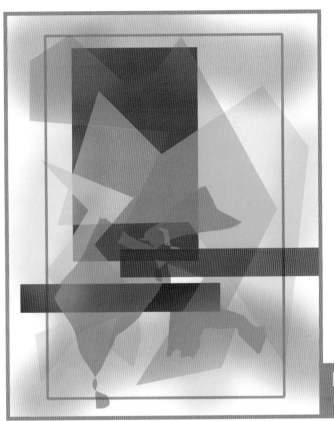

☑ the final

Sylvie Covey, *Abstract Composition*, digital print

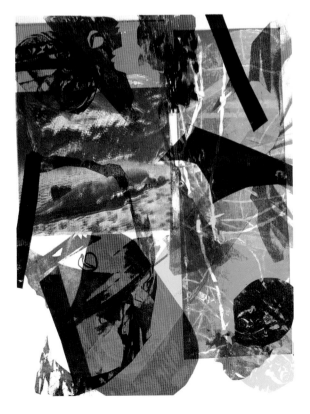

EXAMPLE John Salvi, *Mirror/Jagged Edges*, mixed media

Here is another example of a finished abstract Photoshop composition by artist John Salvi.

Painting Digital Landscapes

In these next methods we look at various ways we can paint foliage and landscape scenery using Photoshop. In the first method, starting from a photograph, we use the Art History Brush Tool, and change the settings and size on each new layer. In the second method, we start from a blank canvas and free-hand paint with the various foliage brushes available in the Brushes library.

PAINTING SCENERY WITH THE ART HISTORY BRUSH TOOL

The Art History Brush Tool is an exciting alternative for creating painting effects, and can be combined with Photoshop's filters and blending modes to apply effects similar to those achieved with layers and masks. The History Brush Tool paints by re-creating a specified source data from an Art History state. This tool makes a sample/copy of the image and then paints with it in the current window. The Art History Brush Tool uses the data, along with the options set in the Tool Options Bar, to produce different colors, sizes, tolerances, and artistic styles. A low tolerance lets you paint unlimited strokes anywhere in the image, while a high tolerance limits paint strokes to areas that are very different from the color in the source History state. The styles determine the types of brushstrokes you choose.

Art History states, or snapshots, are created when painting by clicking on the image. To start painting from a particular time frame, click on the **Create a Snapshot** icon at the bottom of the History palette.

History states, like sequential frames, record the particular state of the painting in each moment, and paint is applied from parts of one History state into another. It is important to remember that History is only available while the file is open, and will be gone when the file is closed. For this reason, it is advisable to complete this project in one sitting. At the very least, finish any painting from a particular snapshot. Also, blending modes should be applied and saved *before* saving and closing the file.

1 Choose a Scenic Image. Open a photo landscape with some sky, trees, and foliage in Photoshop. I chose a scenic image shot in Northern California.

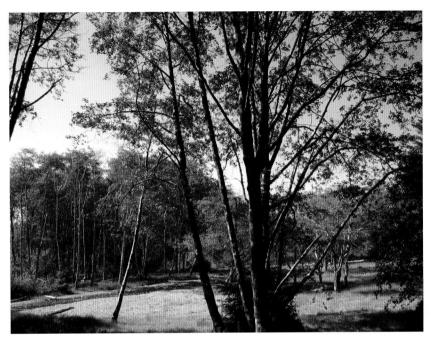

START IMAGE Sylvie Covey,
Trees in California, digital print

Use snapshots to paint. From the Window menu, check **History** to open the History palette and find the **Create a Snapshot** icon. Click on it to create the first snapshot of your image. It is important throughout this process that you select the correct History state from which to paint. Click on the **History Source** box to the left of the correct snapshot to activate the Art History icon.

2 Use the Art History Brush Tool. Select the **Art History Brush Tool** from the Toolbox. It usually hides under the History Brush Tool. On the Tool Options Bar, click on the arrow next to the Brush Picker to open the Brushes library. Choose a brush, preferably the most nonsymmetrical one for better results. I used Dry Brush Tip Light Flow for this tutorial. From the Window menu, open the **Brushes** palette and click on **Shape Dynamics** under Brush Tip Shape. Set the Roundness Jitter to around **50%**. Next, click on **Color Dynamics** and set the Hue Jitter to around **15%**.

3 Use More Brush Settings.
On the Tool Options Bar, set the Style to **Tight Short,** the Tolerance to **0%,** and the Area to around **50 pixels.** You can experiment with other styles to see what suits you best. The Style will determine the characteristics of your brushstroke. The Art History Brush Tool is most effective at a low to medium opacity.

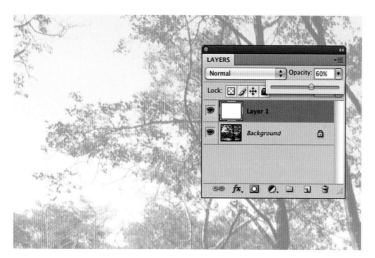

4 Create a Filled Layer as a Canvas to Paint On.
Create a new layer [**Layer > New > Layer**] and fill it with white [**Edit > Fill > Contents > White**]. Lower the filled-layer Opacity to around **60%** to see the image underneath and select the **Art History Brush Tool** from the Toolbox.

5 Paint with a Wide Brush on a New Layer.
Create another new layer [**Layer > New Layer**]. Adjust the brush diameter fairly wide to start (around **60 pixels**), as we will reduce the size of the brush with each layer. Reduce the brush Opacity to around **60%**. In the History palette, check the box to the left of Snapshot 1 to activate the Art History icon. Begin clicking to paint wide strokes on the first layer.

Note: The Snapshot button takes a snapshot of the way your painting appears on the screen at the moment you click it. Each time you click and paint, a new snapshot appears in the History palette.

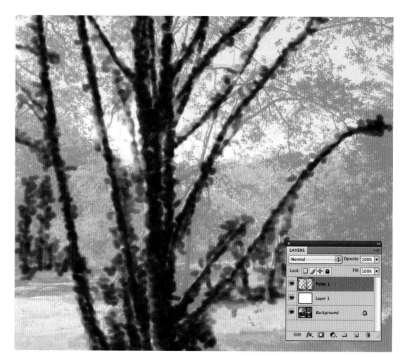

PHOTOSHOP FOR ARTISTS

6 Paint with a Medium Brush on Another New Layer.

Create another new layer, reduce your brush diameter to **30 pixels,** and continue clicking and painting on more specific areas. Adjust the Tolerance and the Opacity as needed.

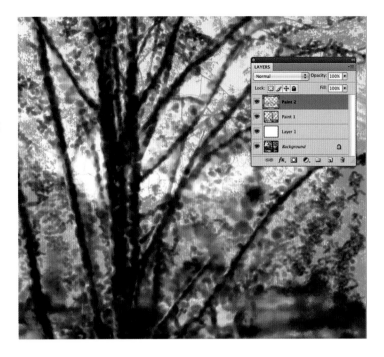

7 Paint with a Small Brush on Another New Layer.

Create a third new layer [**Layer > New > Layer**] with, yet again, a reduced brush size of around **12 pixels** or fewer. Increase the Opacity and work on the details this time.

8 Create a Texture with the Emboss Filter.

To add texture to your painting, flatten your image [**Layer > Flatten**] and then duplicate the "Background" layer [**Layer > Duplicate**]. From the Filter menu go to **Filter > Stylize > Emboss.**

9 Experiment with the Filter Settings and with Blending Modes.

Play with the Emboss filter settings to your liking. Switch the Blend Mode of this layer to **Hard Light** to reveal the painting through the Emboss filter. Try other blending modes as well.

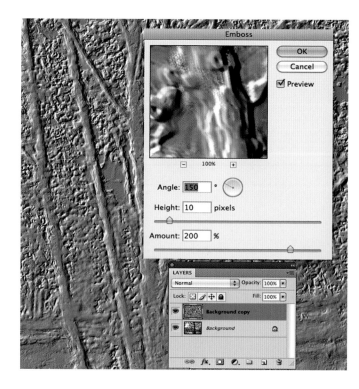

10 Add Details Using the Foliage Brush from the Brush Library.

Select the "Background" layer, and with the **Art History Brush Tool** still selected, switch to the **Scattered Maple Leaves** brush from the brush list without changing the brush settings. This brush, with translucent leaves, gives a soft-focus effect and picks up the colors through the Art History Brush Tool.

11 Experiment with Different Brushes and Colors.

Select the regular **Brush Tool** from the Toolbox and choose the **Scattered Maple Leaves** brush to add foliage details. Pick a nice, green color from the Swatches palette and paint on the image, changing the colors and brush opacities accordingly.

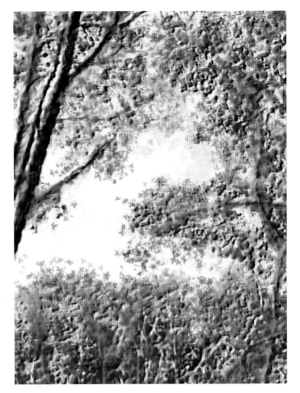

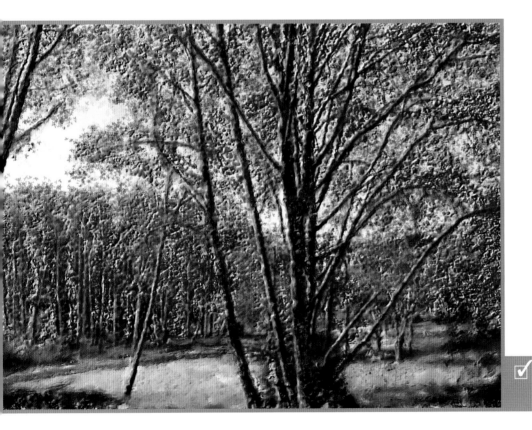

☑ the final

Sylvie Covey, *Tree Bush*, digital painting

PAINTING SCENERY WITH DIVERSE PHOTOSHOP FOLIAGE BRUSHES

Photoshop offers a number of organic and foliage brushes. In the Special Effects brush list, experiment with the brushes Azalea, Scattered Roses, Scattered Daisies, Scattered Flowers, Mums, Scattered Wild Flowers, and Falling Ivy Leaves.

1 Create a New File and Start Painting.
In this example I created a new file [**File > New**] and chose the regular **Brush Tool** from the Toolbox. From the Brush Picker lists, I selected the **Special Effects** brush list, where I found the **Drippy Water** brush and started painting the sky.

2 **Compose Your Image.** Establish your landscape perimeters and decide on a subject and its background, such as trees, flowers, foliage, grass, sky, etc. Adjust the size and opacity of your brush accordingly to the size of your canvas. I used a wide and low opacity brush to paint the sky wash. Click on the arrow at the right of the Brush Picker in the Tool Options Bar to open it and move the Master Diameter slider to change the size of the brush. Move the Opacity slider in the Tool Options Bar to either lower or augment the brush opacity. Pick your colors from the Swatches palette [**Window** > **Swatches**].

3 **Choose Different Colors for the Foreground and Background.** Create and name a new layer for each new brush you choose [**Layer** > **New** > **Layer**]. In this case, I created a new layer and sketched tree branches. I chose the **Grass** brush to establish a foreground. Note that the Grass brush—in addition to all of the scattered brushes—paints with both the foreground and background colors; therefore, I selected two different shades of green for the foreground and background colors.

4 **Use a Different Layer for Each Component.** I created a new layer and chose the **Azalea** brush with two different shades of purple in the foreground and background colors. I continued painting and adjusting the size and opacity of the brush. I also went back to the "Sky" layer and added more drippy, watercolor blues.

5 Build Up the Painting with Layers and Colors.
I went back to the "Grass" layer and painted more grass, using a larger and darker brush in the front, and a smaller and lighter brush further up the horizon. I created a new, additional "Azaleas" layer and added more flowers of varying shades, sizes, and opacities. The entire image was painted with only three brushes: the Drippy Water brush, the Grass brush, and the Azalea brush.

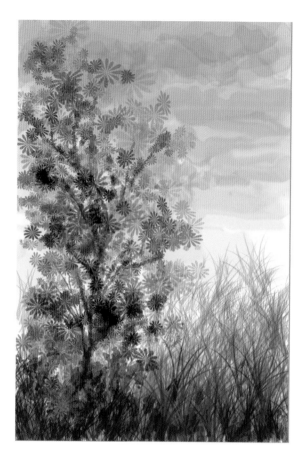

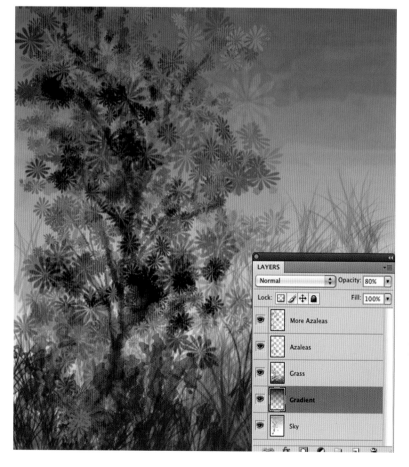

6 Add a Gradient.
Finally, I created a new layer and positioned it just above the "Sky" layer and below the "Grass" and "Azaleas" layers. I named the layer "Gradient," selected the **Gradient Tool** from the Toolbox, and chose a deep blue as the foreground color. With the Gradient Tool selected in the Tool Options Bar, I selected the **Linear > Foreground to Transparent** gradient and then dragged it from the top to the bottom of the image.

7 Save Your File. The final result is a painting achieved with Photoshop's foliage brushes. Save it as a PSD file to keep the layers intact, and as a TIFF file to print.

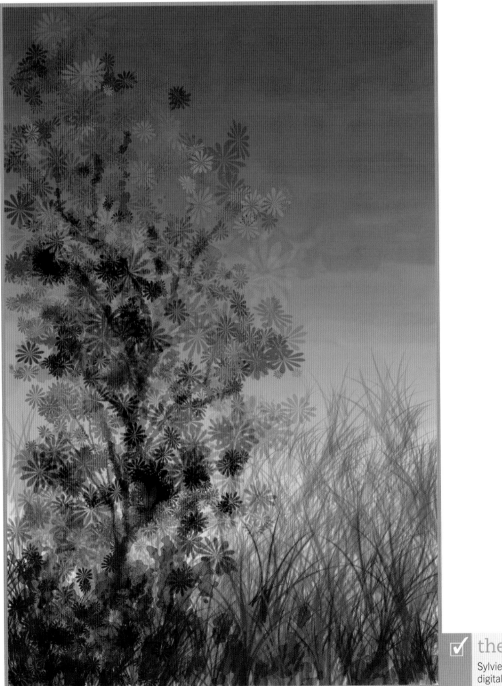

☑ the final
Sylvie Covey, *Azaleas*,
digital painting

Painting with Wet Media Brushes

This tutorial covers digital painting with Wet Media brushes from either a scanned sketch or a photograph to re-create the effects of ink, dyes, watercolor, or acrylic paint. Before we cover the first method, let's first review how to load colors.

Loading Colors

Loading colors from a photograph to your swatches palette is a great way to paint with accurate colors that will match the original photo. Follow these easy steps to load colors.

1 Duplicate the Original Image.

Duplicate the image [Image > Duplicate] and then make sure the duplicate image is flattened [Layer > Flatten].

2 Create a Color Table.

Now, from the Image menu, go to Image > Mode > Indexed Color. Click **OK** in the dialog box. Then go to **Image > Mode > Color Table**. A color table of the image opens. Click on the **Save** button and give your color table a name that you will recognize later. Because color tables are classified as ACT files, your file is now an ACT file. Choose **Desktop** as the Save location.

3 Load the Color Swatches.

Close the file and open the Swatches palette [**Window > Swatches**]. Click on the small arrow at the top right in the Swatches palette and click on **Load Swatches** from the list. From the Load window, look on your desktop for your color table. It will appear as *Your File Name*.act. Select your ACT file. The Load or Cancel options are now available. Click **Load** to see your color swatches added in the Swatches palette.

FREE-HAND PAINTING WITH WET MEDIA BRUSHES

This lesson can be applied to any landscape with buildings and foliage. You may choose to either first hand-draw and then scan a sketch, or to draw inspiration from a photograph. Creating a new layer for each area to paint allows for better editing control.

To simulate the watercolor effect, be sure to pick the correct brush for your goals. There are many watercolor brushes available in Photoshop in the Wet Media Brushes library. The opacity settings on a brush are also important. Lowering the opacity will allow better control for painting.

1 Create a Sketch from a Color Photograph.

Open a landscape image in Photoshop and convert it to black and white [Image > Mode > Grayscale]. Adjust the levels [Image > Adjustments > Levels] and contrasts [Image > Adjustments > Brightness/Contrast]. I chose this photo of a charming rural French village.

Note: There are several ways to convert a color image to black and white, and this one is the simplest. Others offer more options and degrees of quality for photographers, which are covered at length in Changing a Photo from Color to Monochrome on pages 186–193. For our purposes, we only need to convert the image to black and white to make a sketch out of the photograph; therefore, the grayscale option is fine.

START IMAGE Sylvie Covey, *Saint-George-sur-la-Prée*, digital print

2 Use a Filter to Transform the Photo to a Sketch. From the Filter menu, go to **Stylize** > **Find Edges** to create a sketch.

Note: Again, several other filter techniques are available in Photoshop to achieve a sketch from a photograph. These are described in the Drawing Digitally tutorial on pages 32–39. If you think you need more control in the sketch outline result, feel free to try the Glowing Edges/Invert method.

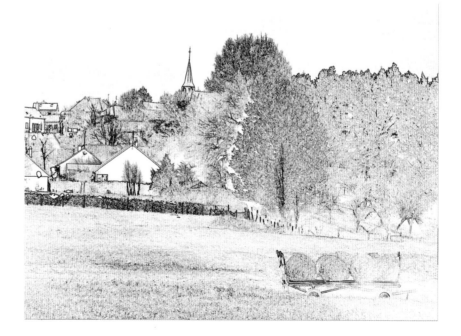

PHOTOSHOP FOR ARTISTS

3 **Sketch in Sepia.** Reconvert the image in RGB so that you
will be able to color the sketch in sepia. Go to **Image > Mode > RGB
Color** and then **Image > Adjustments > Color Balance.** Move the sliders to
a sepia tone.

4 **Load the Brushes.** Click on the little arrow at the top of
the Brush Preset Picker palette, and again on the top right arrow inside
the Brush window. Find and load the **Wet Media Brushes.**

5 Create a New Layer. To create a new layer, go to **Layer > New > Layer**. In the New Layer dialog box, I named this layer "Sky." I painted the sky using the **Heavy Flow Scattered Brush**. In the Brush settings window, I set the Other Dynamics to **Opacity** and the Jitter to **Pen Pressure** to allow for more painting control. When I painted over the lines in the horizon, I used the **Eraser Tool** on the "Sky" layer. Find your loaded colors in the Color Swatches. From the Window menu, select **Swatches** to open the Swatches palette. I then adjusted the brush opacity from the Tool Options Bar and decided on a sky blue, leaving some white for the clouds—like I would if painting with watercolors.

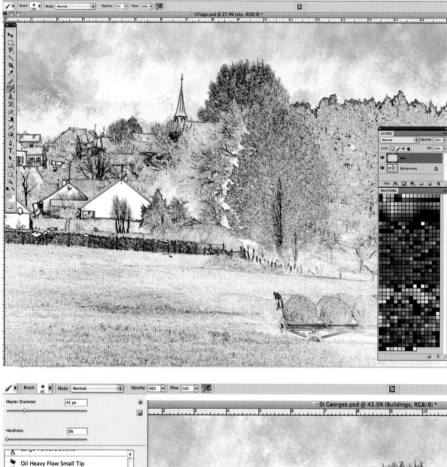

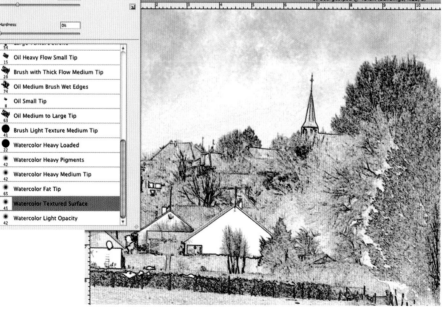

PHOTOSHOP FOR ARTISTS

6 Work from the Background to the Foreground.

I created a new layer and named it "Buildings" [Layer > New > Layer]. Next, I chose the **Watercolor Textured Surface** brush, with an Opacity of around **40%,** to paint the houses on the landscape. I started with an even color for all the buildings and slowly added details, switching colors. Painting over will add more tone, so I like to start with a low opacity.

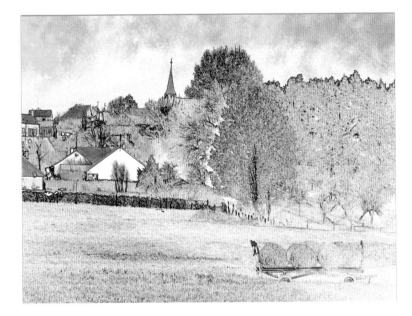

7 Create Another New Layer.

Name a new layer after what you will paint next. I named mine "Trees." I used the **Scattered Dry Brush** from the Wet Media brush list and a light yellow-green to start painting the field. I changed colors, often leaning toward darker green, and picked colors from the Color Swatches palette to go back and forth. I also changed the opacity of my Brush Tool accordingly.

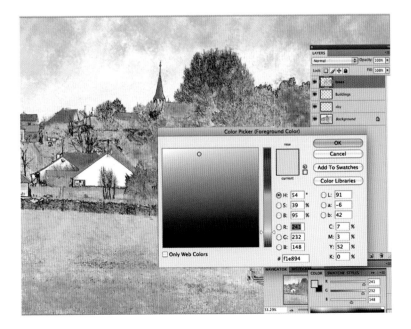

8 Make it Nature Friendly with Digital Paint.

If your image has greenery, the Scattered Dry Brush is perfect for painting leafy foliage. Adjust the diameter, start with a dark green, and then go over some of the top area with a lighter green to give a sense of fullness to the trees. Feel free to try other brushes that might be more appropriate for your image.

Note: After selecting the **Brush Tool** from the Toolbox, remember to access the brush size (using the Master Diameter slider) and Brushes library from the Tool Options Bar. Click on the little arrow next to the Brush swatch in the Tool Options Bar under the main menus to do so.

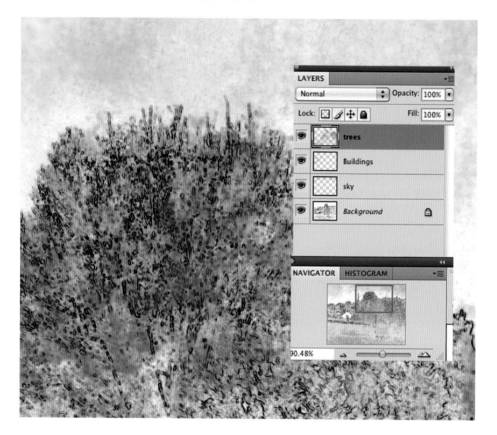

9 Add Another Layer. I created a new layer and named it "Flower Branches." This time, I used the **Pen Tool** (or you could use a smaller paintbrush) with a dark brown color from the swatches. Then I used the **Drippy Water** brush to paint flower buds, using different shades of pink and different brush diameters and opacities.

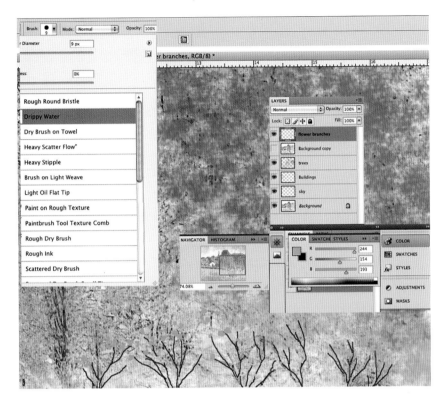

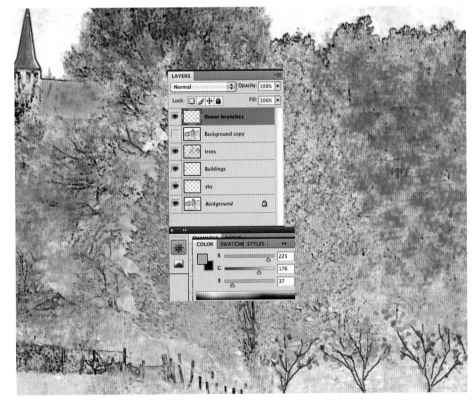

10 Boost the Drawing. Add some details to your
drawing. Then duplicate the "Background" layer, bring it to the top
of the layers stack, and change the Blend Mode to **Linear Burn**.

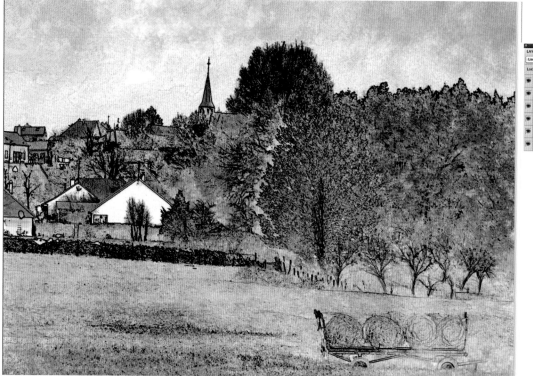

11 Add the Watercolor Paper Texture.
Finally, go to **Layer** > **New Fill Layer** > **Patterns**. Click inside the
Pattern swatch to open the list and choose a paper. I chose the **Washed
Watercolor Paper**. Adjust the scale according to your taste. A higher scale
will give you a rough surface similar to heavy and thick watercolor paper.
Click **OK**.

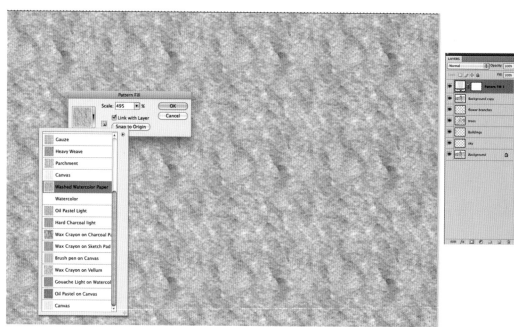

PHOTOSHOP FOR ARTISTS

12 Add the Finishing Touches. Change the
Blend Mode of the Pattern layer to **Linear Burn** to let the image
show through, and keep it at the top of the layer stack. Now you can flatten
the image [**Layer** > **Flatten**] and adjust the levels [**Image** > **Adjustments** >
Levels]. Save your image in a TIFF format to print.

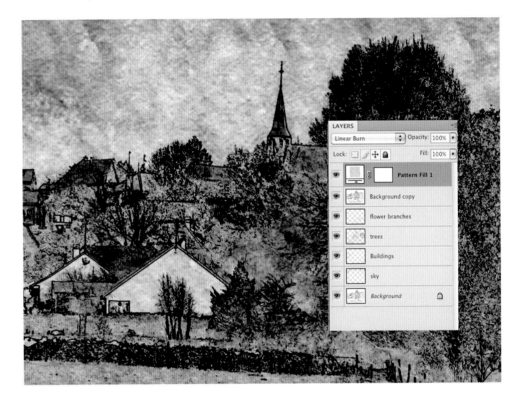

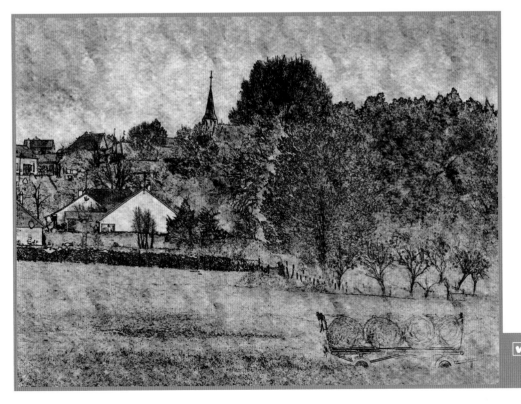

✓ the final

Sylvie Covey, *Memories of My Youth*, digital watercolor

WATERCOLOR PAINTING WITH FILTERS

In this method we will use Photoshop's filters instead of paintbrushes to transform a photograph into a wet-media painting. Using the Glowing Edges filter method to create a sketch provides better control than using the Find Edges filter to render a pencil-like effect. This filter method is also recommended to achieve watercolor paintings with luminous and semitransparent results.

1 Choose a Subject. Open an image in Photoshop that you want to paint as a watercolor. I took this photograph of the Grand Teton National Park in Wyoming.

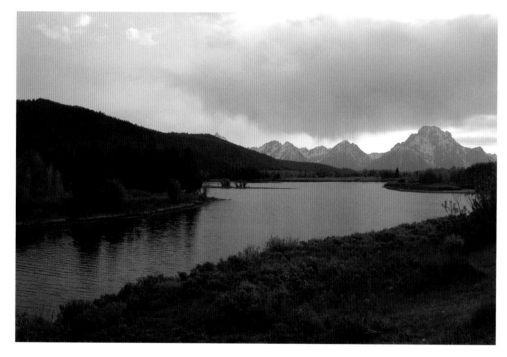

START IMAGE Sylvie Covey, *Grand Tetons River*, digital print

2 Soften the Details. Duplicate the "Background" layer [**Layer > Duplicate Layer**] and name it "Smart Blur." From the Filter menu choose **Blur > Smart Blur,** and in the Smart Blur window move the Radius slider to around **80** and the Threshold slider to **20.** Set the Quality at **Medium** and the Mode at **Normal.** This filter will smooth out the details of the image.

3 Create a Sketch.

Duplicate the "Background" layer again and name it "Sketch." Drag the layer to the top of the layers stack. From the Filter menu go to **Stylize > Glowing Edges**. In the Glowing Edges window, set the Edge Width to **5,** the Edge Brightness to **10,** and the Smoothness to **8.** Click **OK** to apply the filter.

We need to invert this filter to make it a positive. To invert this layer, from the Image menu go to **Adjustments > Invert.**

To finish the sketch, activate the "Sketch" layer, and from the Image menu go to **Adjustments > Desaturate.** Lower the Opacity of the "Sketch" layer to around **50%.**

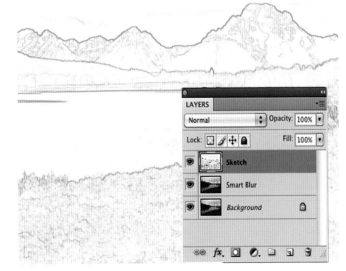

4 **Create a Canvas.** Activate the "Background" layer and then go to **Layer > Duplicate Layer.** Name this layer "Paint." Drag this layer to the top of the layers stack and invert it [**Image > Adjustments > Invert**]. Set the Blend Mode to **Color Dodge.**

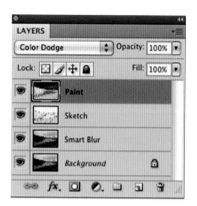

5 **Paint the First Wash.**
Choose the **Brush Tool** from the Toolbox and select a wide, dry brush. Try **Natural** or **Natural 2** from the brush lists. Make the brush's size really large. I set mine at around **700 pixels** and lowered its Opacity to **25%.** Select black as the foreground color. To start the first watercolor layout, hide the "Sketch" layer (click off the **Eye** icon in the Layers palette) and start painting roughly on the top "Paint" layer. Painting with black on the Color Dodge Blend Mode layer will make your image appear.

Paint from the inside out, and leave some areas white on the outside of the image (like when painting a real watercolor, in which the white of the image is the paper itself).

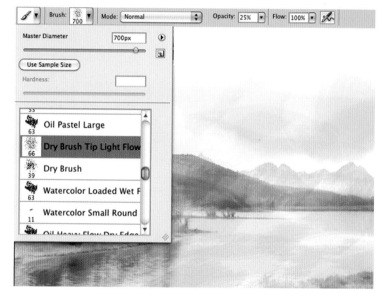

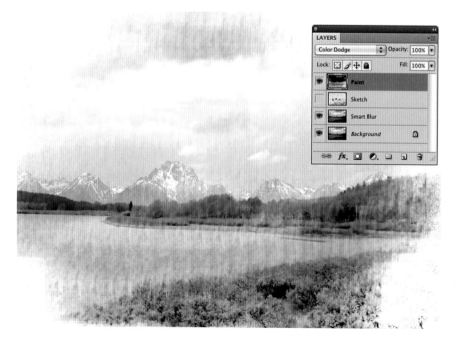

6 **Choose Another Brush and Change Its Opacity.**
Switch to the Wet Media brush library in the Brush Tool Picker and choose the **Watercolor Light Opacity** brush. Adjust the Master Diameter size accordingly for your image and start painting with a low Opacity (around **10%**). Paint with many light strokes, as you would with watercolor paint and water.

7 Create a Watercolor Paper.
From the Layer menu, go to **New Fill Layer** > **Pattern**. From the Pattern Fill window, click on the arrow next to the Pattern swatch to open the Patterns library. Choose **Artist Surfaces** and replace the Preset library with it. From Artist Surfaces, choose **Watercolor Paper** and move the Scale slider to around **700%.** Set the Blend Mode for this layer to **Multiply** and its Opacity to around **65%.**

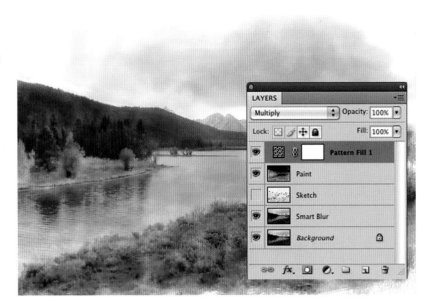

8 Make the Final Touches and Save Your Image.
Keep painting on the top "Paint" layer, fine tuning your watercolor with a few extra paint strokes for the details. Save your image as a PSD file if you intend to work on it further. Duplicate the image and flatten it before saving it as a TIFF file to print.

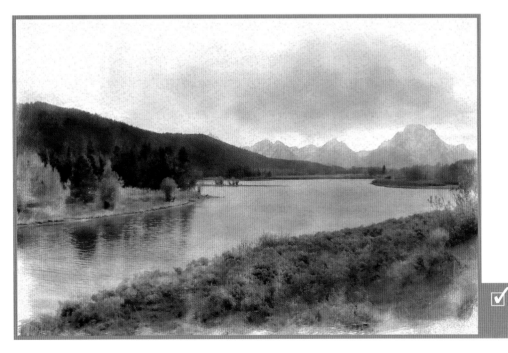

the final
Sylvie Covey, *Grand Tetons River*, digital watercolor, 18 x 22 inches

Digital Oil Painting

In this tutorial we will create a canvas texture using patterns. We will paint on a Layer Mask and apply the Layer Style Bevel and Emboss to create an impasto canvas effect. As noted in the Digital Drawing tutorial, it is important to understand that painting on a Layer Mask does not involve applying real colors, but, instead, reveals the colors hidden by the mask. A black mask is applied to the image and hides it; then the image slowly reappears when white is painted directly onto the mask.

When observing classic oil paintings from the masters, you will notice that the dark areas are thin, but the light areas are thick and stand out, creating an impasto effect. Using this digital-painting method, we will re-create the impasto effect with Photoshop.

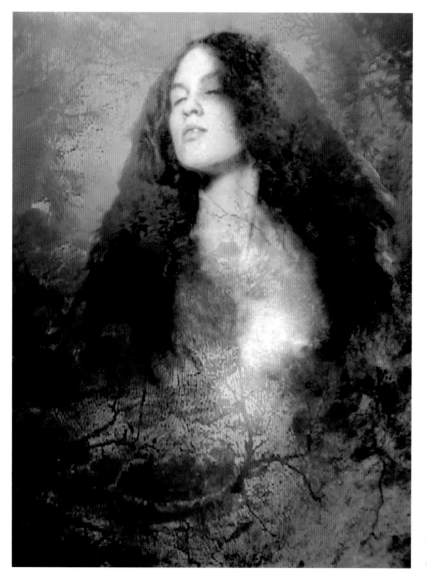

EXAMPLE Sylvie Covey, *Into the Sea 5*, digital painting on canvas, 40 x 30 inches

1 Create a Background Color. Open

a close-up photo portrait that includes a face, neck, and shoulders and add a new layer [Layer > New > Layer]. Choose a warm, midtone color for the foreground swatch and then go to Edit > Fill and choose Foreground Color for Contents. Click on the "Background" layer and duplicate it [Layer > Duplicate Layer].

START IMAGE Sylvie Covey, *Andrea*, digital print

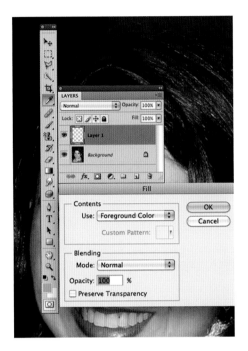

2 Create a Sketch. In the Layers palette, bring the "Background"

Copy" layer to the top of the layers stack [Layer > Arrange > Bring to Front]. With the "Background Copy" layer active, go to Filter > Stylize > Glowing Edges. Play with the settings and observe how the edges change. Decide what works best for you. For my image I used an Edge Width of **4**, Edge Brightness of **12**, and Smoothness of **11**. Click **OK** to apply the filter.

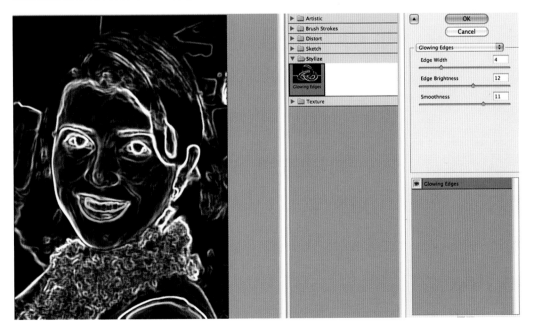

From the Image menu, go to Image > Adjustments > Desaturate.
Then go to Image > Adjustments > Invert. In the Layers palette,
set the Blend Mode for this layer to Overlay. Then click on the
"Background" layer and duplicate it again. Drag the layer to the
top of the layers stack [Layer > Arrange > Bring to Front].

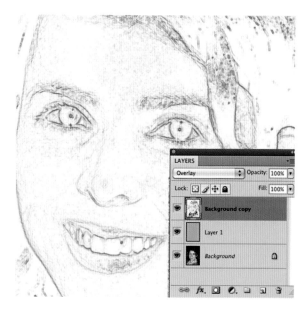

3 Smooth the Image. From the Filter menu, go to Filter >
Artistic > Palette Knife. Try these settings: Stroke Size of 30, Stroke
Detail of 4, and Softness of 10. Depending on the size of your image, you
may vary the Stroke Size until your portrait simplifies but still holds some
details in the facial features. Click OK to apply the filter.

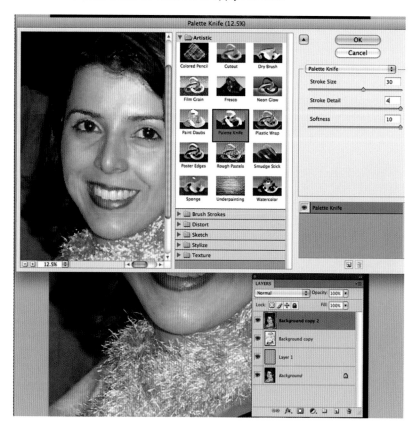

PHOTOSHOP FOR ARTISTS

4 **Create a Canvas Texture.** From the Layer menu, go to **Layer > New Fill Layer > Pattern**. Click in the Pattern swatch and find the small arrow at the right of the swatch to open the Patterns library. Choose **Artists Surfaces** from the list. From the Pattern swatches, choose **Canvas** and set Scale to around **350%**. Click **OK** to apply the pattern. In the Layers palette, set the Blend Mode for this layer to **Linear Burn**. Lower the Opacity of the layer to **50%**.

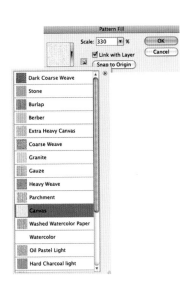

5 **Prepare Your Brush.** Activate "Background Copy 2" below in the layer stack and add a black layer mask [**Layer > Layer Mask > Hide All**].

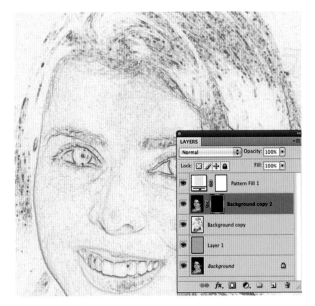

Select the **Brush Tool** from the Toolbox. Click in the Brush Picker and click on the small right-pointing arrow to open the Brushes library. Choose **Wet Media Brushes**.

From the brush thumbnails, find **Brush with Thick Flow Medium Tip.** From the Window menu open the Brushes options window. Click on the **Texture** category and then click in the Texture swatch. Choose **Heavy Weave.** Increase the Scale to around **130%**.

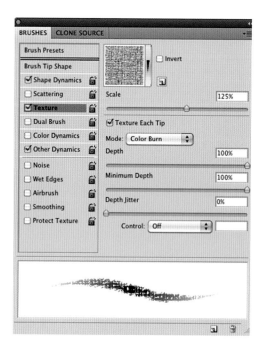

Click on **Other Dynamics** and set the Opacity control to **Pen Pressure.** Make sure that Color Dynamics is *not* checked. Finally click on **Brush Tip Shape** to activate the Brush Tip Shape palette settings. For Roundness enter **50%**. For Angle enter **30°**. In Shape Dynamics, set Minimum Jitter size to **80%**. Feel free to adjust these settings to your own liking.

6 **Start Painting with the Mask.** Activate the layer mask thumbnail on this layer by clicking on it. Select white as the foreground color. Adjust the brush Diameter to around **200 pixels,** reduce the brush Opacity to **40%**, and start painting on the face, slowly revealing its colors.

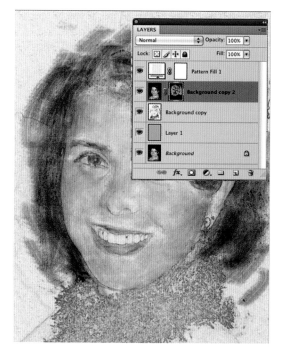

PHOTOSHOP FOR ARTISTS

7 Paint Away.
Use short, varied strokes at different angles. Let some of the canvas show through. In the outer areas use sketchy strokes, again leaving plenty of canvas visible. When you are satisfied, go to **Layer Mask > Apply** from the Layer menu.

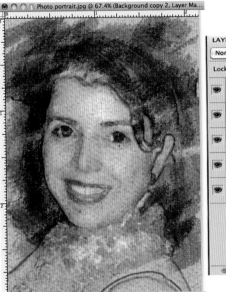

Select the **Smudge Tool,** and from the Brush Picker choose the **Rough Dry Brush.** In the Tool Options Bar, set the Strength to around **40%** and smudge some of the areas.

8 Create Depth.
Click on the original "Background" layer and duplicate it [**Layer > Duplicate Layer**]. Drag this layer to the top of the layers stack [**Layer > Arrange > Bring to Front**]. Go to **Layer > Layer Style > Bevel and Emboss.** In the Layer Style dialog box, enter **4%** for Depth and set both Size and Soften to **2 pixels.** Choose both **Inner Bevel** for Style and **Smooth** for Technique. Click **OK.**

9 Add a Filter Again. Go to **Filter > Artistic > Palette Knife** and adjust the stroke size settings (depending on your earlier size choices). In the Palette Knife window adjust the Stroke Size, Stroke Detail, and Softness sliders to smooth out the portrait. I chose the settings of **12**, **3**, and **10**. Click **OK** to apply the filter. Add a layer mask to the layer via **Layer > Layer Mask > Hide All**.

10 Change Your Brush. Select the **Brush Tool** from the Toolbox and click on the right-pointing arrow in the Brush Picker to open the Brushes library. Choose **Thick Heavy Brushes**. From the brush thumbnails, I selected the **Heavy Smear Wax Crayon** brush, but feel free to try other brushes as well. In the Brush settings palette window, use the same settings as you used for the previous brush.

PHOTOSHOP FOR ARTISTS

11 Continue Painting with White.

Activate the layer mask thumbnail attached to this layer by clicking on the mask. Adjust the Master Diameter in the Brush Picker to around **125 pixels,** or to your liking, and choose white as the foreground color. Paint details and impasto onto the face with various sizes and stroke directions. Build up the paint and vary the opacity of your brush.

Adjust the opacity of your brush; use a lower opacity in the dark areas and a higher opacity in the light areas to build up your painting with impasto. Zoom in with your Navigator to work on the details. Move the sliders of the Navigator to zoom in or out of the Navigator palette. The red rectangle indicates the portion that currently fits in the main window. Concentrate the paint on the face to make it opaque.

12 **Make One More Mask.** Duplicate the layer [**Layer** > **Duplicate Layer**]. Click directly on the layer mask thumbnail for this duplicate layer and go to **Edit** > **Fill**, choosing black for Contents. Reduce the size of your brush and set its Opacity to **100%**. Then paint with white on the black mask. Concentrate on the details.

13 **Create One More Layer.** From the Layer menu select **Layer** > **New** > **Layer** and bring this new layer to the top of the layers stack [**Layer** > **Arrange** > **Bring to Front**]. This time choose real colors using the **Eyedropper Tool** from the Toolbox. Choose colors directly from the image, and paint with a very small brush to add the last details on the eyes and mouth.

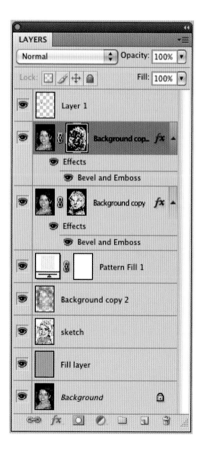

PHOTOSHOP FOR ARTISTS

14 **Save the File.** Finally, save your file as a PSD format if you want to keep one version with all of the layers; then flatten it and save it as a TIFF format to print [**Layer** > **Flatten**].

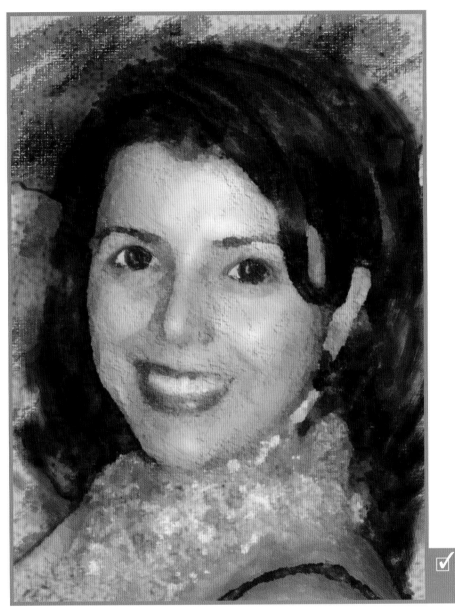

☑ the final
Sylvie Covey, *Andrea II*,
digital painting

Using Digital Pastel and Dry Media Effects

Pastel and dry media provide an interesting cross between painting and drawing. There are many types of pastel and dry media supplies available—some are expensive and some are not. All are made of compressed, dry particles of color pigments that are mixed with fragments of oil, chalk, or wax, which act as binding agents. Pastels and dry media offer the opposite qualities of roughness and smoothness, yet they produce vivid and sensitive renderings.

In this next tutorial we will create a pastel portrait using only Photoshop. We will start by creating a sketch on a midtoned paper surface. We will paint on masks to reveal the underlying colors using a wide variety of different marks and strokes. Next, we will load the image's colors as Color Swatches and continue painting with Dry Media brushes.

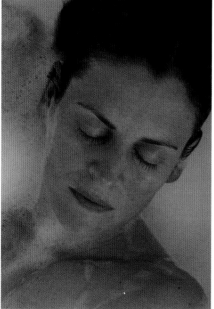

START IMAGE Sylvie Covey, *Laura*, digital print

1 **Create a Sketch.** Choose a close-up color photo-portrait from your files and open it in Photoshop. Save the image as "Original Photo." We will use the original file later. In this tutorial example I used a photograph that I zoomed in on to concentrate on the head.

Duplicate the image [Image > Duplicate] and then duplicate the "Background" layer [Layer > Duplicate Layer]. From the Filter menu go to **Filter > Stylize > Find Edges**.

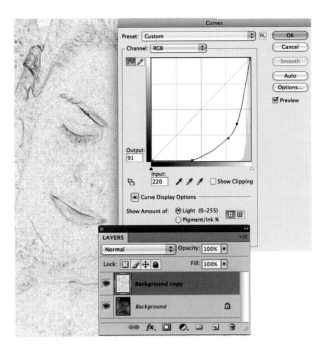

Add a Curves adjustment on the "Background Copy 1" layer to darken or lighten the sketch lines, if needed [Image > Adjustments > Curves].

2 Create a Paper Layer. From the Layer menu go to Layer > New > Layer. From Edit menu choose Fill, and in the Fill dialog box select Pattern for Use.

Click on the arrow next to the Pattern Swatch to open the Pattern library. Click on the second arrow on the upper right of the pattern list to open the library lists. Choose and append the Color Paper list. In this case I chose Beige with White Flecks, but feel free to choose any color paper you like.

In the Fill dialog box, change the Blend Mode of the Pattern paper to Multiply. The sketch now appears on the beige paper. Keep this layer's Blend Mode at Normal.

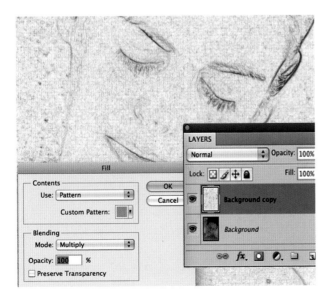

3 Create a Brush.
Select the **Brush Tool** from the Toolbox. Click on the arrow next to the Brush Picker in the Tool Options Bar to open the brush list and then click on the second arrow in the upper right of the window list to open the Brushes Library. Select the **Dry Media** list. Choose a brush from the list, such as the **Pastel Brush Media Tip** or the **Pastel Rough Texture** brush.

Open the Brush palette from the Window menu. Click on **Other Dynamics** under the Brush Tip Shape and set the Control to **Pen Pressure**. In Shape Dynamics, set the Minimum Size to 75%, and in the Texture category increase the Scale slider to around **250%**.

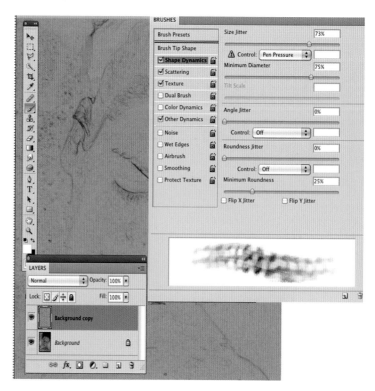

4 Paint on a Mask.
Duplicate the "Background" layer again, name it "Background Copy 2," and bring it to the top. From the Layer menu choose **Layer > Layer Mask > Hide All.** Ensure that your foreground color is white and that the mask thumbnail is active. Start painting on the mask with a low opacity brush (about **50%**). Establish the contour of the figure.

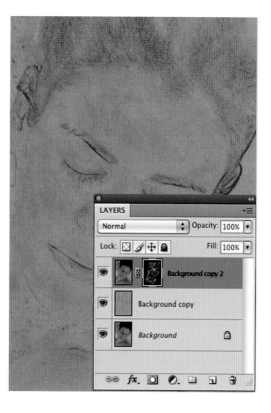

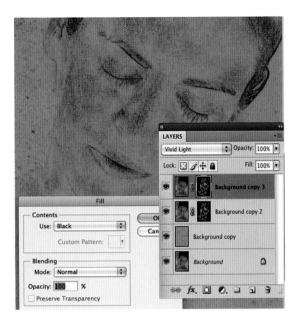

5 **Build Up the Work.** Paint with moving, short strokes and leave plenty of paper showing through. Adjust the size of the brush according to the area you are painting. When the initial colors show through, duplicate this layer [**Layer** > **Duplicate Layer**], name it "Background Copy 3," and set the Blend Mode of the duplicate to **Vivid Light**. Activate the mask thumbnail. From the Edit menu choose **Fill** > **Black** to restore a new black mask.

6 **Change Your Brush.** Next, select a very scratchy and irregular pastel brush from the Dry Media brush library. Ensure that white is the foreground color. With the mask thumbnail active, paint using diagonal strokes to reveal bright color.

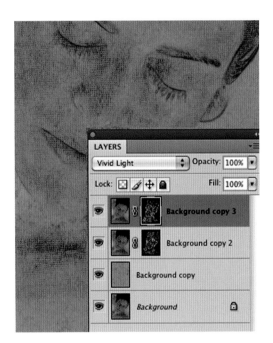

7 Create Highlights.
Create a new layer [Layer > New > Layer], name it "Highlights," and bring it to the top of the layers stack. Click on the **Add a Layer Style** icon (it is the symbol **fx**) at the bottom of the Layers palette and choose **Outer Glow** from the pull-down list. In the Outer Glow dialog box, set the Opacity to **50%,** the Blend Mode to **Screen,** the Color to white, and the Range to **50%.** Click **OK.** Choose a round brush and set the Hardness to **0%,** the Color to white, the Diameter between **30** and **100 pixels,** and the Opacity to a maximum of **20%.** Draw little dots of highlights where needed.

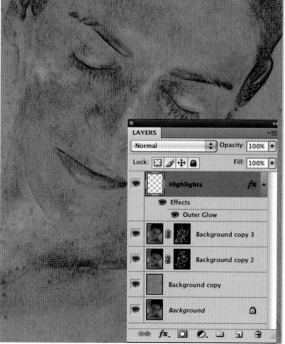

8 **Paint Larger Areas.** Duplicate
"Background Copy 3" [**Layer** > **Duplicate Layer**], drag
this "Background Copy 4" below the "Highlights" layer in the
layers stack, and change the Blend Mode of "Background
Copy 4" to **Multiply**. From the Window menu, reopen the
Brushes palette and click on **Scattering**. Increase the Scatter
to **120%**. Activate the mask thumbnail and paint with white
on the image's background areas with large and smooth
brushstrokes.

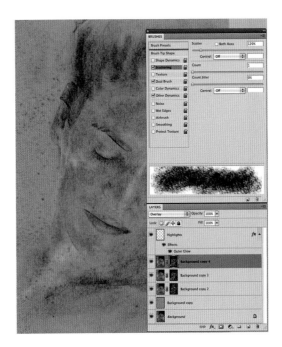

9 **Load Colors for Painting.** To select colors from the
original photo and to load them as Color Swatches, reopen the saved original
photo. Duplicate the original image [**Image** > **Duplicate**] and flatten the duplicate
image [**Layer** > **Flatten**]. Now from the Image menu go to **Image** > **Mode** >
Indexed Color.

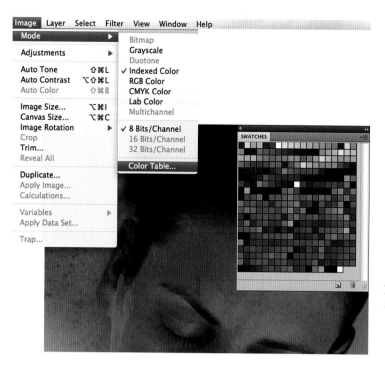

10 Create a Color Table.

Click **OK** in the dialog box and then go to **Image > Mode > Color Table**. A color table of the image opens. Click on the **Save** button, name your color table, and choose **Desktop** as the save location.

Close the file, and from the Window menu open the Swatches palette [**Window > Swatches**]. Click on the small arrow at the top right in the Swatches palette to open the options list and click on **Load Swatches**. Your swatches are saved in the ACT format. Choose **Act** in the Files of Type to locate your saved color table on your desktop. Click **Load Swatches** to see your color swatches added at the bottom of the Swatches palette.

11 Paint with Real Color. Activate your

Dry Media painting file and add a new layer [**Layer > New > Layer**]. Keep this new layer below the "Highlights" layer. Choose a soft **Oil Pastel** brush, and in the Tool Options Bar, lower the Opacity to **50%**. Pick a color from the loaded swatches and start adding real color onto this new layer.

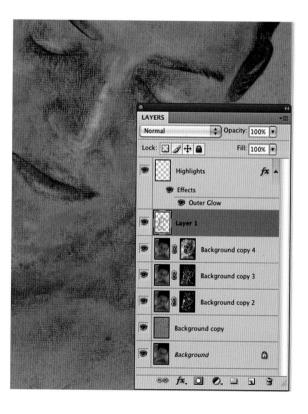

PHOTOSHOP FOR ARTISTS

12 Add Finishing Touches.

Adjust the diameter of your brush often and switch colors. Paint like you would in reality, choosing your colors carefully. On this layer you may use the Eraser Tool from the Toolbox, if needed. When you are satisfied, flatten and save your image in a TIFF format. I chose to keep my pastel painting light and sketchy, and I let the paper texture show in the background.

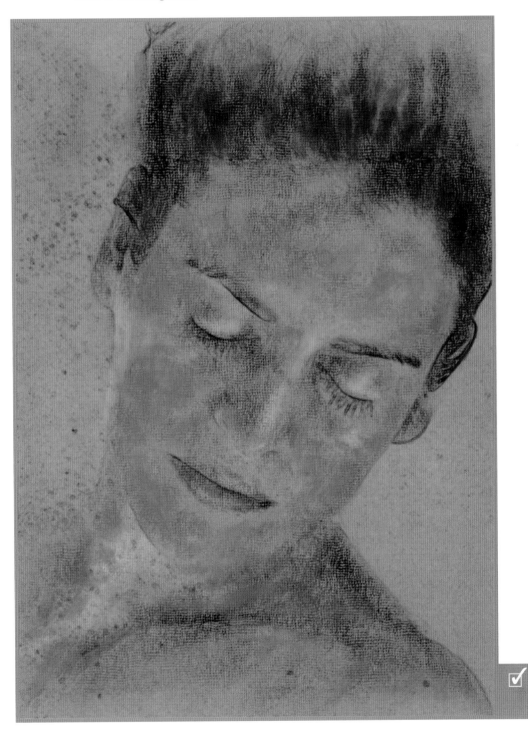

☑ the final

Sylvie Covey, *Laura in Pastel*, digital dry media drawing, 22 x 16 inches

Painting Special Effects on Photographs

In this tutorial you will learn how to transform a photo into a striking color composition with paintbrushes, masks, blending modes, color, and paper texture. In the following two methods the image is first rendered in a highly contrasted black and white, so that it is later suitable as a Color Range selection. A paper is then created and color is painted onto a new layer. The image is selected with the Color Range option by sampling a tonal range. Color Range will then select all the pixels of that particular tonal range. A mask is created to reveal the paint on the selection, and a filter can also be applied to create texture or increased light effect. In the first method Photoshop brushes are used with Color Range to create a special effect. In the second method, the color washes are made with real paint, and the texture is created with spotted paint in the studio.

USING DIGITAL PAINT FOR SPECIAL EFFECTS

In this first method I use brushes and color from Photoshop to paint special effects with Color Range for selection.

1 **Prepare Your Image.** In Photoshop open a photo portrait with a clean backdrop. I chose a portrait by Paris-based French photographer Marc Picot.

Note: To remove unwanted elements in a background, make a rough selection with the **Lasso Tool**. Then go to Select > Refine Edge and in the Feather slider apply a heavy feathering such as **20 pixels** or more. From the Filter menu go to **Blur** > **Gaussian Blur** and set the Radius to **20**. Repeat on other areas to phase them out.

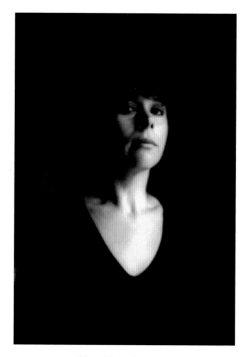

START IMAGE Marc Picot, *Danielle*, tinted photograph

PHOTOSHOP FOR ARTISTS

Duplicate the "Background" layer [Layer > Duplicate Layer]. Go to Image > Adjustments > Black & White and click OK in the Black & White window. Then from the Image menu go to Image > Adjustments > Brightness/Contrast. Adjust the Brightness and Contrast sliders to lessen the gray tones as much as you can.

2 Clean Up the Background. If the backdrop is dark or busy, use the **Quick Selection Tool** to select it. You can also use the method described in step 1 to phase out a busy background. When using the Quick Selection Tool, be sure to use the Add to Selection or Subtract from Selection options in the Tool Options Bar on the upper-left side of the screen.

With the background selection active, use a paintbrush with white as the foreground color to paint out all the gray areas in the background. The subject should stand out alone on a white background.

3 Add a Filter. From the Select menu choose **Deselect,** and then from the Filter menu choose **Artistic > Paint Daubs.** Set the Brush Size to **12,** the Brush Detail to **9** (some versions of Photoshop will not have this setting), the Sharpness to **5,** and choose **Light Rough** for the Brush Type. Click **OK.** From **Image > Adjustments > Levels,** set the levels to about **32, 1.00,** and **200.** For more details on Levels, see Making Basic Photo Corrections on pages 136–147.

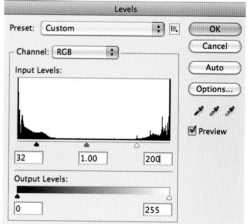

4 **Create a Paper.** From the Layer menu go to **New Fill Layer**
> Pattern.

Click inside the Pattern swatch to open the list, and from the Artist Surfaces
list choose a texture. I chose **Washed Watercolor Paper** for my image. Adjust
the Scale to around **600%** or more and click **OK**. Change the Blend Mode of
this layer to **Multiply**.

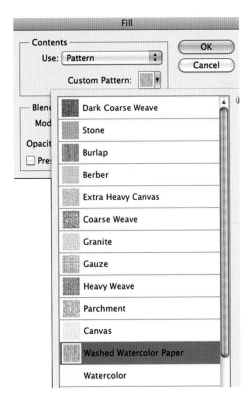

5 **Tint Your Paper.** To add a color tint to the paper, go to the Layer menu and choose **New Adjustment Layer > Color Balance.** For this image I set the Color Balance for the Midtones as Cyan +60, Magenta 0, and Yellow −80. Feel free to tint your paper as you wish.

6 **Create a Painting Layer.** Add a new layer [Layer > New > Layer]. I named mine "Warm Tones." Choose the **Brush Tool,** and from the brush list select a brush. For this image I selected the **Oil Medium Wet Flow** brush and set it at around **800 pixels.** Chose any brush that will give you texture and transparency. Open the Swatches palette from the Window menu and pick a color.

Start painting on the "Warm Tones" layer using intense colors. Here, I started with yellow and red tones.

PHOTOSHOP FOR ARTISTS

Alternate your brushes, and also try the Splatter brushes. In the Tool Options Bar, switch the Blend Mode to **Multiply**. Use single clicks on the paintbrush rather than holding the mouse down and dragging. Start with lighter colors and gradually work toward darker tones.

7 **Select with Color Range.** Activate the "Background Copy." From the Select menu choose **Color Range**. In the preview window check **Selection.** Notice the three eyedropper sampler icons in the Color Range window. The first one is automatically selected. Click on a black area of the image to select the black areas and then click **OK**. If you wish to add to this selection, choose the **Add to Sample Eyedropper Tool** and click on a middle tone in your image. (The plus or minus eyedroppers, respectively, add or delete the number of pixels selected. The more pixels that are selected, the more color is displayed.)

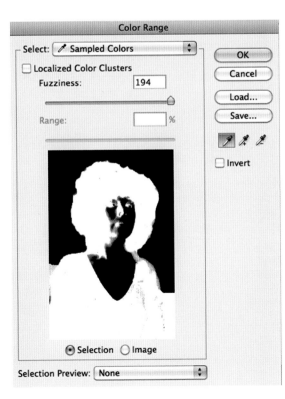

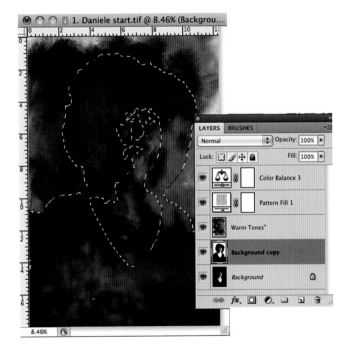

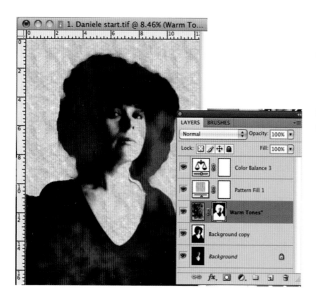

With the black areas still selected, activate the "Warm Tones" layer. Click on the **Add a Layer Mask** icon at the bottom of the Layers palette. Your selection will automatically be added as the mask. Now delete the "Background Copy" layer by dragging it to the trashcan in the Layers palette.

8 **Paint on the Mask.** To make the selection look more natural, I decided to roughen up the edges around the hair. To fix the edges of your mask, activate the layer mask by clicking directly on the mask thumbnail. Select the **Brush Tool** and choose a brush from the brush list. I used the paintbrush **Dry Brush on Towel** with black as the foreground color to roughen the edges of my image.

9 **Apply the Mask and a Subtle Texture.** Duplicate the "Warm Tones" layer [**Layer > Duplicate Layer**]. Drag the mask to the trashcan in the Layers palette, and when the option comes up to apply or delete the mask, click **Apply.** From the Filter menu choose **Filter > Artistic > Fresco.** I set the Brush Size to **6,** the Brush Detail to **8,** and the Texture to **3.**

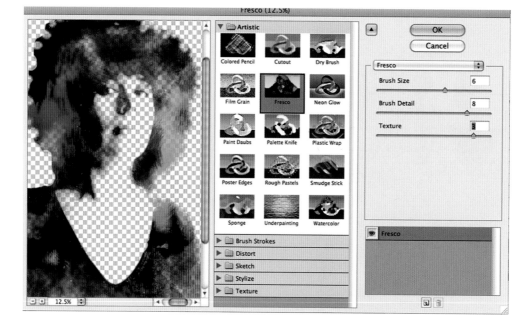

To blend this layer to the layer below, first lower the Opacity of the layer to around **35%**. Try different blending modes in the Layers palette to allow the texture to show through. I chose **Overlay.**

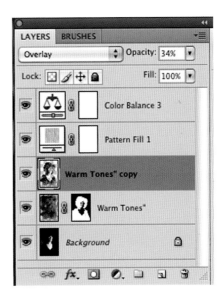

10 **Save Your File.** Duplicate your image file, flatten it, and save it as a TIFF document.

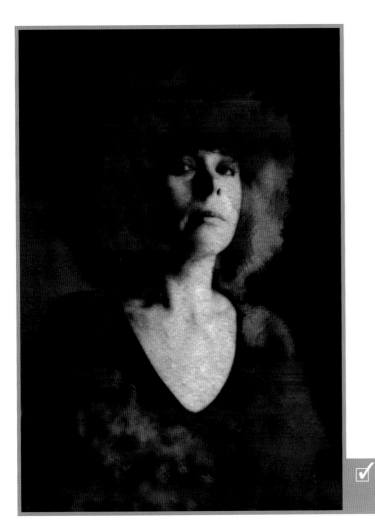

☑ the final

Sylvie Covey, *Danielle in Colors,*
digital print, 22 x 16 inches

USING REAL PAINT WASHES FOR SPECIAL EFFECTS

In this second method color washes are first created with real watercolor paint and paper in the studio. I painted one with warm red and yellow colors, and another with cold greens and blues. I also made one with spotted texture. These color washes were then scanned and saved as TIFF files with a 300 dpi resolution. See pages 22–23 for more information on scanning an image. Remember that you can use your scanned color washes with many different images.

1 **Choose Your Subject from Your Photo Files.** Open an image in Photoshop and duplicate the "Background" layer [**Layer > Duplicate Layer**]. I chose a close-up of a forest scene shot in Northern California.

START IMAGE Sylvie Covey, *Forest*, digital print

PHOTOSHOP FOR ARTISTS

2 Switch Your Image from Color to Black and White. From the Image

menu choose **Image > Adjustments > Black & White**. In the Black and White dialog box, choose **High Contrast Red Filter** from the Preset options. This filter will give your image a highly contrasted effect.

Black and White

Preset:	High Contrast Red Filter	
Reds:	■	120 %
Yellows:		120 %
Greens:	■	-10 %
Cyans:	■	-50 %
Blues:	■	-50 %
Magentas:	■	120 %

☐ Tint

Hue °

Saturation %

OK
Cancel
Auto
☑ Preview

3 Adjust the Brightness and Contrast. In

order to improve the contrast again, from the Image menu go to **Image > Adjustments > Brightness/Contrast**. Move the Brightness slider to around **125** and the Contrast slider to around **100**. These settings can be adjusted according to your image.

Brightness/Contrast

Brightness: 125

Contrast: 100

OK
Cancel
☑ Preview
☐ Use Legacy

4 Merge Your Color Wash onto the Photograph.

Open your first color-wash painting in Photoshop. From the Select menu go to **Select > All,** and from the Edit menu go to **Edit > Copy.** Activate your image file, and from the Edit menu choose **Paste.** Your color wash now sits above your image in the Layers palette.

5 Adjust the Size of Both Files.

From the View menu select **Zoom** and zoom out a couple of times to give yourself enough space to use the Scale command; then from the Edit menu choose **Edit > Transform > Scale.** Pull the scale handles out on each side to fill the layer with your color wash and hide any margins.

6 Select the White Areas to Receive the First Color Wash.

From the Select menu choose **Select > Color Range.** In the Color Range window, look for three eyedroppers icons placed under the OK/Cancel/Load/Save list. With **Selection** checked, notice which eyedropper is selected. The eyedropper on the left selects whichever pixels are of the same value as that of the selection. When you click on an area of your image with that eyedropper, all of the pixels of that particular tonal range become selected. The eyedropper in the center adds to the sample selection, and the eyedropper on the right subtracts from the sample selection. For this first selection, choose the white and light areas. Play with the Add to Sample Eyedropper Tool or Subtract from Sample Eyedropper Tool until you like your selection. Remember that *only the selected area will show color.* In this step I chose to select and color the white areas.

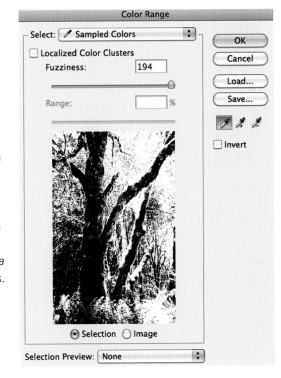

7 Bring Your First Color Selection into a Layer Mask.

With the selection active, hide the "Background Copy" layer's visibility by checking off the Eye icon in the Layers palette; then activate "Layer 1." In the Layers palette find and click on the Add a Layer Mask icon. The first color wash now appears in the selected white areas.

8 Add a Second Color Wash.

Open your second color wash painting in Photoshop. From the Select menu go to **Select > All,** and from the Edit menu go to **Edit > Copy.** Activate your image file, and from the Edit menu choose **Paste.** Your second color wash now appears under the "Background Copy" layer.

9 Select the Black Areas of Your Image for the Second Color Wash.

Reopen the visibility of the "Background Copy" layer by clicking on its Eye icon and activating that layer. From the Select menu go to **Color Range**, and this time use the **Eyedropper Tool** to sample the black areas of your image. The selection should look like the opposite of the image in step 6.

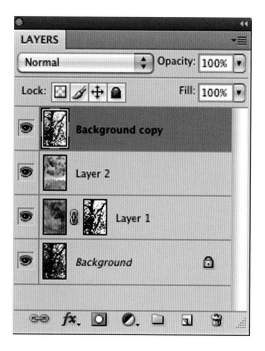

10 Reveal the Second Color Wash in the Black Areas.

With that selection active, hide the "Background Copy" layer's visibility by checking off its Eye icon in the Layers palette; then activate "Layer 2." In the Layers palette find and click on the Add a Layer Mask icon. The second color wash now appears in the selected black areas.

11 Add a Texture with a Third Color Wash.
To add a little texture go to **Edit > Fill > Pattern** and choose a texture. I opened my third "Color Spotted" file and selected it [**Select > All**]. Then I copied it [**Edit > Copy**] and pasted it [**Edit > Paste**] onto my image and then I changed the Blend Mode of the layer to **Vivid Light**.

12 Adjust the Curves and Save Your File.
Finally, you can add some contrast with an S-shape curve adjustment [**Image > Adjustments > Curves**] and save your file as a PSD file. Then flatten it and save it as a TIFF file to print.

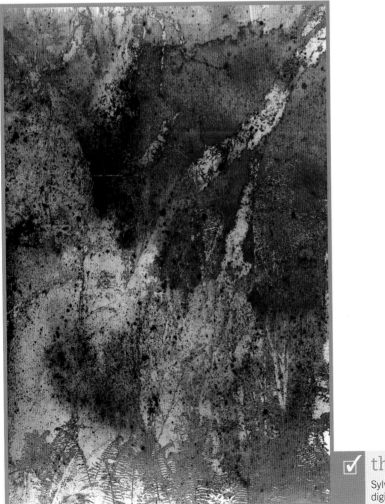

☑ the final
Sylvie Covey, *Fiery Trees*,
digital print

Adding Custom Washes to Photographs

In this tutorial we will combine traditional painting methods with Photoshop to create fantastic effects.

We start by creating watercolor washes in the studio with real watercolor paintbrushes and crayons. These washes are then scanned or photographed and applied over a digital image to enhance its textures and colors and to turn it into a digital painting. We will use the Select menu option, then the Edit > Copy, Edit > Paste, and Edit > Transform commands; the Magnetic Lasso Tool, Smudge Tool, and Move Tool; as well as the Layers palette's Blend Mode and Opacity Mode. You can create your own textures and color washes in your painting studio, scan or photograph them digitally, and use them over and over on different images.

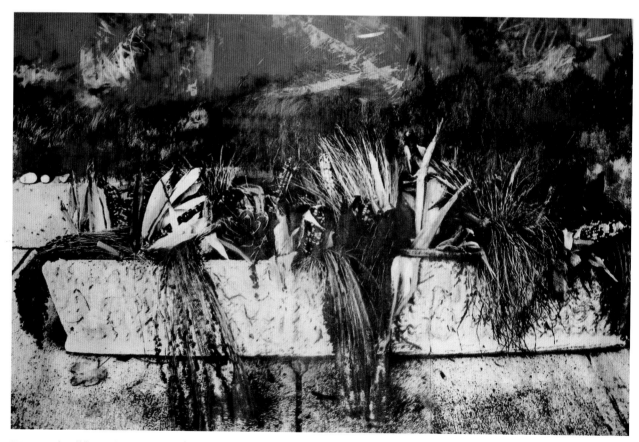

EXAMPLE Ann Winston Brown, *Flower Basket*, mixed media, 22 x 30 inches

This is a great example of Custom Washes added to a photograph.

1 Paint Abstract Color Washes.

Get your watercolor or acrylic paints out and make some color washes and splashes on sheets of watercolor paper. Mix in some water-based crayon and create diverse textures.

2 Get Creative with Your Washes.

Use drops of water and manipulate the color puddles. You can also use a paper towel or even blow air through a straw to splash the color around. Dry your work completely before scanning it or take digital photos and upload them onto your computer. See pages 22–23 for instructions on how to scan an image.

3 Choose a Subject in Your Photo Files, Size It, and Select It.

Open your subject images in Photoshop, and from the Image menu go to **Image Size**. Give it a resolution of **300 dpi** and choose the size of your image in inches. Choose the **Magnetic Lasso Tool** from the Toolbox and start lassoing around your subject until the selection is complete. I chose a picture of a peacock for this exercise. Other selective tools available to capture a subject, such as the regular Lasso Tool, the Polygonal Lasso Tool, and the Quick Selection Tool, are also handy. (See Painting Abstract Compositions on pages 56–61.)

4 Cut Out Your Subject from Its Background.

With your selection active, go to the Select menu and choose **Inverse**; then from the Edit menu choose **Cut**. Your subject is now cut-out and left on a white background. To smooth out the selection, choose the **Smudge Tool** and smudge all around your subject. This will make it easier to blend in your watercolor washes—depending on your image and on the quality of your selection.

5 Merge the Photo Subject to the Watercolor and Adjust the Size with the Scale Command.

Open the watercolor image. From the Select menu choose **All**; then from the Edit menu choose **Copy**. Activate your subject image by clicking on it; then from the Edit menu choose **Paste**. Your watercolor layer is now sitting on top of your subject layer. Use the **Edit** > **Transform** > **Scale** command to scale the watercolor over the entire subject image.

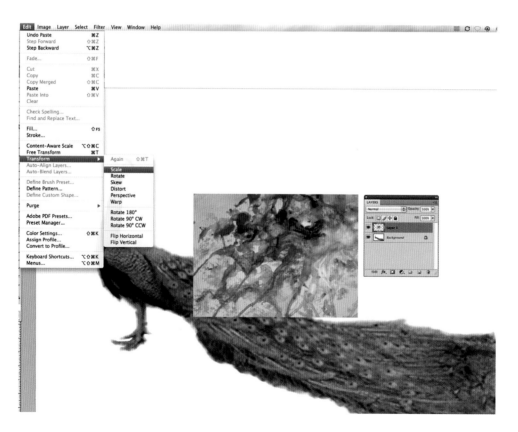

PHOTOSHOP FOR ARTISTS

6 Apply the Transform Command and Change the Blend Mode.

Click **Return/Enter** on your keyboard to prompt the questions "Apply" or "Don't Apply" to the transformation. Click **Apply.** Remember, you must always apply a transformation to continue working. Photoshop will not let you continue until your transformation is either applied or canceled by hitting Return/Enter.

Look for the Blend Mode pull-down menu in the Layers palette by clicking on the arrow next to the word "Normal." This arrow opens a list of blending modes that we will use often. Change the watercolor layer's Blend Mode to **Multiply.** This blending mode makes the white disappear so that only the areas with color tones remain visible while the background layer shows through. Be sure to experiment with the many different effects of each blending mode in the Layers palette.

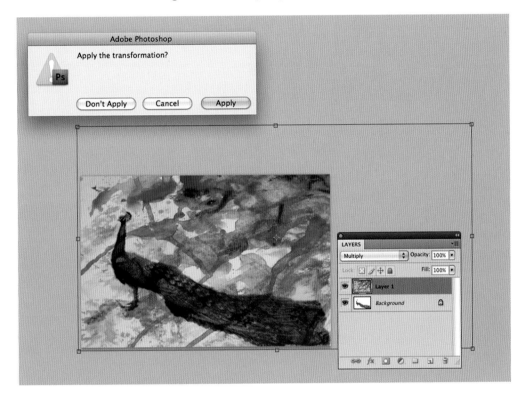

7 Add More Watercolor Textures and Change the Blending Mode.

Open a second watercolor texture and from the Select menu go to **Select** > **All**. To activate your image, go to **Edit** > **Copy**, and then **Edit** > **Paste** it onto your subject file. You can use **Edit** > **Transform** > **Scale** again and apply the transformation by hitting **Return/Enter** or clicking on any tool in the Toolbox and choosing **Apply**. If you scale your watercolor much larger than the subject image, you will be able to use the Move Tool on that layer to select a better area on the watercolor. Change the Blend Mode of that layer to **Overlay**.

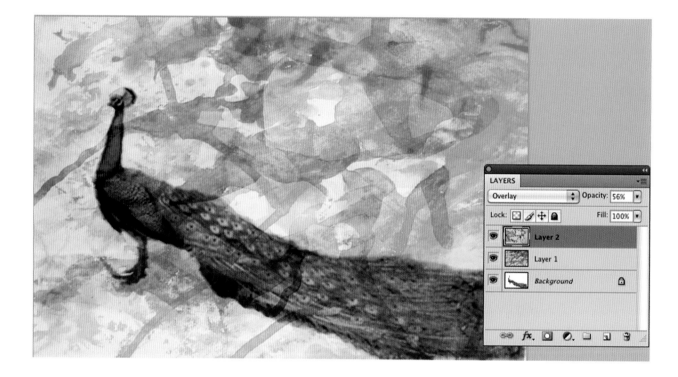

PHOTOSHOP FOR ARTISTS

8 Experiment with Blending Modes. Duplicate

the "Background" layer. Go to **Image** > **Adjustments** > **Invert** to invert the layer and then change the Blend Mode to **Difference**. You can experiment with different blending modes and opacities in each layer and decide which suits you best. Save your image as a PSD format to keep the layers intact [**File** > **Save as** > **Format** > **Photoshop**]; then from the Layer menu flatten your image and save it in a TIFF format to print.

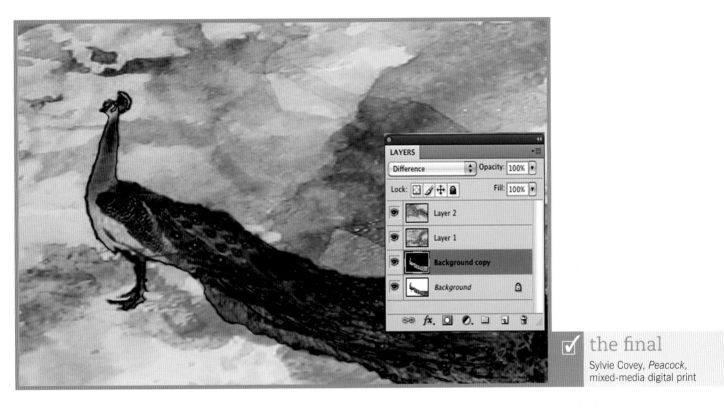

☑ the final
Sylvie Covey, *Peacock*,
mixed-media digital print

Painting with Filters and Blends

This tutorial will show how to use filters to achieve a natural media-effect painting. Filters in Photoshop are sometimes overused or too obvious. The use of a single filter often renders a mechanical effect on the final image. However, by applying multiple filters creatively over multiple layers, we will see how their interaction produces a subtle, painterly effect without using real paint. In this tutorial you will experiment with a number of artistic filters, layer blending modes, and layer masks so that you can achieve a sublime painting in Photoshop—and at the same time change reality through blending methods creatively.

Note: The original "Background" layer must be duplicated each time a new filter is introduced.

1 Choose an Image Suitable for This Tutorial. Open a photograph in Photoshop. I used this image of a deer I took in Zion Park, Utah.

START IMAGE Sylvie Covey, *Deer in Utah*, digital print

PHOTOSHOP FOR ARTISTS

2 **Create a Canvas.** Start by creating a new, filled canvas layer. From the Layer menu go to **Layer** > **New** > **Layer**. Name the layer "Canvas." From the Window menu check **Swatches** to open the Swatches palette. I chose a light blue-gray color for my canvas. Now fill this new layer with the color by going to **Edit** > **Fill** and then selecting **Foreground Color** for the Contents Use option. Make sure Preserve Transparency is unchecked in the Fill window to create an opaque fill.

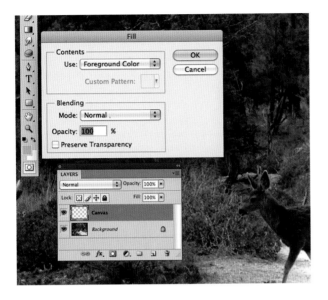

3 **Create a Layer Sketch with Glowing Edge Filter.** Duplicate the "Background" layer [**Layer** > **Duplicate Layer**] and name it "Sketch"; choose **Layer** > **Arrange** > **Bring to Front**. With the "Sketch" layer activated, choose **Filter** > **Stylize** > **Glowing Edges**. I applied the following settings: an Edge Width of **3**, an Edge Brightness of **12**, and a Smoothness of **8**. Feel free to adjust these settings to your liking.

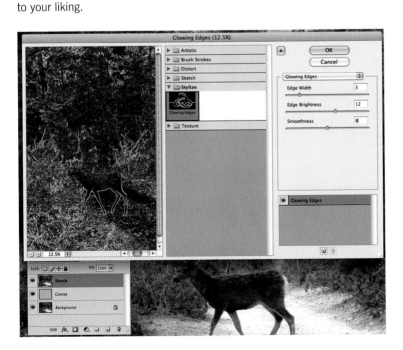

4 Reveal the Sketch on the Canvas. Click OK

to apply the filter. Now go to Image > Adjustments > Invert. The image is now a color sketch. In the Layers palette set the Blend Mode for this layer to Multiply, in order to hide the white areas of the layer and to show the color canvas beneath.

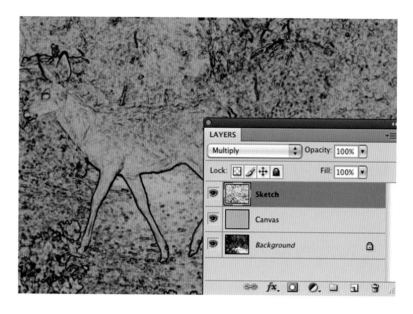

5 Use the Smudge Stick Filter. Activate the

"Background" layer and duplicate it [Layer > Duplicate Layer]. Name it "Smudge Stick." Go to Layer > Arrange > Bring to Front so it's sitting above the "Canvas" layer. Now go to Filter > Artistic > Smudge Stick. In the Filter window pick a Stroke Length around 9, a Highlight Area around 5, and an Intensity around 5 as well. Observe the result in the Preview window and adjust the settings as needed.

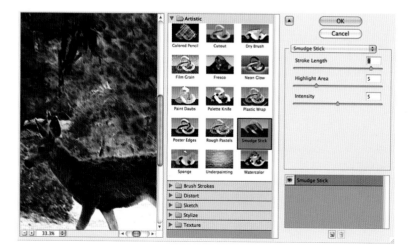

PHOTOSHOP FOR ARTISTS

6 **Change Reality.** To change some of the colors of that "Smudge Stick" layer, from the Image menu choose **Image >** **Adjustments > Hue/Saturation**. I moved the Hue slider all the way to the left to change the hue to **–154** and added some saturation by moving the Saturation slider toward the right to **+35.**

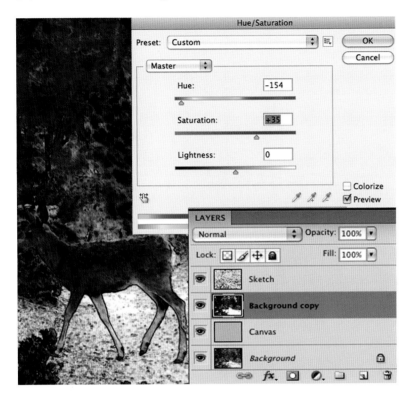

7 **Use Levels and a Blend Mode.** From the Image menu go to **Image > Adjustments > Levels**. Move the gray arrow in the middle to lighten the midtones, around a value of **1.50.** Click **OK** to apply the Levels adjustment. In the Layers palette set the Blend Mode for this "Smudge Stick" layer to **Vivid Light**.

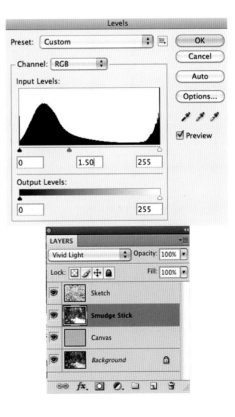

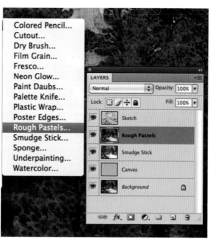

8 Use the Rough Pastels Filter. Activate the "Background" layer, duplicate it again [Layer > Duplicate Layer], and name it "Rough Pastels." Bring this layer above the "Smudge Stick" layer. From the Filter menu choose **Artistic > Rough Pastels**. I chose the following settings: a Stroke Length of **4**, a Stroke Detail of **3**, **Canvas** for the Texture, a Scaling of **120%**, a Relief of **25**, and **Bottom Left** for the Light. Adjust these settings to your own liking.

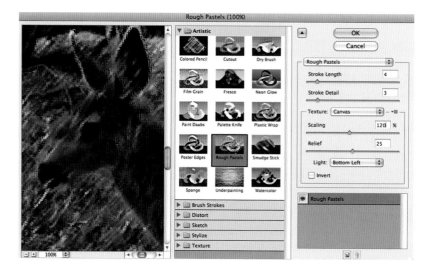

9 Add Another Blend Mode. In the Layers palette change the Blend Mode for this layer to **Saturation**. This blending mode will let you see where the colors were changed on the layer beneath. Double-click the thumbnail of the layer image to open the Blending Options dialog box and make sure the Blend If option is set to **Gray**. Slide the white arrow beneath the This Layer slider to a value of around **200**. Click **OK**.

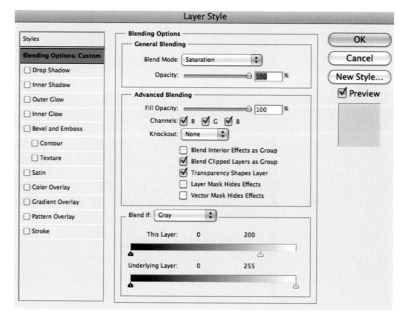

10 **Reveal Color with a Mask.** From the Layer
menu go to **Layer > Layer Mask > Reveal All**. Select the **Brush Tool** and set your foreground color as black. I chose **Wet Brush** from the Brush Picker. Now click on the layer mask thumbnail to activate it and paint over some areas to reveal the added color from the layer beneath.

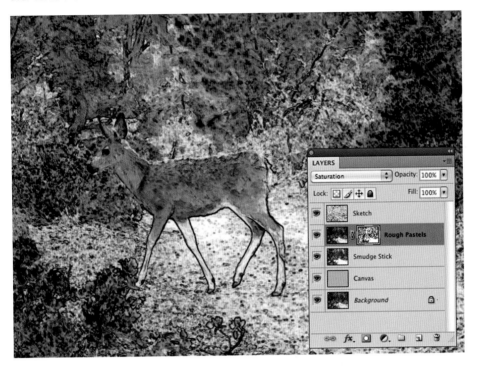

11 **Add a Fresco Filter.** Duplicate the "Background"
layer again [**Layer > Duplicate Layer**]. Name it "Fresco" and move it above the "Canvas" layer. With "Fresco" activated, go to **Filter > Artistic > Fresco**. I used a Brush Size of **6,** a Brush Detail of **5,** and a Texture of **3.** Experiment with these settings, and when you like what you see hit **OK.** Set the Blend Mode of the "Fresco" layer to **Exclusion**.

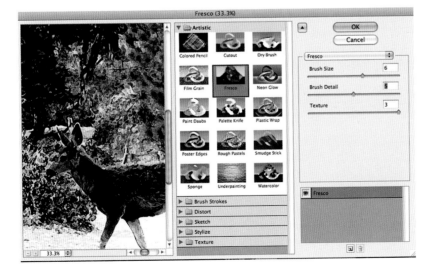

12 Adjust the Hue and Saturation. Go to

Image > Adjustments > Hue/Saturation. Drag the Saturation
slider up to the maximum value and click OK to accentuate the color values.

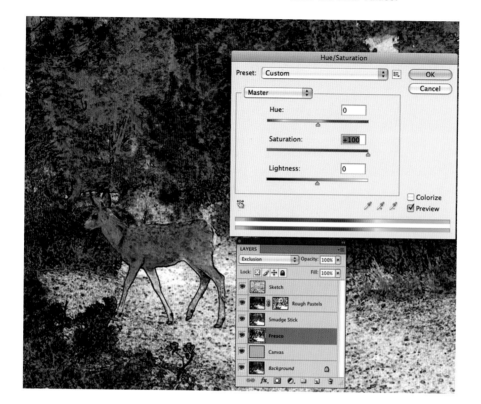

13 Define Lighter Tones. Activate the "Background"

layer and select the **Magic Wand Tool** from the Toolbox. In the Tool
Options Bar make sure Contiguous is *not* selected. Click on **Anti-alias** and set
the Tolerance to about **60.** Click on the lightest area of the image, and with
that selection active, go to **Layer > New > Layer via Copy.**

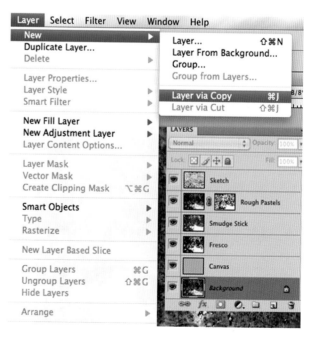

PHOTOSHOP FOR ARTISTS

14 Change the Blend Mode and Opacity.
Move this pasted layer above the "Rough Pastels" layer. Set the Blend Mode for this layer to **Linear Burn** and the Opacity to **70%**. Go to **Filter** > **Stylize** > **Find Edges**.

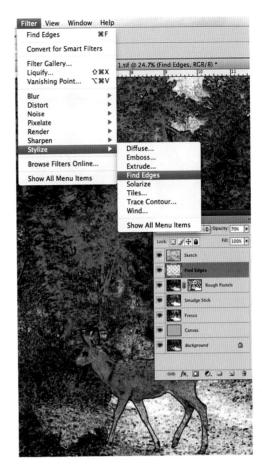

15 Add a Sprayed Strokes Filter.
Activate the "Background" layer and duplicate it one more time. Name this background copy "Sprayed Strokes," and bring it to the top of the layers stack. Go to **Filter** > **Brush Stroke** > **Sprayed Strokes**. I used the following settings: a Stroke Length of **10**, a Spray Radius of **18**, and a Stroke Direction of **Left Diagonal**. Choose your settings and click **OK**.

To reveal all the colors and layers, I changed the Blend Mode of this "Sprayed Strokes" layer to **Luminosity** and reduced the Opacity to around **80%**.

16 Add an Emboss Filter for Texture. To

get the effect of impasto with thick areas of painting, duplicate the "Background" layer one more time and name it "Emboss." Bring the "Background Copy" layer up the stack and below the "Sketch" layer. Change the layer's Blend Mode to **Overlay**; then go to **Filter > Stylize > Emboss**. With the Preview box checked, I used the following settings: an Angle of 150°, a Height of **7 pixels,** and an Amount of **170%**. Experiment with different settings.

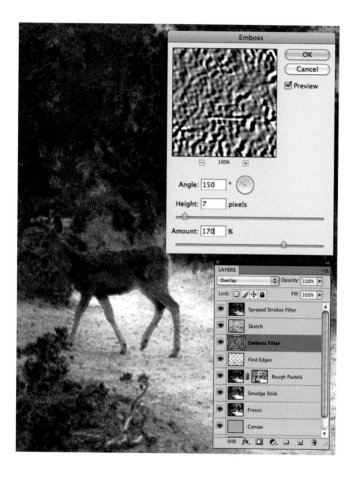

PHOTOSHOP FOR ARTISTS

17 Save Your File. Save your PSD file to keep your layers intact in case you want to rework them. Duplicate your file and flatten the layers to save it in a TIFF format for printing [**Layer > Flatten**].

☑ the final

Sylvie Covey, *Imagine a Deer in Utah*, digital print, 18 x 24 inches

PART THREE

Tutorials for Creating and Developing Fine-Art Digital Photography

Film photographers in the past have questioned the validity of digital technology, but the effects from bringing the computer into the darkroom have delivered results that are the best of both worlds. Digital photography is fun, exciting, and engaging, and, today, photographers find that digital technology, combined with photography, exceeds all expectations for art creation.

Sylvie Covey, *Wyoming 18*,
Digital print on silk, 24 x 36 inches

Making Basic Photo Corrections

In this tutorial we will look at adjusting the balance of light and color through Photoshop's adjustments with levels, curves, and color balance. We will correct a fading photograph with manipulating channels and fix overexposure with blending modes. There are several options in Photoshop for correcting the exposure of light or dark images and for removing unwanted colorcasts. The main Photoshop tools for image correction are Levels, Curves, and Color Balance.

EXAMPLE Richard Turchetti, *Japanese Garden*, mixed-media digital photograph, 10 x 7½ inches

This image was first shot as a digital color photo, then rendered as sepia, and reworked with posterization. It was printed on transparent inkjet paper and then backed with muted-gold craft paper.

CORRECTING OVEREXPOSURE WITH A LEVELS ADJUSTMENT LAYER

I chose this Wyoming landscape because of its heavy haze. Find a similar image for this exercise.

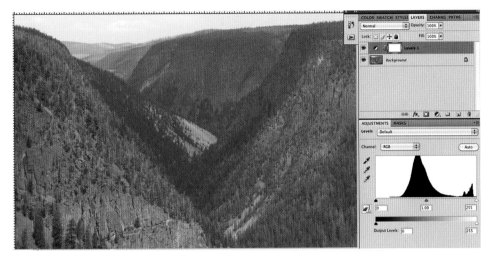

START IMAGE Sylvie Covey, *Valley*, digital print

To lower the haze and correct the overexposure of a landscape, add a Levels Adjustment layer by going to **Layer > New Adjustment Layer > Levels**. In the Levels dialog box, move the black-and-white sliders below the horizontal graph axis until they are just inside the ends of the graph. The image now has a normal range of tone and contrast. Levels adjust the brightness, contrast, and tonal range by specifying the location of complete black, complete white, and midtones in a histogram. The triangle on the left below the slider controls the shadows, the one in the middle controls the midtones, and the one on the right controls the highlights.

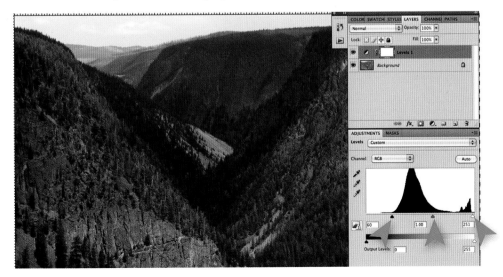

CORRECTING OVEREXPOSURE WITH A CURVES ADJUSTMENT LAYER

Using a Curves New Adjustment layer to adjust the tonal values of an image is a more advanced and flexible method for making corrections. Curves give you better control, allowing you to push and pull tones and colors, as well as adjust brightness, contrast, and gamma. Curves let you adjust the Output tones or values against the Input tones or values.

A Curves dialog box has a graph with black to white on the vertical axis and black to white on the horizontal axis. To darken an image, drag the center of the Curves line down so that the output (vertical axis) pixels are darker in the midtones than the input.

Go to **Layer** > **New Adjustment Layer** > **Curves**. To correct the haze and overexposure of an image, click and drag the Curves line in the graph. Create several control points by clicking on the line to allow specific parts of the tonal range to be adjusted.

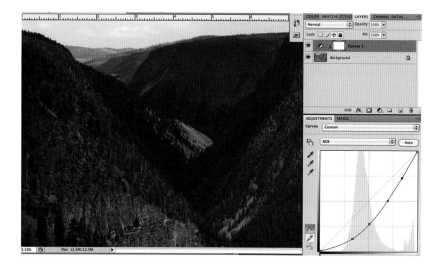

CORRECTING UNDEREXPOSURE WITH A LEVELS OR CURVES ADJUSTMENT LAYER

A Levels or Curves Adjustment layer can be used to correct dark and underexposed images. To prevent a sky from getting too light, create a control point in the light area and lower the curve line.

CORRECTING COLORCAST WITH A
COLOR BALANCE ADJUSTMENT LAYER

This rocky mountaintop, also from Wyoming, looks bluish and needs a color adjustment. To correct the blue colorcast often produced by heat and altitude, create a Color Balance Adjustment layer.

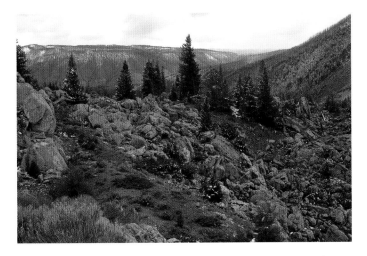

START IMAGE Sylvie Covey, *Rocky Mountains*, digital print

Go to **Layer > New Adjustment Layer > Color Balance** and move the slider accordingly in the midtones, highlights, and shadows to bring back a more natural color to the image.

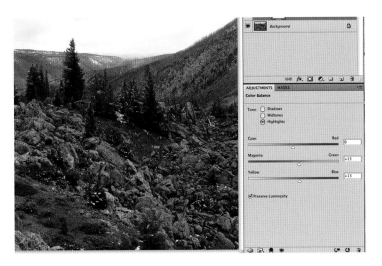

CORRECTING FADED PHOTOS WITH CHANNELS

Over time, some colors will age more quickly than others in photographs, leaving a faded look of colorcast. To bring life back to old and timeworn photos, first load a Levels Adjustment layer to access each individual channel. The full tonal range can be adjusted from black to white using the Histogram and Channels. The Histogram will show what channel needs to be adjusted. For this example, I used a faded photograph of my father during World War II. Find a similar faded photo from your family photo albums.

START IMAGE Photographer Unknown, *Yvon Germain*, scanned photograph

1 **Open a Histogram.** Open the Histogram palette from the Window menu. Click on the upper-right arrow to open the Context menu and select the **All Channels View.** This will show each color channel graph individually.

2 **Add a Levels Adjustment Layer.** We see that the Red channel info is shifted to the right and that the Green channel sits a lot further to the right than the Blue channel. This placement indicates the need for correction. To bring the channels into line and remove the colorcasts, create a Levels Adjustment layer. Go to **Layer > New Adjustment Layer > Levels.**

In the Levels palette, click on the arrow next to RGB to access each individual channel. Choose **Red** to start.

The black in the graph represents the channel information. The endpoint sliders need to meet both ends of the Histogram to achieve a balanced color. I shifted the black slider under the graph so that it now meets the Histogram without an empty gap. The white slider already meets the other end and does not have to be touched.

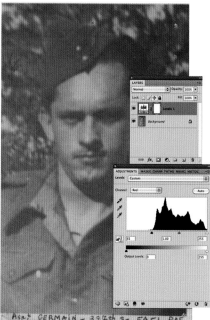

3 Repeat Steps 1 and 2. Do the same corrections with
the Green channel and the Blue channel, sliding the arrows under the
Histogram so that they meet its beginning and end without a gap.

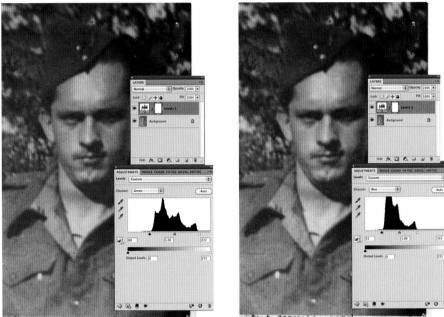

When all three channels are corrected, the photo has regained its
original color.

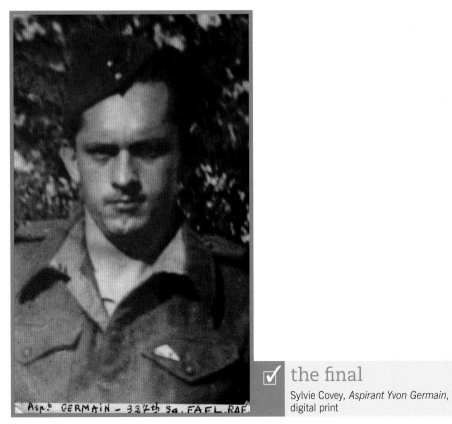

☑ the final
Sylvie Covey, *Aspirant Yvon Germain*,
digital print

CORRECTING OVEREXPOSURE WITH BLENDING MODES

Flat lighting, bright light, or excessive exposure are often to blame for overly bright images that lack darker tones. In the lightest part of an overly bright image, a "white out" occurs where extremely overexposed areas lose any detail and cannot be recovered. This next method corrects an overly bright image using Photoshop's options in layers and blending modes. In this lake photo with distant mountains, the overexposure resulted in poor colors.

START IMAGE Sylvie Covey, *Overexposed Lake*, digital photograph

1 **Open a Histogram.** Open a bright image, and from the Window menu choose **Histogram**. A histogram shows the numerical tonal distribution between the black and white extremes. An overly bright image shows few middle-to-dark tones, with a predominance of middle-to-light tones.

PHOTOSHOP FOR ARTISTS

2 **Make a Copy.** Make a copy of the background [**Layer >
Duplicate Layer**]. In the Layers palette, choose **Multiply** in the Blend
Mode drop-down menu. This will double the previous values of all the tones
and result in a darker image.

3 **Add a Color Balance Adjustment Layer.**
To reduce the colorcast and make your image more natural, go to
Layer > New Adjustment Layer > Color Balance and adjust the sliders
to improve the colors. Make sure you adjust the midtones, shadows, and
highlights according to your taste.

IMPROVING SELECTIVE AREAS

Often, it is difficult to get one adjustment to work for an entire image. To improve a dull image suffering from poor contrast and low color saturation, specific areas can be selected for improvement. Some elements of an image require more intensity to make the whole picture look more dramatic. For this exercise, I started from the same overexposed image of the western lake with distant mountains I used in the previous method.

In the lake photo, the enhancements required for the sky and those for the mountains and water are different. The sky needs to be darkened and the foreground needs more contrast. To facilitate these individual changes we will use a masked Curves Adjustment layer.

1 **Select the Background.** I decided to use the **Quick Selection Tool** to capture the sky only. From the Tool Options Bar I chose the **Refine Edges** option. In the Refine Edges dialog box I selected **1 pixel** for Feather and **1 pixel** for Radius. This slight feathering of the selection will help to blend the different changes to the sky and mountains.

2 **Save the Selection.** From the Select menu I chose **Save Selection,** and in the Save Selection dialog box I named the selection "Sky." In the Operations section I made sure the **New Channel** option was active.

PHOTOSHOP FOR ARTISTS

3 Add a Curves Adjustment Layer. With
the "Sky" layer selected, from the Layer menu I created a **New Adjustment Layer >
Curves.** I clicked on and dragged the Curves line to darken the sky and make it look more dramatic. When you click **OK** a masked Adjustment layer is created and the changes only apply to the selected portion of the image.

4 Add Another Curves Adjustment Layer. To
improve the foreground, from the Select menu I chose **Load Selection.** From the Select menu again, I chose **Inverse** to select the foreground only. From the Layer menu I chose **New Adjustment Layer > Curves** and created a Curves line in an S-shape to increase the contrasts between the highlights and the darker tones. This action also improved the color saturation.

The end result is a transformed and powerful image that differs dramatically from the start image.

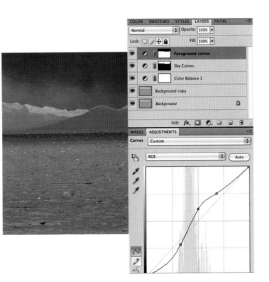

☑ the final

Sylvie Covey, *Western Lake,* digital print

USING LAB COLOR

The Lab Color space is used in Photoshop when graphics for print have to be converted from RGB to CMYK, as the Lab gamut includes both the RGB and CMYK gamuts. It is also used as an interchange format between different devices. In the RGB Color mode (red, green, and blue), the brightness and color is stored across all of the channels. In the Lab Color mode the brightness is stored in one channel, and the color is split across the a and b channels. When using the Lab Color mode, a new world of possibilities opens up. The word "Lab" stands for the three dimensions—Luminance (L) plus the A and B axes, each of which can be adjusted independently. A Lab Color space is a color-opponent space with dimension L for lightness and A and B for the color-opponent dimensions. The nonlinear relations for L, A, and B are intended to mimic the nonlinear response of the eye.

1 Change the Mode of the Image.
Open a photo portrait, and from the Image menu go to **Mode > Lab Color**. I chose this portrait I took of an Upstate New York farmer feeding a baby goat.

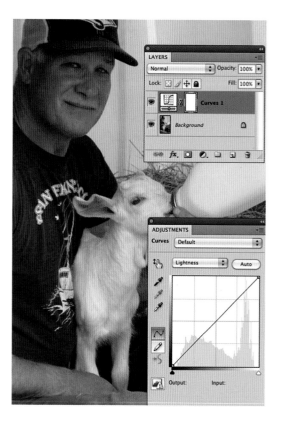

2 Add a Curves Adjustment Layer.
Color and Brightness (or Luminance) are separate in Lab Color mode; therefore, you can make changes in color saturation without affecting the brightness, and vice-versa. The implications are that you can gain a lot of latitude with the Curves New Adjustment layer. Choose a channel through **Layer > New Adjustment Layer > Curves**.

In the Curves dialog box look for the Channel drop-down menu and pick the **Lightness** channel, which is synonymous with brightness or luminance. The changes you make with the Curves will only affect

PHOTOSHOP FOR ARTISTS

how bright the pixels are and will not affect the color saturation.

To boost the color, choose the **A** channel and drag the bottom-left section of the curves line to get –100 Input. Do the same on the top right to get 100 Input. This change is now symmetrical.

Choose the **B** channel and repeat this process. The color balance has not changed, but the color saturation is enhanced by the mirrored curves changes.

To remove or introduce colorcasts, the Lab Color mode is useful for adjusting colors on each channel. Note that the A channel deals with magenta and green, and the B channel deals with yellow and blue.

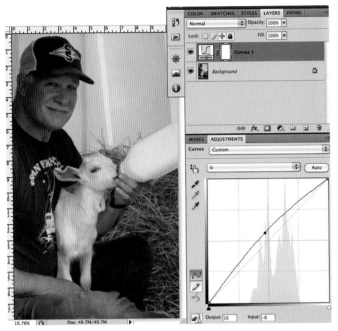

3 Convert the File into a RGB or CMYK Color Mode.
It is important to note that you can save PSD files in Lab Color mode; however, JPEG and TIFF files only work in RGB and CMYK Color modes. As a result, when you are done with the adjustments you must flatten and convert your file back to either RGB or CMYK Color mode. You must flatten the adjustments because RGB and CMYK work differently than Lab Color.

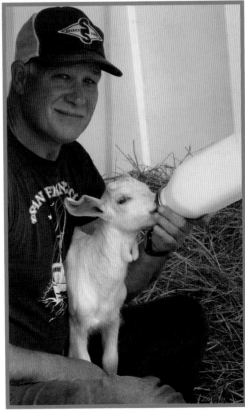

☑ **the final**
Sylvie Covey, *Feeding the Baby Goat*, digital print

TUTORIAL 11 Using Blending Modes

This tutorial is an introduction to photomontage techniques using only layer blending modes. The blending modes I often use for photomontage are as follows:

Multiply: This mode multiplies the tonal values of the pixels of a layer being blended from, by the layer being blended to. This blending mode is named after the math function performed behind the scenes. Photoshop takes the colors from the layer that is set to the Multiply Blend Mode and multiplies them by the colors on the layer(s) below it, then divides them by 255 to give us the best result. Multiplying white pixels makes white disappear, while multiplying black pixels makes black appear. For this reason, the layer below a layer with a Multiply Blend Mode will show through, without changing the layer's opacity.

Screen: This mode is similar to Multiply but it multiplies the inverse values of the pixels, where blacks are lost and only lighter pixels remain, therefore producing a negative result.

Linear Dodge: This mode is similar to Screen but emphasizes the base layer.

Overlay: This mode doubles the pixels' value in that layer.

Difference: This mode inverses the pixels' value of the previous layer.

BLENDING MODES WITH TWO OR MORE TEXTURE LAYERS

Here is a step-by-step example of how I create some of my work. You can follow these steps using your own imagery and change the choice of blending modes as you see fit.

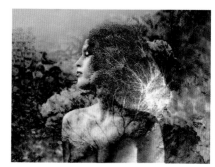

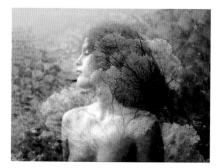

EXAMPLE Sylvie Covey, *Portrait in Various Modes*, digital print on canvas, 40 x 15 inches

This image is a perfect example of different results working with various combinations of blending modes.

1 Select the Images.

Choose a subject image and a background/environment/texture image from your files. From the Image menu, resize both images to the same Resolution (**300 dpi**) and the same Size in inches [**Image** > **Image Size**]. I named my chosen images "Leaves" and "Foam."

START IMAGE Sylvie Covey, *Leaves*, digital print

START IMAGE Sylvie Covey, *Foam*, digital print

2 Merge the Two Images.

I activated the "Foam" image and selected it [**Select** > **All**]; then from the Edit menu I copied it [**Edit** > **Copy**]. I activated the "Leaves" image, and from the Edit menu I pasted the "Foam" image onto the "Leaves" image [**Edit** > **Paste**]. I changed the Blend Mode in the Layers palette to **Difference** for the "foam" layer. The "Foam" layer now shows through the "Leaves" layer in inverted colors.

Note: You can use the Edit > Free Transform option from the Edit menu to fit an image onto another.

3 Duplicate Your Layers and Change Their Blend Modes.

I activated the "Leaves" layer and duplicated it [Layer > Duplicate Layer]. I did the same with the "Foam" layer. I moved the "Leaves Copy" layer up, above the "Foam" layer, and changed the "Foam Copy" layer's Blend Mode to **Darken**, and the "Leaves Copy" layer's Blend Mode to **Difference**.

4 Add More Blend Modes.

I duplicated the "Leaves Copy" layer again ("Leaves Copy 2") and changed the Blend Mode to **Lighter Color**, and then I duplicated the "Foam Copy" layer again ("Foam Copy 2") and changed its Blend Mode to **Multiply**.

5 Add a Third Image for Texture.

I decided to add a second texture to my image. For this I opened a new image of "Trees," resized it to **300 dpi** Resolution, and made it the same size in inches as my main file. I selected the "Trees" image [**Select > All**], activated the main file, and from the Edit menu I pasted it [**Edit > Paste**]. I then changed the Blend Mode of the "Trees" layer to **Difference**.

START IMAGE Sylvie Covey, *Trees in the Sky*, digital print

PHOTOSHOP FOR ARTISTS

6 Add a Curves Adjustment layer. Next,

I decided to add a new Curves Adjustment layer [**Layer > New Adjustment Layer > Curves**] and lightened the leaves a bit with the Curves adjustments.

7 Save Your File. Finally, I saved this file in PSD format,

then flattened the image, and saved it as a TIFF file to print.

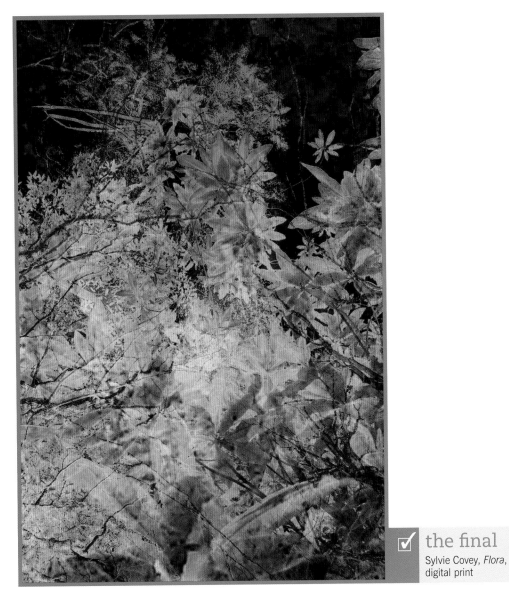

✓ **the final**
Sylvie Covey, *Flora*,
digital print

Replacing/Composing Scenery

Many photographers have numerous shots of interesting subjects or places that are in environments that dull or lessen the images. This tutorial is about perfecting an image by swapping scenery and creating a new reality via Photoshop. We will work with the selection tools, the Transform/Scale commands, channels, and masks to compose a new, perfected image from two or more photographs.

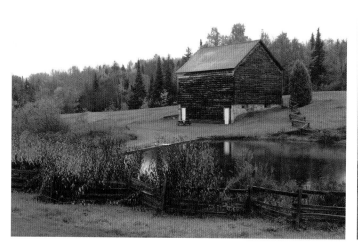

EXAMPLE *The image above is the original photograph.*

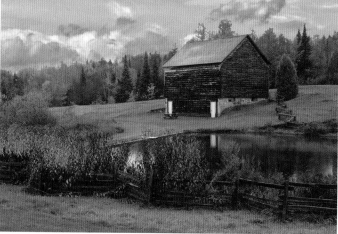

Janet Millstein, *John Brown's Barn*, digital print
This image features the replaced sky.

COMPOSING FANTASY LANDSCAPES

Some compositions require very subtle selections to blend into their new environment. Selection tools such as the marquees, the lassos, the Magic Wand Tool, or the Quick Selection Tool are well-equipped for sharp pixel selections. However, sometimes an image demands a more subtle selection, especially when dealing with foliage, hair, and tones. In this method we will create a new channel in the RGB Channels palette and use it to select an area to be replaced, so that the selection is based on the grayscale values of that channel—rather than on an outline tool selection.

1 Envision Your Composition.

In Photoshop, open two images you want to merge as a composition. In this example I chose an Upstate New York countryside landscape with a New York City skyline.

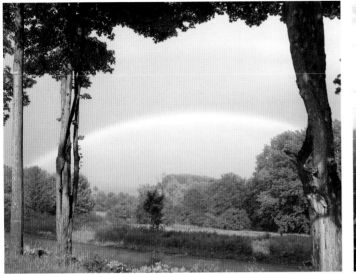

START IMAGE Sylvie Covey, *Rainbow*, digital print

START IMAGE Sylvie Covey, *Empire State Building*, digital print

From the Image menu go to **Image Size** and adjust both your images to the same Size in inches and set the Resolution at **300 dpi.** In this method, make sure both images are in RGB Color mode [**Image** > **Mode** > **RGB Color**]. RGB refers to the red, green, and blue color modes used on computer screens. (See page 18 in the Digital Basics section of Part One.)

2 Select the Receiving Image.

Choose which of the two images you will bring into the new environment of the other image. One image will be better suited as the receiving environment; the other should be the addition. In this example, I chose to bring the city into the landscape. I activated the cityscape image and dragged its "Background" layer into the countryside image window.

Note: To do this, you must have both images open in two side-by-side windows. If both your images are open but in the same window frame, another way to copy them onto one another is to simply activate one image (go to the Select menu and choose **All,** then **Edit** > **Copy**) and then activate the other image from the bar at the top of the images window by clicking on its name. With the second image activated, choose **Paste** from the Edit menu.

3 Duplicate the Background. When both your
addition and receiving image layers are stacked on top of each other,
activate the "Background" (receiving) layer and duplicate it [Layer >
Duplicate Layer]. Move this duplicate to the top of the layers stack.

Note: To move layers, you have the choice of either dragging them up and
down in the Layers palette with your cursor, or going to the Layer menu
and choosing Arrange > Bring to Front to bring the layer to the top of the
stack. There are other Arrange options to choose from, depending on what
is required.

4 Make a Channel to Create a Selection.
Open the Channels palette from the Window menu. By clicking on and
off the Eye icon on each channel you will notice that the Blue channel offers
better contrast than the others. To create a "Blue Copy," activate the Blue
channel and drag it into the Create a New Channel icon at the bottom of the
Channels window.

5 Add Adjustment Levels. To add more contrast to this selected channel, go to **Image** > **Adjustments** > **Levels** with the "Blue Copy" layer active. In the Levels palette move the sliders until the image is very high in contrast. Click on **RGB** in the Channel option in the Channels palette to restore the visibility of all, and then reopen the Layers palette.

6 Use the New Channel as a Selection. From the Select menu choose **Load Selection**, and in the Load Selection window look in the Channel pull-down menu. Choose **Blue copy** as your Channel selection and check on the **Invert** box to invert the selection. Click **OK** to apply.

7 Perfect the Selection. A selection is now created on the
Grayscale values of the "Blue Copy" layer. If you feel some areas are missing
from this selection, with the selection active simply lasso those areas and use
the lasso option **Add to Selection** from the Tool Options Bar. These areas will be
automatically integrated in the main selection.

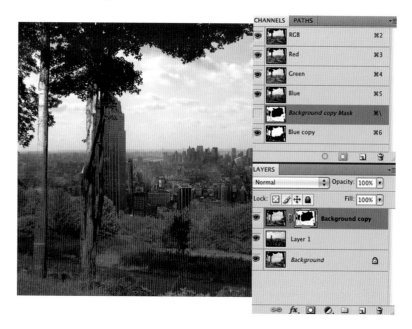

8 Make a Mask to Reveal the Inverted
Selection. With your selection still active, click on the Add a Layer
Mask icon at the bottom of the Layers palette. My cityscape is now revealed in the
country landscape. Some areas from the receiving image may be missing. They are
easily retrieved by making sure the black mask thumbnail is activated in the Layers
palette and that white is selected as the foreground color in the toolbox, to be
painted with the Brush Tool on the missing areas.

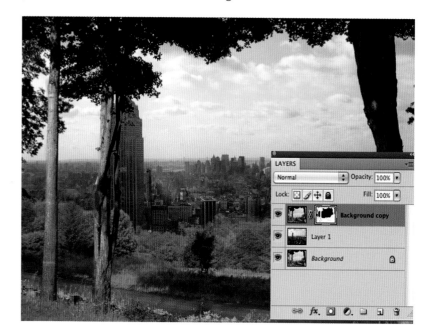

PHOTOSHOP FOR ARTISTS

9 Soften the Edges of the Mask.

With the mask thumbnail activated in the Layers palette, go to the Filter menu and choose **Blur > Gaussian Blur**. You might want to do this twice—it should soften the edges of the mask enough so that both the original images blend smoothly into one.

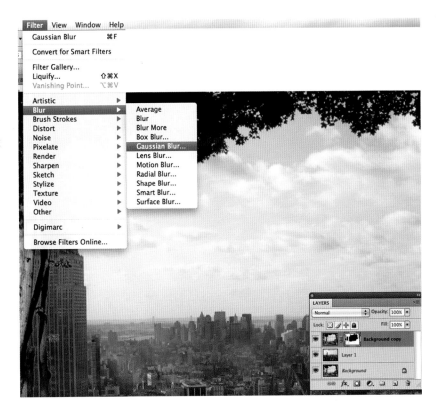

10 Add a Blend Mode.

Finally, for this example I wanted to retrieve my countryside rainbow and blend it with the cityscape, so I changed the city layer's Blend Mode to **Multiply**. You might want to experiment with other blending modes for a final tune-up.

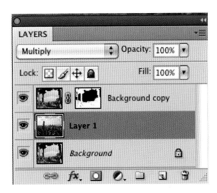

11 Save Your File.

When you are satisfied with your composition, flatten your image and save it as a TIFF file to print.

✓ the final

Sylvie Covey, *City in the Country*, digital print, 18 x 24 inches

Applying New Adjustment Layer Effects

The principle of layering is not unique to Photoshop and was originally used in animation, where objects and characters are kept separate from their backgrounds. Working with layers allows for great flexibility in editing an image by isolating its different components. The New Adjustment Layer menu allows you to select from a variety of methods to change an image. One of the best reasons for working with adjustment layers is that they make it possible to improve an image without altering the source file. Adjustment layers can be easily added or removed, and are created just above the active layer. Contrast or saturation, for example, can be increased or lowered without changing or ruining the original file. As a result, working from the New Adjustment Layer menu provides a safe and versatile way to edit wonderful imagery.

The Curves Adjustment layer is particularly powerful and useful for making a visual impact on images that need editing. Other adjustment layers include Brightness/Contrast, Levels, Exposure, Vibrance, Hue/Saturation, Color Balance, Channel Mixer, Gradient Map, and more. This sample image by New Jersey–based artist Dail Fried was created purely with a Curves Adjustment layer.

EXAMPLE Dail Fried, *Copenhagen Flower Pot Bench*, digital print, 22 x 30 inches

APPLYING THE CURVES ADJUSTMENT LAYER

The Curves Adjustment layer allows you to select tones within an image and move them independently from other tones within the image. For example, you can choose to make only the lighter tones darker, while preserving the midtones and the darker tones as they are. This exciting editing feature also allows you to move the highlights in one direction and the shadows in another. This results in adding contrast without losing information and detail in the shadows and highlights.

1 Select Your Image. Open a color photograph in Photoshop that is suitable for adjustments. The image I chose is a little dark and needs to be lightened.

START IMAGE Sylvie Covey, *Al Fresco Lunch*, digital print

2 Lighten or Darken Your Image. From the Layer menu choose **New Adjustment Layer > Curves.** You can also access all the adjustment layers from the New Adjustment Layer icon at the bottom of the Layers palette. A Curves dialog box opens with a black to white vertical axis and a white to black horizontal axis. To darken or lighten the image, click on the diagonal line and drag the center of the curve up or down.

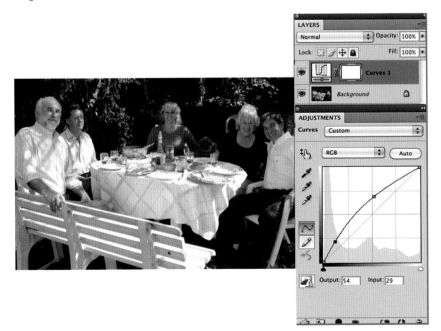

3 **Add Contrast.** Curves offer many creative editing options, especially for scenery. Open a landscape or still-life image in Photoshop and try these: For higher contrast, make an S-shape with the Curves. If you click on the line and let the cursor go, it will create an anchor dot. You can make as many anchor dots as you wish.

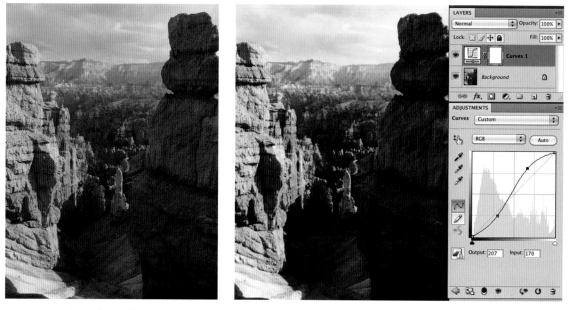

START IMAGE Sylvie Covey, *Bryce Canyon, Utah*, digital mural print

4 **Add a High-key Effect.** Lighten the tones of the entire image by dragging the Curves line up, while dragging a little on the right to keep the dark pixels.

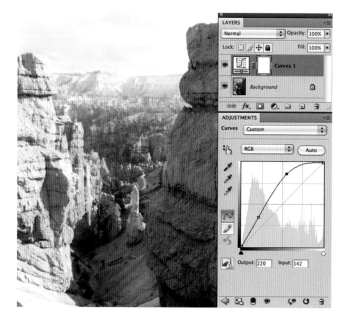

PHOTOSHOP FOR ARTISTS

5 Adjust the Saturation. Drag the input values on the
horizontal axis to increase the saturation of the output tones.

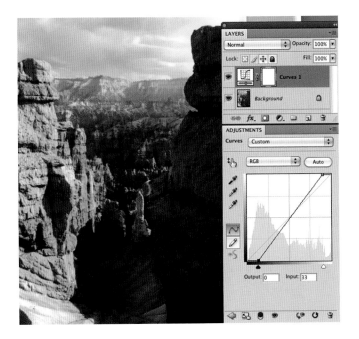

6 Add Creative Abstraction. Click a few anchor
points on the Curves line and drag it up and down to create different
color values.

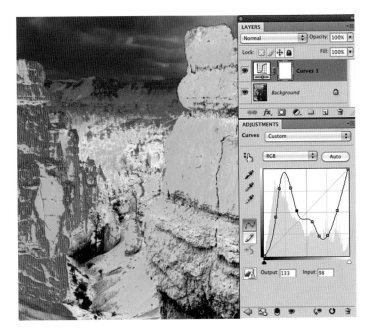

7 Edit Selective Areas with a Curves Adjustment Layer Mask.

I darkened the lower part of my landscape to emphasize the sky. Next, I activated the mask thumbnail in the Curves Adjustment layer and chose the **Gradient Tool** in the Toolbox. I dragged a black-and-white gradient from top to bottom on my image to mask out the bottom part.

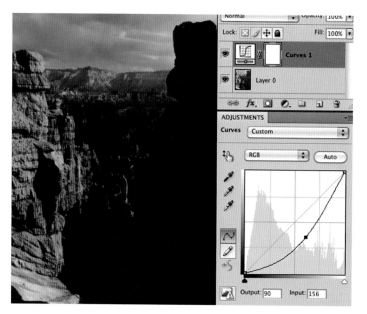

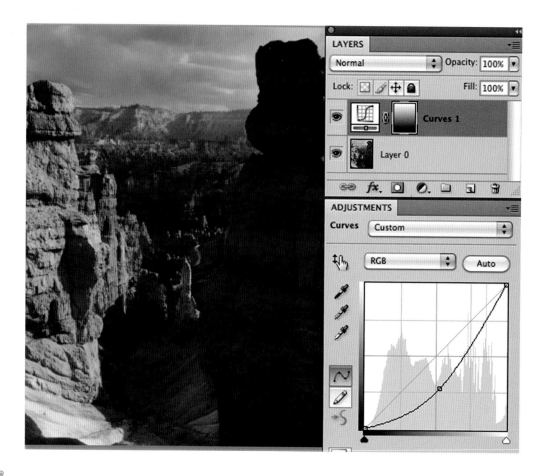

PHOTOSHOP FOR ARTISTS

APPLYING THE LEVELS ADJUSTMENT LAYER

The Levels Adjustment layer enables you to lighten a layer, darken it, or increase the shadows and highlights. You should use Levels for all initial brightness and contrast adjustments. (The Brightness/Contrast adjustment feature can result in loss of information.)

1 **Select Your Image.** Open an image that needs a lighting adjustment. This photo portrait I chose is currently a little too dense.

2 **Create a Levels Adjustment Layer.** From the Layer menu I went to **New Adjustment Layer > Levels**. You can also access the Adjustment Layer menu from the New Adjustment Layer icon in the Layers palette. I moved the Midtones gray slider to **1.20** on the left to lighten the midtones, and the Highlights white slider to **230**.

 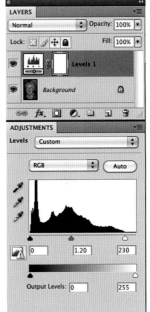

START IMAGE Sylvie Covey, *Olga*, digital print

3 **Examine the Final Image.** The result is a well-balanced photo portrait.

 the final
Sylvie Covey, *Olga*, digital print,
12 x 8 inches

APPLYING COLOR BALANCE AND CHANNEL MIXER ADJUSTMENT LAYERS

Using an Adjustment layer allows the color and tonal changes to reside only on the Adjustment layer and does not permanently change the pixels of the image. In effect, you are viewing the visible layers through the Adjustment layer above them. When creating a new Color Balance Adjustment layer or a new Channel Mixer Adjustment layer, a window opens that allows you to try different colors and tonal adjustments by moving the Color and Channel sliders in the Adjustment window.

1 Select Your Image. Adjust the colors of a photo with the Color Balance Adjustment layer. Start by opening a photo portrait. I chose this one because the colors need adjusting.

START IMAGE Sylvie Covey, *Nicolas*, digital photograph

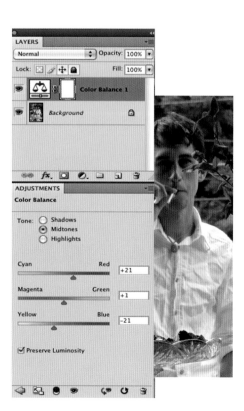

2 Use the Color Balance Adjustment Layer. I selected the **Create a New Fill or Adjustment Layer** icon in the Layers palette and chose **Color Balance** from the pull-down menu. The Color Balance window offers three options for adjusting: Midtones, Highlights, and Shadows. I started with the Midtones, warming up the tones. Then, with the Highlights, I added color to the bright areas, and with Shadows I darkened the shades a bit.

3 Use the Channel Mixer Adjustment Layer.
I added a new Adjustment layer, but this time I chose **Channel Mixer** from the Layers Adjustments pull-down menu and tweaked the **Red** slider to further warm up the image.

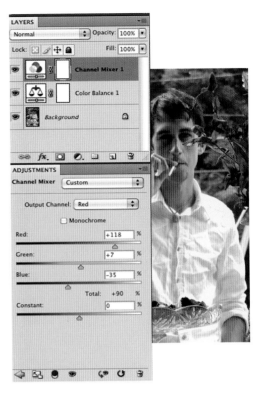

4 Examine the Final Image.
The result is a bright and colorful photo portrait.

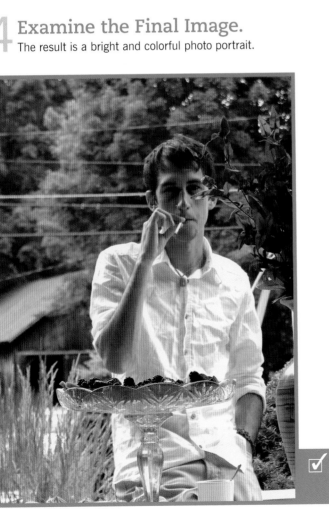

☑ the final
Sylvie Covey, *Nicolas*, digital print,
12 x 8 inches

APPLYING THE GRADIENT MAP ADJUSTMENT LAYER

The Gradient Map Adjustment layer also offers a good way to edit your image non-destructively. This adjustment works by replacing the tones of your image with the colors of your chosen gradient. The gradient maps the image evenly and matches the original tones. Gradient fills offer transparent to opaque color fadeouts and are very effective for creating atmosphere through various color combinations. Gradients can also be used with layer masks to blend images smoothly.

1 **Select Your Image.** Open an image to be adjusted. I chose this portrait of a model I took in Paris, France.

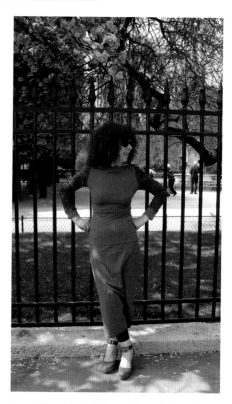

START IMAGE Sylvie Covey, *Danielle in a Green Dress*, digital photograph

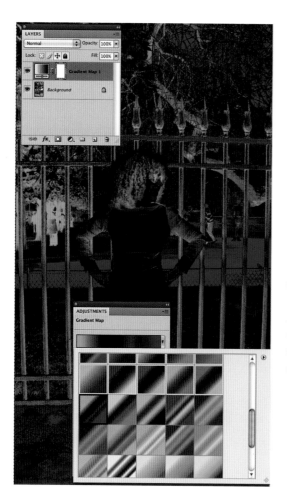

2 **Choose a Gradient Map.** A number of Gradient Maps created by Photoshop are interesting to try. Select the **Create a New Fill or Adjustment Layer** icon in the Layers palette and choose **Gradient Map** from the pull-down menu. From the Gradient dialog box choose your colors and settings. Click **OK**.

PHOTOSHOP FOR ARTISTS

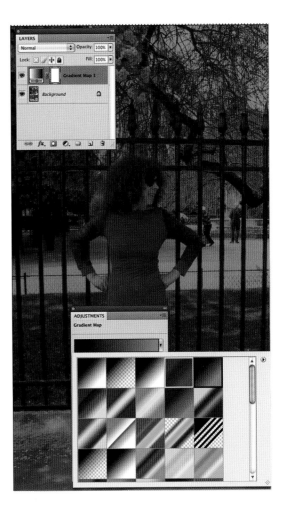

3 Make Your Own Gradient Map.
You can also make your own Gradient Map by selecting a foreground color and a background color from the Swatches window. Then find your new Gradient Map in the Gradient Map window.

4 Add Final Touches.
Reducing the Opacity of the Layers palette will allow some of the original colors to show through the Gradient Map and will create an interesting atmosphere.

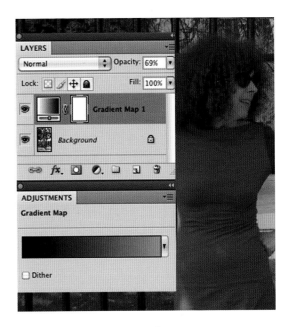

APPLYING SELECTIVE COLOR AND PHOTO FILTER ADJUSTMENT LAYERS

Adding a Selective Color Adjustment layer helps you adjust one color at a time—and in greater details. The Selective Color Adjustment layer allows you to control saturation over a limited range of colors. Choosing a specific color in the Selective Color window will fine-tune the color range that is adjusted. To darken a specific color with the Selective Color option, choose the target color from the pull-down list and move the black slider to the right to augment the percentage. The Photo Filter Adjustment option allows less control than Curves or Color Balance. However, it offers similar ways to add filters, just as traditional film photographers have used filters on their cameras to adjust color and atmosphere. In the Photo Filter window, click on the arrow next to the name of the filter to open the pull-down list of filters. Note that the numbers shown correspond to the equivalent glass filters that were attached to the camera lens.

1 Use a Selective Color Adjustment. Choose the color to be adjusted. I changed the reds and yellows of my image to give it a classic, tinted feel.

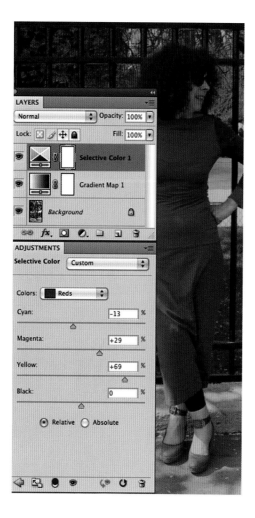

PHOTOSHOP FOR ARTISTS

2 Use a Photo Filter Adjustment. Finally,
experiment with the Photo Filter Adjustments layer, which offers a variety of warming and cooling photo filters. Check out the different color filters and choose a density percentage by moving the Density slider in the Photo Filter Adjustments layer window.

☑ the final
Sylvie Covey, *Danielle in a Green Dress II*,
digital photograph, 12 x 8 inches

Applying a Digital Double Exposure

Blending two or more images together is a wonderful way to create a digital double exposure. In film photography a double exposure occurs when two framed shots are exposed with one on top of the other. Before going digital, I spent years shooting multiple exposures of film, and I also mounted pairs of negatives together in slide holders before exposing them in an enlarger. Thankfully, with Photoshop it is much easier to create digital double exposures. In this tutorial we will use a layer blending mode to reveal one image on top of another. We will create a layer mask and adjustment layers with Curves and Hue/Saturation to adjust the background tones with the subject's colors. The resulting images display character and mystery.

For this tutorial you will need a subject image and a texture/environment image. You can scan a texture or download one from the Internet, or simply use one of your own. This simple technique works best if the background of the subject image is not too busy. To darken and minimize the background of your subject, use the Quick Selection Tool to capture the subject; then inverse your selection [Select > Inverse]; then use a Curves Adjustment layer to darken the background only [Layer > Adjustment Layer > Curves]. When your subject stands out, flatten your image, save it, and start the tutorial. Below is an example of digital double exposure.

Nora used this image of a rose combined with a photo portrait.

EXAMPLE Nora Winn, *Kiley Rose*, digital print

1 Choose Two Images to be Paired.

In Photoshop, open two images suitable for blending, such as a live subject with lights, midtones, and shadows, and a texture from nature—or anything with details such as a pattern from a fabric. A bold texture with an irregular pattern is best, with a full tonal range and good contrast. Here, Nora starts with the same portrait from the example and a close-up shot of sunflower as her texture image.

Note: Both the subject and texture images must be converted to RGB by going to Image > Mode > RGB Color. Both images should also be converted to the same resolution and similar size. From the Image menu go to Image > Image Size and adjust both images to the same Resolution (300 dpi). The size in inches can be adjusted as described below with the Edit > Free Transform option.

START IMAGE Nora Winn, *Kiley*, digital print

START IMAGE Nora Winn, *Sunflower Seeds*, digital print

2 Paste Two Images on Top of One Another.
From the Layers palette, drag the texture thumbnail onto the subject image while holding down the **Shift** key. The Shift key will ensure that the texture will center on the subject. If this seems difficult, you can also simply click on the texture image to activate the image; then from the Select menu go to **Select** > **All**. From the Edit menu go to **Edit** > **Copy**; then click on the subject image to activate it and click on **Edit** > **Paste**. The main subject now displays two layers with the texture layer on top.

3 Resize the Pasting Job.
If the texture image does not quite cover the subject image, use the **Edit** > **Free Transform** command to resize the texture image so that it covers the figure on the image, or vice-versa. Pull on the handles of the Free Transform action around one image to fit it on the other. Apply the transformation by pressing **Enter/Return** on the keyboard.

4 Reveal an Image with a Layer Blending Mode.
In the Layers palette, set the Blend Mode of the top layer to **Multiply** or **Overlay**. Click on the arrow next to the word "Normal" to open the Blend Modes pull-down menu in the Layers palette. Experiment with adjusting the opacity of the layer using the Opacity slider in the Layers palette.

PHOTOSHOP FOR ARTISTS

5 **Select the Figure.** Switch off the visibility of "Layer 1" texture by clicking off the **Eye** icon on the left of the layer in the Layers palette. Click on the "Background" layer to make it the active layer. Select the **Magic Wand Tool** from the Toolbox and click on the figure to create a selection. You may have to use the **Quick Selection Tool**'s Add to Selection and Subtract from Selection options in the Tool Options Bar. Choose how much of your subject you want to select.

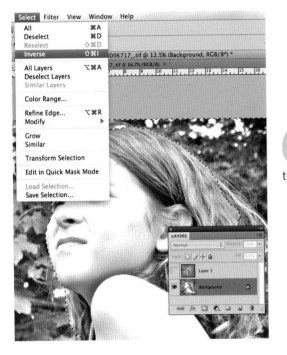

6 **Use Inverse to Select the Background.** With the figure selection still active, from the Select menu choose **Inverse** to select the background instead.

7 **Refine the Edges.** Click on **Refine Edge** in the Tool Options Bar. The default settings in the dialog box (a Radius of 1 pixel, with Smooth at 3, and Feather at 1 pixel) should improve the edge quality, but it is difficult to see the changes to your selection without viewing your subject against a different color background. A thin, black fringe will now be visible around your subject. Remove this fringe by moving the Contract/Expand slider to a value of –65%. Select **OK** to apply these changes to your selection.

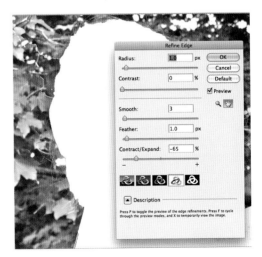

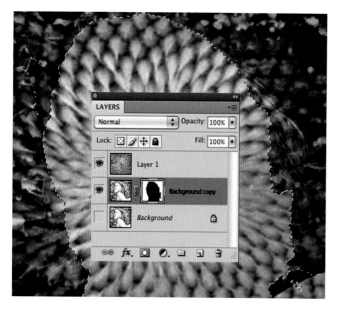

8 Adjust the Background Color by Using a Layer Mask.

Duplicate the "Background" layer [Layer > Duplicate Layer] and hide the visibility of the original background by clicking off the Eye icon in the Layers palette.

Switch back on the visibility of "Layer 1" by clicking on the Eye icon and activating the "Background Copy" layer. Then click on the Add a Layer Mask icon at the bottom of the Layers palette. Hold the Control and Command keys simultaneously and click on the layer mask to load it as a selection. We now have a selection that can be used to adjust the tonality of the background without affecting the subject.

9 Change the Background with Individual Channel Adjustments through Curves.

With the selection active click on the Create a New Fill or Adjustment Layer icon in the Layers palette and choose a Curves New Adjustment layer. Select the Blue channel and click and drag the adjustment point sitting in the bottom left-hand corner of the diagonal line until the value changes. Do the same with the Red and Green channels until you like the color.

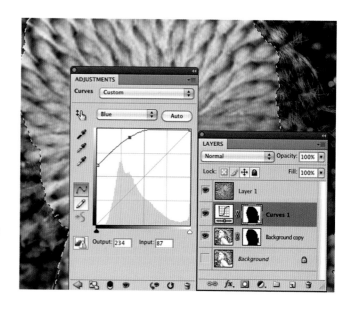

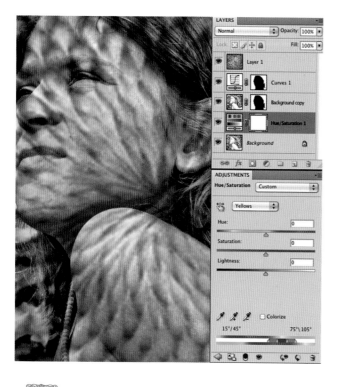

10 Balance the Colors of Both Layers.

Click on the "Background" layer to make it active. All new layers will appear above the active layer. Click the Eye icon back on to make it visible again; then click on the Create a New Fill or Adjustment Layer icon at the bottom of the Layers palette and select Hue/Saturation. Move the Hue and Saturation sliders to the left or right until you like what you see.

11 Darken or Lighten the Background Only.

Finally, use the **Magic Wand Tool** to select the background only. Click on the **Create a New Fill or Adjustment Layer** icon and choose **Curves** from the pull-down menu. Bring that new layer up the layers stack and under "Layer 1." Darken or lighten the tones as needed.

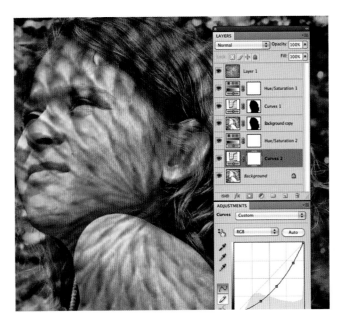

12 Save Your File.

When satisfied, flatten the image [**Layer > Flatten**] and save your file as a TIFF.

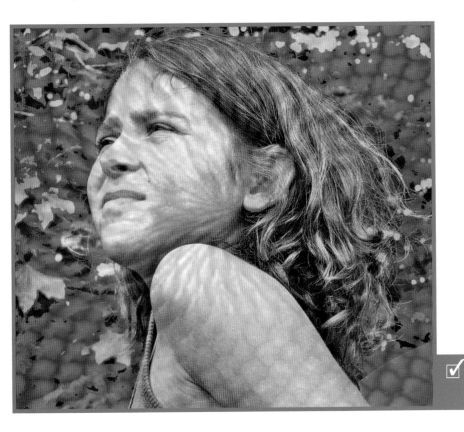

☑ the final

Nora Winn, *Sunflower Kiley*, digital print

Making Creative Photomontages

The art of creating collages and image montages has been around forever. Today, with digital technology, creating a photomontage has become much easier and more powerful than ever. Cutting and pasting are simple tasks. Using Photoshop we can also separate an image from its background with elaborate selective tools, create a digital multiple exposure with blending modes, and use masks and erasers to hide or reveal selections. When composing a photomontage, it is important to understand the method of working with layers, where each element occupies a separate and different space (or layer) above the "Background" layer of an image. Each element can be reworked, moved, or removed—without altering the rest of the image—by simply activating the layer where the particular element sits.

MAKING A PHOTOMONTAGE FROM ONE IMAGE

The first lesson in this tutorial demonstrates how to create a photomontage starting with a single image and using the Pen Tool as a selection tool, blending modes, and the Transform and Distort options. This exercise can be done using your own image.

1 Select Your Image. Janet Millstein started by choosing the photograph she took of a butterfly sitting on a car hood, which was reflecting the sky. Select one of your own photographs featuring a close-up element in an interesting environment.

START IMAGE Janet Millstein, *Butterfly on the Hood*, digital print

2 Use the Pen Tool for Selecting. The Pen Tool
is designed to draw, but it is also useful for making detailed selections.
Janet selected the **Pen Tool** from the Toolbox and the **Paths** option from the
Tool Options Bar. She then started clicking around the butterfly to complete
a path. Clicking creates anchor points that define the path. The more anchor
points created, the more detailed the path and selection will be. In the Paths
window she double-clicked on the words **Work Path** to make it "Path 1" then
she clicked on the small arrow in the upper right of the Paths window to
open the pull-down options and selected **Make Selection**. "Path 1" is now a
detailed selection. Selections can be saved and loaded whenever needed.

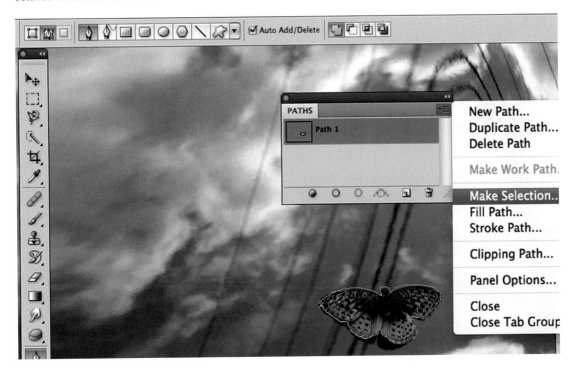

3 Paste the Selection into a
New Layer. With the selection active, Janet
went to the Edit menu and chose **Copy** [Edit > Copy] and
then **Paste** [Edit > Paste] to paste the selection onto a
new layer. (The new layer is automatically created.)

4 **Duplicate and Move Your Selection.** Next, she duplicated the "Butterfly" layer six times [**Layer > Duplicate Layer**], and with each layer active she moved the butterfly around with the Move Tool.

5 **Experiment with the Blend Mode on Each Layer.** She changed the Blend Mode of three of these layers to **Pin Light, Difference,** and **Luminosity**.

PHOTOSHOP FOR ARTISTS

6 Use the Transform Command. From the Edit
menu she chose **Transform** > **Distort** and changed the shape and size
of some of the copied butterflies.

7 Experiment with the Blend Mode Again.
Janet decided to change the Blend Mode of most of the butterflies' layers to **Luminosity**, except for the "Background" layer and the center butterfly.

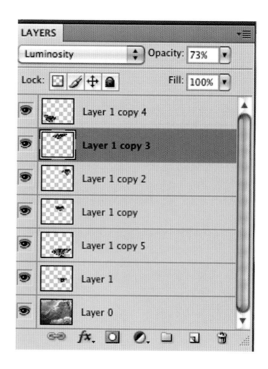

8 Experiment with Diverse Options with the Transform Command.
Activating each appropriate layer, she went back to further **Edit** > **Transform** > **Distort** the background butterflies. She also adjusted the Opacity of each layer.

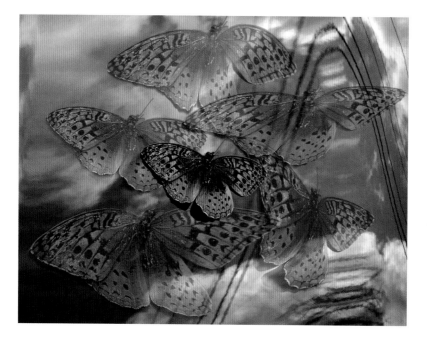

9 Add a Curves Adjustment Layer. After
flattening the image [Layer > Flatten], she added a Curves Adjustment layer to deepen the colors [Layer > New Adjustment Layer > Curves].

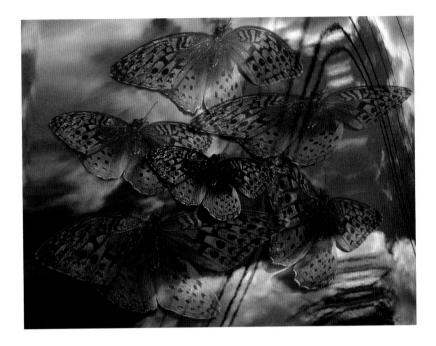

10 Change the Image Mode for Outputting an Image. Finally, Janet changed the image mode to CMYK
and hand printed her image as a photolithograph. See Making Color Separations in Lithography on pages 256–265 for further details on this technique.

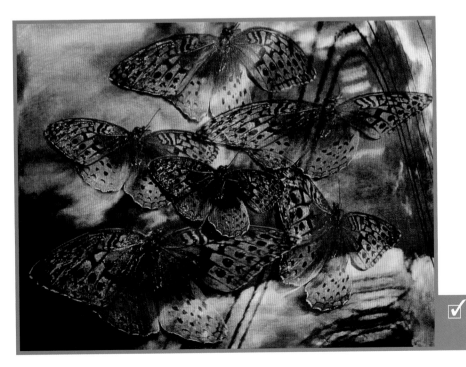

☑ **the final**
Janet Millstein, *Madame Butterfly*,
photolithograph, 22 x 30 inches

MAKING A PHOTOMONTAGE
FROM DIVERSE IMAGES

This time, Janet Millstein chose six different images to compose her photomontage. One main image is a photo of children, another is the main background, and the other four are close-up nature images.

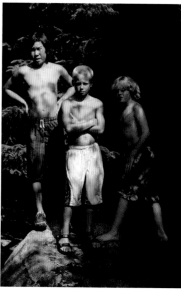

PHOTOSHOP FOR ARTISTS

1 Select and Size Your Images.
Choose a main subject image and a theme for your additional images as a background. Janet started from a blank canvas and copied a landscape on it. From the Image menu go to **Image** > **Image Size** and decide on the Height and Width in inches, depending on your other image sizes. Type **300** for Resolution.

2 Copy Your Subject Image onto the Canvas.
From the Select menu choose **All** and from the Edit menu choose **Copy**. Activate your canvas, and from the Edit menu choose **Paste**. The main background now sits on the canvas.

3 Add a New Component to the Main File.
Select the next element to add to your montage using a selective tool such as the **Pen Tool** set as a path selection or the **Magnetic Lasso Tool** or whichever is more convenient to your image and liking. When your selection is complete, from the Edit menu choose **Copy**. Activate your main file project and from the Edit menu choose **Paste**.

4 Add the Next Element to Your Photomontage and Use the Transform Command.
Select your next element. Try the **Magic Wand Tool** or the **Quick Selection Tool**, depending on what works for your image. Then from the Edit menu, copy and paste the element onto your main file. Janet copied the fern leaf and duplicated it three times via the **Edit > Copy** and **Edit > Paste** commands. She then made three versions of the size of each fern via the **Edit > Transform > Scale** command.

5 Add a Blend Mode and Mask.
The next element needed a change of Blend Mode. Experiment with which Blend Mode works best to reveal all your image's elements. Finally, introduce the subject's image onto an elaborate background with a mask. In our example, the "Flower" layer's Blend Mode was changed to **Overlay**.

6 Examine the Final Result.
The finished work is a powerful and yet harmonious blend of images that Janet assembled in her final photomontage.

✓ **the final**
Janet Millstein,
Wild, digital print,
18 x 30 inches

Changing a Photo from Color to Monochrome

Removing color from an image sometimes gives it a timeless quality. It also emphasizes and highlights the shapes, forms, and patterns within a scene and the interaction between light and shadow.

Not all images are right for black-and-white conversion. You need a subject/scene with strong shapes, textures, or contrasts to start with, as well as a good spread of gray tones throughout the image.

Photoshop offers several methods to convert color to black and white. Some methods are easy and quick with little control, and some techniques are more involved. The main objectives for the latter are to retain as much tonal information as possible, especially in the highlights and shadows, and to be able to fine-tune results with the ability to rework them later.

Open a dramatic color image in Photoshop. I chose this shot I took of trees burnt by sulfur seeping from the ground in Yellowstone National Park.

START IMAGE Sylvie Covey, *Yellowstone National Park*, digital photograph

PHOTOSHOP FOR ARTISTS

CONVERT TO GRAYSCALE

One of the fastest methods is to convert the image to Grayscale mode [**Image > Mode > Grayscale**]. This method records only grayscale values for each pixel. This is an easy and quick way to convert to black and white; however, the whole file will be changed forever, so make sure you first make a duplicate of your original color file. Furthermore, this method does not offer any control or flexibility for editing the grayscale effect. The result is a muted image suited for quick jobs.

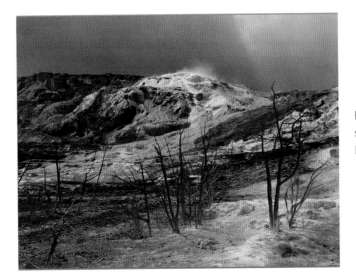

Note: It is still possible to edit the image by selecting **Layer > New Adjustment Layer > Levels** and tweaking with the Histogram sliders.

DESATURATE THE IMAGE

From the Image menu go to **Image > Adjustments > Desaturate**. Photoshop makes the image monochrome by setting each pixel with an equal value of red, green, and blue. Note that the image gets desaturated on the original background layer, not on an added layer. To avoid destroying your original file, make a duplicate layer [**Layer > Duplicate Layer**] before desaturating the copy layer, but, again, there is no control, and it can sometimes generate flat results.

ADD A HUE/SATURATION ADJUSTMENT LAYER

Activate the **Create a New Fill or Adjustment Layer** icon in the Layers palette and choose **Hue/Saturation** from the pull-down menu. In the Hue/Saturation dialog box, drag the Saturation slider to **–100**. There is still no control, and the file stays big with unused color values. However, note that using a Desaturate Adjustment layer allows for creation of color effects by simply lowering the Opacity.

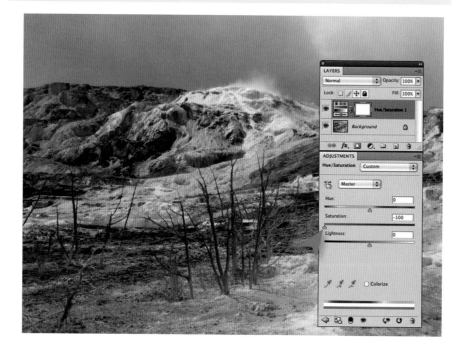

LAB COLOR METHOD

An alternative and better method is to convert to Lab Color. From the Image menu choose **Image > Mode > Lab Color**. Lab Mode records color by assigning each pixel a Luminosity value and adds two color axes values named "A" and "B." These are arbitrary color axes, but they produce higher quality in the separation of shadow and highlights. From the Window menu select **Channels** to open the Channels window [**Window > Channels**] to access the information on the Luminosity channel.

PHOTOSHOP FOR ARTISTS

Monochrome with Lab Color Method

Activate either the A or B channel and drag it to the Layers palette trashcan. The resulting image should be a finer version of black and white than would result from a conversion to Grayscale or Desaturation.

BLACK & WHITE ADJUSTMENTS METHOD

From the Image menu go to **Image** > **Adjustments** > **Black & White** to open the Black and White dialog box. Open the pull-down menu for the Preset options. You can then change the settings and experiment with the different filters.

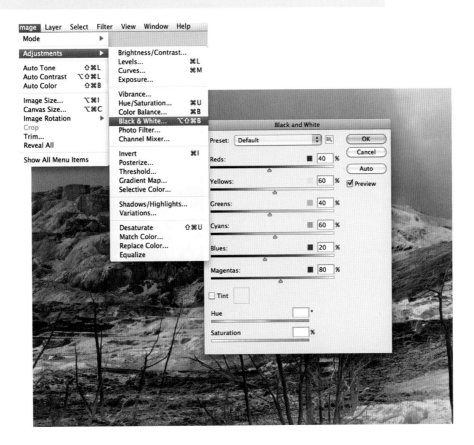

DIGITAL FILTER METHOD

This technique does not destroy the original file and is much more precise and powerful than the previous methods. Here, we use two Hue/Saturation Adjustment layers, one being desaturated and acting as a black-and-white transparency, and the second acting as a lens filter. Adjusting the "Filter" layer's hue and saturation allows for more control and subtlety in the black-and-white tonality.

START IMAGE Sylvie Covey, *Manhattan*, digital photograph

1 **Add a New Adjustment Layer.** Click on the **Create a New Fill or Adjustment Layer** icon in the Layers palette and choose **Hue/Saturation** from the pull-down menu. Change the Blend Mode of this layer to **Color** and rename it "Filter," as this layer now works like a colored-lens filter.

2 **Add a Hue/Saturation Adjustment Layer.** Add another Hue/Saturation Adjustment layer, and in the dialog box drag the Saturation slider to –100. Click **OK** and see the image turn black and white.

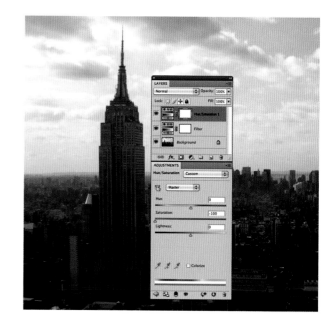

PHOTOSHOP FOR ARTISTS

3 **Experiment.** Activate the "Filter" layer by double-clicking on its icon, and in the Hue/Saturation dialog box experiment with the sliders to improve the tonality of the image. You can also open the Master pull-down menu and try the individual colors in Hue/Saturation.

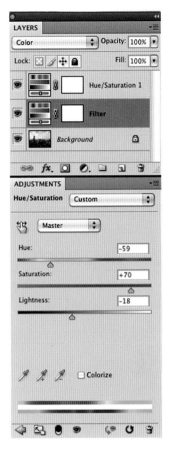

4 **Create and Save the Final Image.** When the image is complete, flatten it and save as a TIFF file to print.

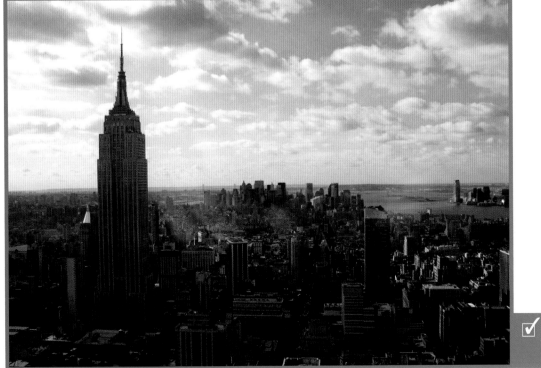

☑ the final

Sylvie Covey, *Manhattan*, black-and-white digital photograph

CHANNEL MIXER METHOD

Many digital photographers find that using a Channel Mixer Adjustment layer along with a monochrome setting is the most precise way to convert a color image to black and white. The Channel Mixer palette works like filters for film photography, in that filters control the amount of light that is recorded on the negative.

The Channel Mixer method allows a separation of tones using digital color filters into a finer black-and-white print. Another important advantage is that this technique is not destructive, unlike the previous methods. Using Channel Mixer does not change the digital file permanently, and it allows for adjustments in the black-and-white conversion after touching up the image, such as changing the contrast or dodging and burning. A record of the filtering is kept so that the same effects can be applied to similar photographs. The file can also be restored to color. The Channel Mixer window can be accessed from **Image** > **Adjustments** > **Channel Mixer**.

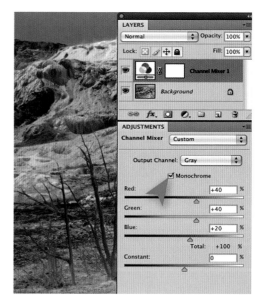

1 Add a Channel Mixer Adjustment. On the Layers palette, click on the **Create New Fill or Adjustment Layer** icon and select the **Channel Mixer** from the drop-down menu. Click on the **Monochrome** box. Make sure the **Preview** box is checked as well.

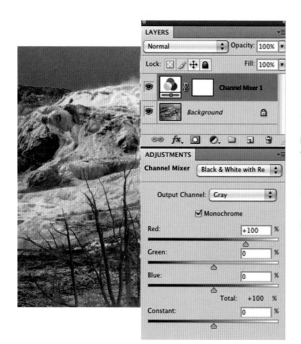

2 Enhance the Image. Tweak the color channels to enhance the respective colors within and add contrast. The most popular channel to use is the Red one, which deepens blue skies and adds impact. Experiment with the effects created by moving each color slider, making sure the total values add up to 100%. Setting the Blue channel to 100% acts like a blue filter and lightens the sky.

PHOTOSHOP FOR ARTISTS

3 **Boost the Contrast.** Finally, add a new Brightness/ Contrast Adjustment layer [**Layer** > **New Adjustment Layer** > **Brightness/Contrast**]. Move the Contrast slider to the right until the desired level of impact is achieved. Then from the Layer menu click on **Flatten** to merge your layers. Save your work as a TIFF file.

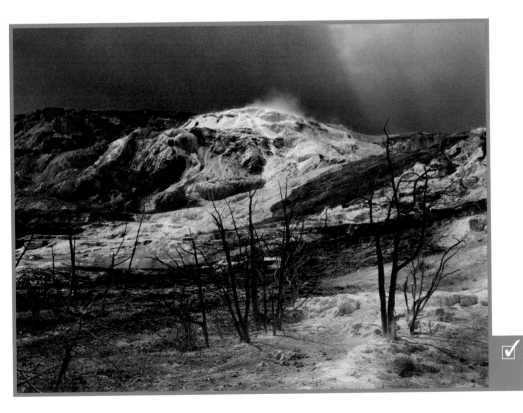

✓ the final
Sylvie Covey, *Yellowstone*, black-and-white digital photograph

Adding Sepia and Other Tones

For many photographers, sepia toning symbolizes the passage of time, as we see it in an aging and discolored image. Darkroom photographers used different chemical toners such as selenium, thiocarbamine, and gold to enhance a print's look. Today, with Photoshop we can change a color or a black-and-white photo into a sepia-toned image to create a genuine antique look, and tone an image with two or more different color tints as duotones to create a special atmosphere.

COLOR TO SEPIA TONING WITH COLOR BALANCE

Desaturating a color image and experimenting with the Color Balance sliders is one of the simplest methods of achieving an attractive, aged look in your photos.

START IMAGE Sylvie Covey, *Flower Girl and Bridesmaids*, digital photograph

1 Select Your Image. Open a color image in Photoshop that you would like to render sepia. From the Image menu go to **Image > Adjustments > Desaturate**.

Note: We use the Desaturate command rather than converting to Grayscale mode in order to stay in the RGB Color mode, which is necessary to use the Color Balance Tool.

2 Add a Color Balance Adjustment Layer. Click
on **Layer** > **Duplicate Layer**; then with the new
layer selected go to **Image** > **Adjustments** >
Color Balance.

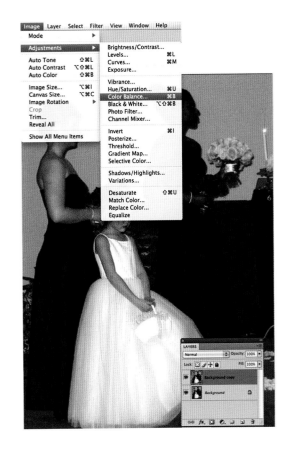

3 Adjust the Midtones. In the
Color Balance window select the **Midtones** and
click on **Preserve Luminosity**. Move the Yellow/Blue
slider toward the yellow end. Move the Cyan/Red slider
toward red to inject a browner hue. Increase the effect
by repeating this process with the highlights.

4 Adjust the Opacity and Save Your File. You can tone down
the effect by reducing the Opacity of the duplicate
layer. Then flatten the image and save it as a TIFF file.

✓ the final
Sylvie Covey, *Flower Girl and
Bridesmaids*, digital photograph

BLACK AND WHITE TO SEPIA TONING WITH CURVES

This alternative method works well to tone a black-and-white or a color image with warm sepia using a Curves Adjustment layer.

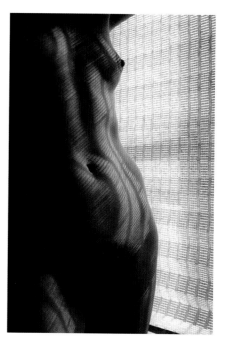

1 Select an Image and Put It in RGB Color Mode.
Open a black-and-white image in Photoshop, or desaturate a color image. From the Image menu go to **Image > Mode** and check **RGB Color**. We want to be in RGB mode and not in Grayscale mode. Here, I selected a beautiful image of a nude woman by French photographer Marc Picot.

START IMAGE Marc Picot, *341–19–19*, photograph

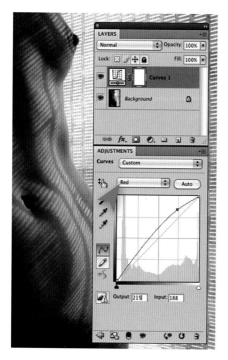

2 Add a Curves Adjustment Layer.
From the Layer menu go to **Layer > New Adjustment Layer > Curves**. You can also access it from the **Create a New Fill or Adjustment Layer** icon in the Layers palette.

In the Curves palette we can now add or subtract tone. Select the Red channel and type a value of around **188** in the Input box, and around **215** in the Output box. You can also use the sliders if you prefer.

3 **Change the Channel.** Then select the Blue channel and drag the curve toward the right with an Input value of around **42** to create a sepia tone.

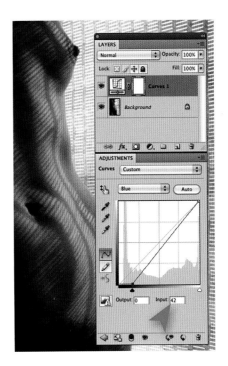

4 **Finalize the Sepia Tone.** There is no need to adjust the Green channel for a sepia tone, so click **OK** to apply the Curves Adjustment layer. We now have an antique, warm sepia-toned image.

☑ the final

Sylvie Covey, *Sepia Nude* (from an original Marc Picot photograph), digital photograph, 12 x 8 inches

CREATING DUOTONES

Every photographer is tempted at one point or another to tone her or his photographs, because simply put, color toning brings one's imagery from real to surreal. In film photography, the traditional toning process might render interesting colors, but apart from the risks involved with working with the toxic chemical selenium in a darkroom, it also reduces the dynamic range of an image.

In our new digital world, however, duotones, tritones, and quadtones simulate the separate inks of a printing press. The range of color toning and color combinations is unlimited, as is the control we can exercise over the effects rendered. Our darkroom skills have changed for a new set of digital options.

1 **Select Your Image.** To create a duotone, open an image in Photoshop and convert it to Grayscale [**Image > Mode > Grayscale**]. Here is another lovely image of a nude woman by photographer Marc Picot, "Danielle."

2 **Open the Duotone Window.** From the Image menu go to **Image > Mode > Duotone** to open the Duotone Options window. Make sure the **Preview** box is checked so that you can monitor the changes on your original photo. Choose **Duotone** in the Type options.

START IMAGE Marc Picot, *Danielle*, black-and-white photograph

3 **Select the Duotone Colors.** Double-click on each of the Ink box swatches and use the Color Picker to select your chosen hue. The top color should be the darker tone, while the subsequent color should be lighter.

4 Open the Color Libraries. For
a more precise color choice, Photoshop also offers color libraries with numerous lists of shades. Choose **Color Libraries** from the Select Ink Color window to select from the libraries. Click on different shades of an opened library and watch your preview image change color.

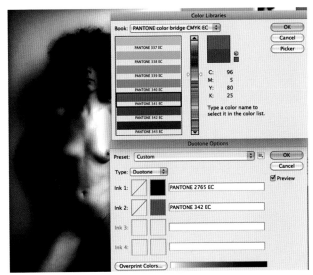

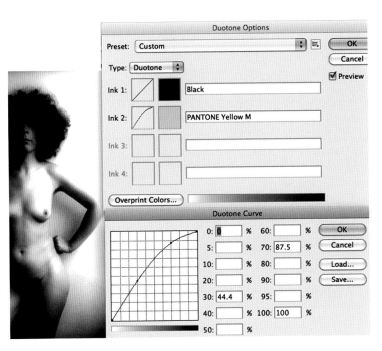

5 Manipulate the Colors.
You can manipulate each color independently with the Curve button on the left of the color swatch to adjust the range of tones and their densities. Simply click on the **Curve** button to open the Duotone Curve window and gently drag the curve up or down to adjust the density with which the colors will be applied to the tonal values selected. Click **OK** to apply the curve.

6 Experiment with Tritone and Quadtone.
You can also experiment with Tritone and Quadtone using the same method from the Type option in the Duotone Options window. The range of color combinations is almost infinite, so when you find color combinations you like you might want to save your duotone or tritone image in a PSD format. When finished, save as a TIFF file for print.

☑ the final
Sylvie Covey, *Danielle* (from an original Marc Picot photograph), digital photograph, 12 x 8 inches

Split Toning

Split-tone is similar to duotone but more advanced, as split toning an image involves toning with more than one tone in the highlights, midtones, and shadows. Usually, choices of colors are determined by the characteristics of warmth versus cold, such as sepia and dark blue.

In this tutorial we will use a portrait photo to replace colors with two types of tones. This technique can be used with any image, but it is especially flattering on skin tones, adding an extra touch of warmth, color, and atmosphere. The photo is toned twice, first the highlights with one color, then the shadows with another. The midtones take a blend of both.

The first split-toning technique described in this tutorial can be achieved with any version of Photoshop. The second split-toning technique uses Adobe Camera Raw, which requires a CS3 version of Photoshop or higher.

EXAMPLE Sylvie Covey, *Portrait of Youth*, digital print, 40 x 30 inches

SPLIT TONING WITH COLOR BALANCE

In this method we are going to replicate a sepia highlight with a blue shadow split-tone effect using a Color Balance Adjustment layer and a Layer Style blending option.

1 Select Your Image.

Open a close-up color photo portrait in Photoshop.

START IMAGE Sylvie Covey, *Happy Couple*, digital photograph

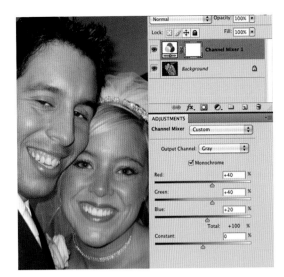

2 Change It to Monochrome.

In order to change the image into a sepia tone, we first need to create a black-and-white layer. From the Layer menu choose **Layer > New Adjustment Layer > Channel Mixer** and check on the **Monochrome** box.

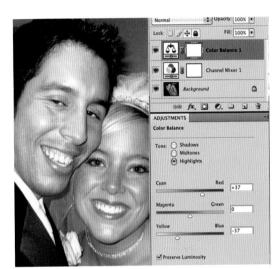

3 Add a Color Balance Adjustment Layer.

In the Layer window click on the **Create a New Fill or Adjustment Layer** icon and select **Color Balance** from the drop-down list. In the Color Balance dialog box select the **Highlights** tone and move the Cyan/Red slider toward the red end, and the Yellow/Blue slider toward the yellow end, until the skin color is warm sepia.

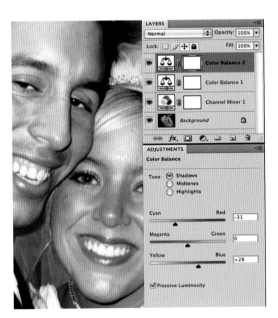

4 Add Another Color Balance Adjustment Layer.

To create some cooler tones, create a new Color Balance Adjustment layer and select the **Shadows** tone in the Color Balance dialog box. Move the Cyan/Red slider toward the cyan end and the Yellow/Blue slider toward the blue end. The shadows have now taken a cool, blue tone.

5 Use the Layer Style Blending Options.

The tones so far are sitting on top of one another, but they are not really split yet. To achieve a split-tone, the blending mode must be adjusted. Choose the **Midtones** in the Color Balance Adjustment layer window. Double-click on the **Highlights** layer to open that Layer Style window. You can also right-click on it and choose **Blending Options** to open the Layer Style window.

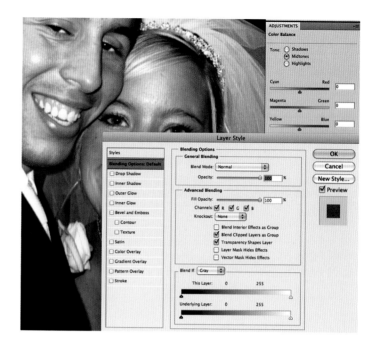

6 Split the Tones.

In the Blend If section, there is a black triangle under the This Layer slider. Move that triangle toward the right to give it a value of about **60**. As a result, the blue tone shows with a sharper edge, and the pixels of that current layer with a value below 60 will not show. The blend value of 60 is a range of values that will smooth out transitions between the sepia and blue tones.

Hold down the **Alt/Option** key and click on the right part of the black triangle to split it open. Drag the half triangle to a value of about **200** and notice how the edges of the tones get smoother.

PHOTOSHOP FOR ARTISTS

7 Examine the Split-toned Result.

The result is a split-toned image with deeper and smoother transitional values.

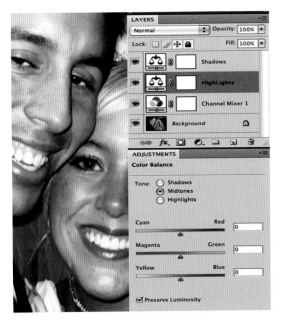

8 Add Final Touches.

To adjust the strength of the colors, from the Layer menu choose **New Adjustment Layer > Hue/Saturation** and adjust the Saturation slider to strengthen or weaken the hues. You can also add a Brightness/Contrast Adjustment layer if you feel it is needed.

☑ the final

Sylvie Covey, *Happy Couple*, split-toned digital photograph, 8 x 10 inches

SPLIT TONING USING ADOBE CAMERA RAW

A Camera Raw file is created in a digital camera and contains all the pixel information with no compression. Many digital cameras can save images in Raw format. Shooting in Raw format has the advantage of enabling the photographer, rather than the camera, to make adjustments and conversions. By comparison, shooting in JPEG format locks the adjustments into the camera's settings.

In Camera Raw the camera does not do any image processing. The file is downloaded into a computer and Photoshop is used to set the tonal range, color saturation, white balance, contrast, and sharpening. Raw files are like original negatives in film photography, files that can be reprocessed with Photoshop anytime we want.

Both Adobe Bridge and Photoshop CS3, and higher versions, let you open and process Raw files. You can also process multiple images by processing one and then applying the settings to all other chosen shots.

In this technique we can start from either a TIFF, JPEG, or Raw image file. In contrast with creating a split-tone with Photoshop alone, using the tools of Camera Raw is easy and gives you better control over the distribution of colors. This method of split toning offers limitless color combinations, with the finishing touch of a vignette effect.

1 Select Your Original Image.
Open the original photo portrait in Photoshop and from the Image menu choose **Image > Adjustments > Black & White**. Save it as a black-and-white portrait and close the file. Now from the File menu go to **Browse in Bridge**.

Note: Adobe Bridge is a file browser (introduced in CS2) that can be accessed via the other Creative Suite applications. Bridge allows you to preview, adjust, and process multiple Raw files at once. Bridge can run independently from Photoshop as a stand-alone application. I find Bridge very useful to see all of my files as images rather than icons.

In Bridge, navigate to the folder containing the black-and-white portrait. From the File menu choose **Open in Camera Raw.**

PHOTOSHOP FOR ARTISTS

2 Use Camera Raw. In
the Camera Raw window locate the
Histogram, and below it find the Split Toning
icon. Click on the **Split Toning** icon to open
its window.

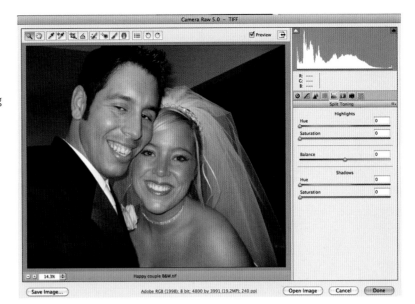

3 Adjust the Saturation
Sliders. This section shows two distinct
areas, one for the Highlights and the other for the
Shadows. Set the Saturation sliders for both Highlights
and Shadows at around **30%**.

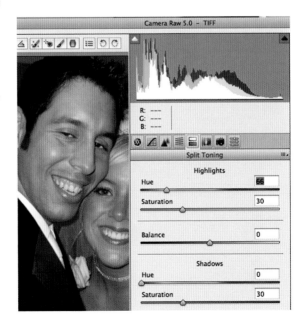

4 Adjust the Hue Slider. For now,
the color tint is the same for both the highlights
and shadows. Grab the Hue slider in the Highlights
section and drag it to change the color. Notice how
the sliders point to show the current color.

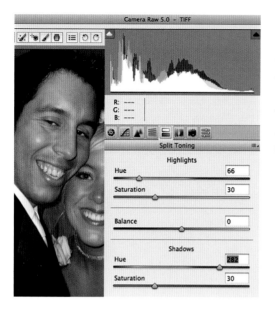

5 Choose Your Colors. Choose a different color in the Shadows section by dragging the Hue slider. Find a darker color for the shadows and a brighter color for the highlights. It is preferable to choose two opposites, such as a warm and a cold color, to achieve a successful split-toned image. Experiment with different combinations.

6 Use the Balance Slider. Adjust the Saturation sliders for each color. It is preferable to saturate the shadows more than the highlights. Dragging the Saturation slider to the right will increase the color; dragging to the left will have the opposite effect. The Balance slider is useful for fine-tuning these adjustments.

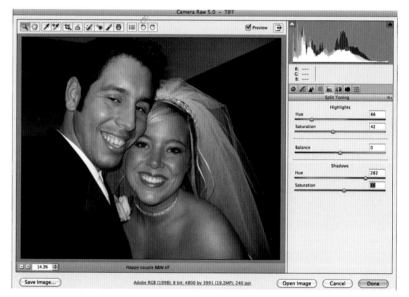

7 Add a Vignette. To add a vignette effect, find the Lens Correction icon under the Histogram of the Camera Raw window. Experiment with the Lens Vignetting Amount and Midpoint by dragging their sliders. Notice how the Amount slider goes from dark to light. Experiment also with the Post Crop Vignetting sliders to achieve either a light or dark vignette. When you are satisfied click **Open Image** at the bottom of the image.

PHOTOSHOP FOR ARTISTS

8 **Add Contrast.** Click on the **Photoshop Application** icon on your computer screen. Back in the Photoshop workspace go to **Image** > **Adjustments** > **Curves** and create a very shallow S-shape on the Curves line to add a slight contrast to your finished image.

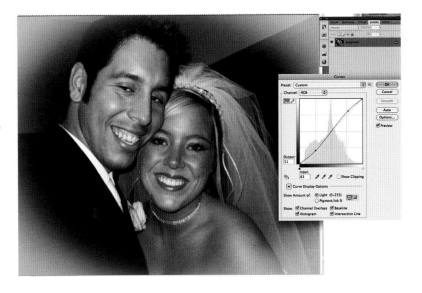

9 **Save Your File.** Save your finished split-toned image.

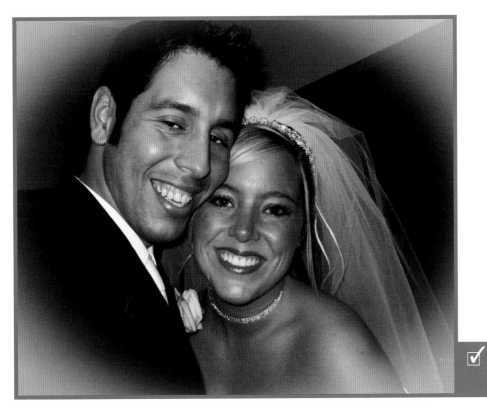

✓ the final
Sylvie Covey, *Special Day*, digital photograph, 8 x 10 inches

Solarization

Solarization refers to a partly reversed image, sometimes with mackie lines around high-contrast areas. The reversal of the image tone is due to extreme exposure, with lighter parts going dark but shadows and midtones remaining unchanged. This technique is known as the Sabattier Effect and was invented by French photographer Armand Sabattier, 70 years before American photographer Man Ray made it popular in the 1920s. The Sabattier Effect occurs when a normally exposed print is exposed to a more concentrated light midway during its development.

Armand Sabattier discovered that when a partially developed print is exposed to strong light, the tonalities reverse because the developed areas are desensitized, but the relatively undeveloped areas can be developed further. A silvery gray tone results, with a white line around linear areas in the image.

A variation of density related to the size of the area being developed also occurs and is known as the Eberhard Effect.

The great photographer Man Ray did a variation of the Sabattier Effect by continuing to develop a print that was accidentally exposed to light, resulting in a combination of positive and negative image. Consequently he used that technique of flashing photographic paper while it was still in the developing tray to create many of his abstract photographs.

Fortunately for us, today there are many ways to simulate the Sabattier Effect with Adobe Photoshop.

SOLARIZATION FROM A COLOR IMAGE USING A FILTER

Photoshop offers various ways to solarize an image, and when using a color image the simplest way is to use a filter. In this method I used a Solarize filter and added a Curves Adjustment layer.

1 **Select Your Image.** First open an image in Photoshop; it can be in RGB Color or any Image Mode. I chose this image of a lighthouse from northern California.

START IMAGE Sylvie Covey, *Lighthouse*, digital photograph

2 Use a Stylize Filter.

In the Filter menu choose **Filter > Stylize > Solarize**. This filter does a straight conversion. Note that the filter does not allow much room to create.

3 Adjust the Setting and Blending Mode.

However, you can reduce the effect of this filter or change its blending mode by going to **Edit > Fade Solarize**. In this instance I faded my Solarize filter to **85%** and chose a **Hard Light** Mode for my image.

4 Try a Curves Adjustment Layer.

Another simple technique for a color-solarized image is to add a Curves Adjustment layer and to fine-tune it later. (See the following exercise for more details on Curves.) From the Image menu go to **Image > Adjustments > Curves**. In the Curves window anchor some points on the Curves line and make some broad Curves moves. Watch the Preview window to follow the changes made by the Curves.

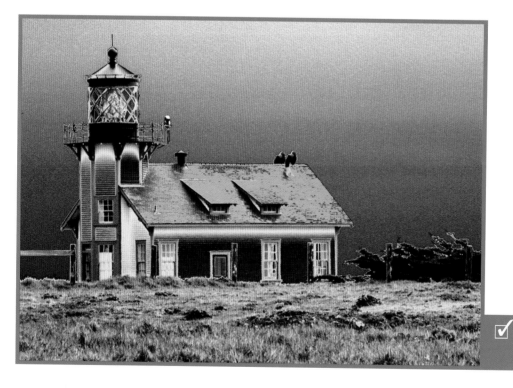

☑ **the final**

Sylvie Covey, *Lighthouse,* solarized digital photograph

PHOTOSHOP FOR ARTISTS

SOLARIZATION FROM A GRAYSCALE IMAGE USING MULTIPLE LAYERS, CURVES, AND BLENDING MODES

This method uses multiple layers and as a result gives much more flexibility and artistic control for achieving the solarization effect. The better effects result from adjusting each layer differently. Notice that using Image > Adjustments > Invert produces an effect similar to using a paper negative in film photography.

1 **Start with Grayscale.** First convert your color image to Grayscale. From the Image menu go to **Image > Mode > Grayscale**.

From the Window menu check on **Layer** to open the Layers window, then duplicate the background [**Layer > Duplicate Layer**].

2 **Use the Invert Option.** Now invert the "Background Copy" layer. With that layer activated, from the Image menu go to **Image > Adjustments > Invert**.

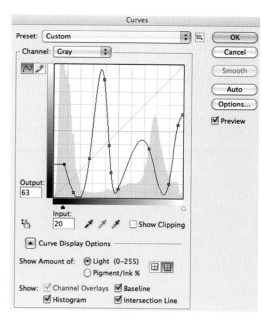

3 **Use the Curves Command.** Adjust the tones with Curves. From the Image menu go to **Image > Adjustments > Curves**. You can also create a new Curves Adjustment layer by clicking on the **black-and-white Cookie** icon in the Layers window and choose **Curves** from the pull-down menu.

4 **Create Contrast with Curves.** Once you have opened the Curves window you will notice in the dialog box a graph with a diagonal line crossing it from bottom left to top right. This represents input and output brightness. The vertical grading scale controls shadows and light from bottom to top of the graph image, and the horizontal grading scale controls it from left to right. There are also three Eyedropper icons for each of these settings. Press the **Control** and **Command** keys and click on the image with each Eyedropper icon to see its brightness value displayed in the graph, from black to gray to white values.

For my inverted image I added contrast by shaping the Curves into an S shape that boosts the highlights as it does the shadows.

PHOTOSHOP FOR ARTISTS

5 Change the Blend Mode on a Background Duplicate Layer.

Duplicate the original background again by activating the "Background" layer and going to **Layer** > **Duplicate Layer**.

In the Layers window move that layer ("Background Copy 2") to the top of the layers stack. Change the Blend Mode of that top layer to **Difference**.

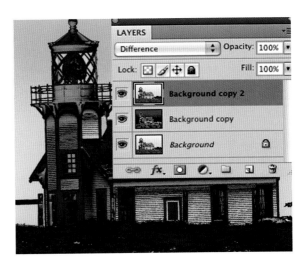

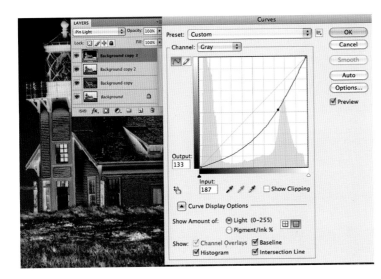

6 Add More Duplicates, Blend Modes, and Curves.

Duplicate the original background again, change the Blend Mode of the "Background Copy 3" layer to **Pin Light**, and bring it to the top of the layers stack.

Invert the "Background Copy 3" layer [**Image** > **Adjustments** > **Invert**].

Starting from the bottom to the top, adjust each layer with Curves.

7 Save Your File. When you like the result, flatten the image and save it as a TIFF file to print. You now have a refined solarized black-and-white image.

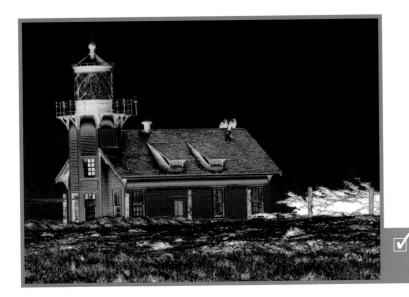

SOLARIZATION USING CURVES WITH NUMERICAL INPUT AND OUTPUT SETTINGS

This method is useful if you wish to save your specific Curves settings to use them with a number of other similar images. Start with a black-and-white image. It can be RGB Color, Grayscale, or any image mode. I chose this photo of a pond I shot in Upstate New York.

1 Select Your Image and Create a Curves Adjustment Layer.
From the Layer menu choose **Layer > New Adjustment Layer > Curves**. The Curves dialog box allows precise control over how the pixels values are outputted. Click the bottom left of the Curves line and drag it to the top of the vertical axis. The result will be that all pixels are outputted with a brightness of 255. The image should now appear white.

START IMAGE Sylvie Covey, *Reflective Pond*, digital photograph

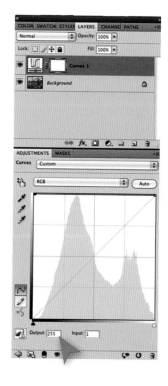

PHOTOSHOP FOR ARTISTS

2 Input and Output Settings.
Click the middle of the Curves line and drag
it downward so that it resembles a V shape. The
image almost turns negative but its highlights are still
brighter than the midtones. Save the input and output
settings in the Curves dialog box.

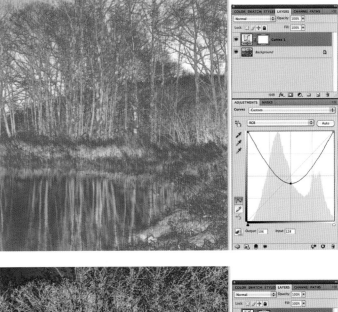

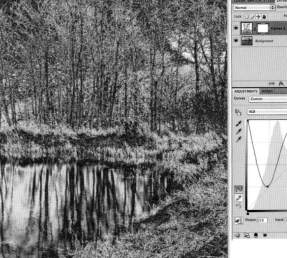

3 Experiment with the Curves Line.
Click and drag two
more areas on the Curves to make it a W shape.
Experiment with different settings of the Curves line.
The steeper the W shape, the more contrast you
add to your image. Again, save the input and output
settings in the Curves dialog box. You can use those
settings with other similar images.

4 Save Your File.
When you are
satisfied with the effect, click **OK**.
Flatten and save your image as a TIFF file.

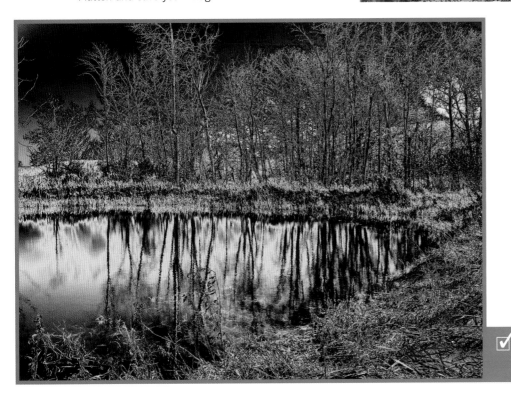

☑ **the final**
Sylvie Covey, *Reflective Pond
Solarized*, digital photograph

Adding HDR Effect

High Dynamic Range (HDR) photography is a method of creating images of a dreamscape appearance with extra-sharp details and rich, vibrant colors. High Dynamic Range is a photographic technique often used to shoot at night or in low-light conditions. Through a culmination of shooting the same scene with different exposures and with image-editing skills, all of the details at either end of the light spectrum can be maintained, without the occurrence of grain or loss of information in the shadows. The most dramatic results using HDR often occur from scenery with a large contrast between lights and shadows.

Shooting film with High Dynamic Range requires a tripod and an elaborate setup. However, with Photoshop we can re-create a High Dynamic Range effect digitally from a single image and deeply enhance our photographs.

HDR EFFECT ON A SINGLE SHOT PHOTOGRAPH

The traditional method of creating HDR requires several shots of different exposures of the same image. This basic method allows you to achieve the same effect with a single shot. It is recommended that you shoot Raw files with the proper exposure to capture as much shadow detail as possible. Use the in-camera noise reduction features, if they are available. Here is an example of a HDR digital photograph by Bert G. F. Shankman.

This example is special because this artist uses the High Dynamic Range technique in his own way. Below is Bert G. F. Shankman's partial description of his technique:

In Photoshop I worked out a procedure to combine all the exposures of a composition into a single file. After dragging each one of the exposures into a master file, thereby becoming a layer, I applied a mask. This was similar to applying a resist in watercolor painting with which I was familiar. I would paint out all the parts of each exposure, leaving only what I wanted. This gave me clear (i.e., focus) where I wanted it—softer in other places—opened up (lighter) shadows where I felt it was needed, and prevented overexposure where I might lose information.

. . . While I would commonly spend two or three hours, and as much as twenty, doing this manually, today there are several programs which will do this in a minute or two. Currently, my favorite is Zerene. Exposure balancing, as I did it then, had no name, but today is called HDR.

EXAMPLE Bert G. F. Shankman, *Spinoza*, manual HDR photograph from a digital Nikon D200

HDR EFFECTS WITH BLEND MODES AND FILTERS

This method is very effective for creating images with vibrant and rich colors, particularly in photographs shot at dawn or at night. The use of blending modes and filters transforms a dull or dark image into a sharp and brilliant composition.

1 Select and Invert Your Image. Open a scenic photograph in Photoshop. I chose a night shot taken from the Bellagio Hotel in Las Vegas.

START IMAGE Sylvie Covey, *Bellagio*, digital photograph

Duplicate the "Background" layer [**Layer** > **Duplicate Layer**]. With the new layer active, go to **Image** > **Adjustments** > **Desaturate** from the Image menu. Then go to **Image** > **Adjustments** > **Invert** to invert the layer.

2 Use a Gaussian Blur Filter and a Blend Mode.
Apply a Gaussian Blur filter of **12 pixels** to that layer [**Filter > Blur > Gaussian Blur**]. In the Layer window set the Blend Mode to **Overlay** and the Opacity to **75%**.

These steps generate a very basic HDR image. You can see the difference by clicking on and off the visibility of the "Background" layer.

3 Sharpen the Image.
Make another copy of the original "Background" layer [**Layer > Duplicate Layer**], name it "High Pass," and move it to the top of the layers stack. Go to **Filters > Sharpen > Unsharp Mask** and adjust the sliders to reveal an extreme amount of detail in the image. I set the Amount to **25%**, the Radius to **9.7 pixels**, and the Threshold to **5 levels.**

PHOTOSHOP FOR ARTISTS

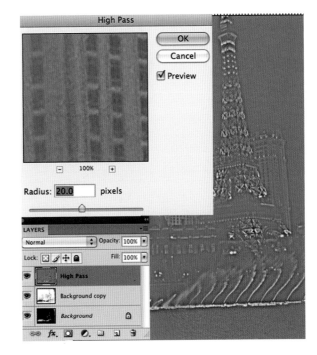

4 **Add More Details.** From the Filter menu go to **Other > High Pass**. Adjust the slider until the image details are crisp, but have a soft glow around them (with an approximate Radius of **20** pixels). Set this layer's Blend Mode to **Hard Light**.

5 **Add Final Touches.** Finally, duplicate the "High Pass" layer and move it to the top. Set the Blend Mode to **Hard Light** and reduce the opacity accordingly for the image.

☑ the final

Sylvie Covey, *Bellagio*, HDR digital photograph, 8 x 12 inches

HDR EFFECT WITH ADJUSTMENT LAYERS

In this third method the use of the High Pass filter with an Overlay Blend Mode allows extremely sharp details to show, and several Adjustment layers create the vibrant and otherworldly colors of this effect.

1 **Select Your Image.** Open a scenic image in Photoshop. I shot this one in Bryce Canyon, Utah.

START IMAGE Sylvie Covey, *Bryce Canyon*, digital mural print

2 Adjust the Shadows and Highlights.

Duplicate the "Background" layer [Layer > Duplicate Layer] and from the Image menu go to **Image > Adjustments > Shadows/Highlights**. In the Shadows/Highlights dialog window, check the **Show More Options** box. In the Shadows section, set the Amount to **100%**, the Tonal Width to **50%**, and the Radius to **35 pixels**. In the Highlights section, set the Amount to **25%**, the Tonal Width to **50%**, and the Radius to **30 pixels**. In the Adjustments section leave the Color Correction set at **+20** and set the Midtone Contrast to **0**.

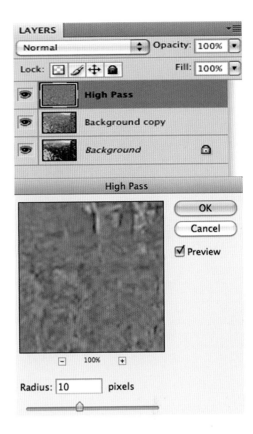

3 Add a High Pass Filter.

Duplicate the "Shadows/Highlights" layer [Layer > Duplicate Layer] and rename it "High Pass." From the Filter menu choose **Filter > Other > High Pass** and set the Radius to **10 pixels**. In the Layers palette open the Blend Mode's list and choose **Overlay**.

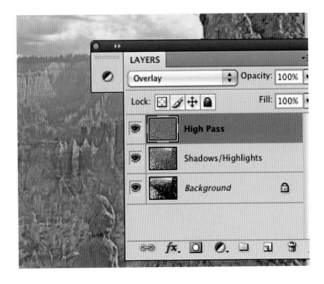

4 Add Vibrancy Settings.
Click on the **Create a New Fill or Adjustment Layer** icon in the Layers palette and from the Adjustments pull-down menu choose **Vibrance**. In the Vibrance dialog box, set the Vibrance to **50** and the Saturation to **15**.

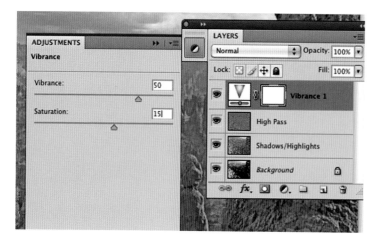

5 Add a Hue/Saturation Adjustment Layer.
Click on the **Create a New Fill or Adjustment Layer** icon again and this time select **Hue/Saturation** from the Adjustments pull-down menu. Select various colors from the Adjustments panel pull-down menu and make necessary color adjustments.

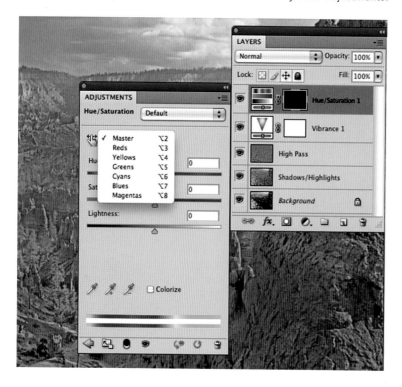

PHOTOSHOP FOR ARTISTS

6 Add Final Touches for Sharpening. Finally,
to add and sharpen the details, duplicate the "High Pass" layer and
drag it to the top of the layers stack. Change the Blend Mode of the duplicate
to Vivid Light.

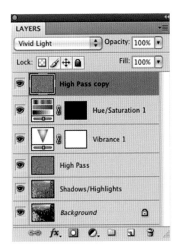

7 Save Your HDR File. The result is
a sharpened and detailed highlighted image. Save
it as a PDF file and as a TIFF file after flattening.

✓ **the final**
Sylvie Covey, *Bryce Canyon*,
HDR digital print

Replacing Color

There are three main ways of replacing color in Photoshop. The first is to use the Color Replacement Tool. The second is to use the Replace Color command, which is useful for changing a specific color or a range of colors in an image. These two methods use a semiautomated selection based around a chosen color that lets you manipulate that color. The third method offers more control, as it involves making a careful selection of the object using the Quick Selection Tool, the Magnetic Lasso Tool, or the Pen Tool as a selective path. An image Adjustment layer such as Color Balance, Levels, Curves, or Hue/Saturation is then used to alter the color of the selection.

In this tutorial the choice of method depends largely on the image and its context. A subject with complex edges, where the color is very distinct from its surroundings, is best suited for use with the Photoshop semiautomated tools from the first and second methods. By comparison, if the subject's distinction from its background is not clear and if the contrasts of the edges are low, color changes will bleed in areas they should not. Cleaning up would take as much time as making a careful manual selection, so choosing the third manual method would be appropriate.

REPLACING COLOR WITH THE COLOR REPLACEMENT TOOL

In this first method the Color Replacement Tool brush makes a semiautomated selection based around a specific color that can then be manipulated.

1 Select Your Image. Open an image in Photoshop with a well-defined subject that is distinct from its surroundings. I chose this photo of a large moth I took on the door of my front porch.

START IMAGE Sylvie Covey, *Big Moth*, digital print

2 Choose the Color Replacement Tool's Settings.
From the Layer menu choose **Duplicate Layer** to duplicate the "Background," and from the toolbox choose the **Color Replacement Tool**. (It is paired with the Brush Tool and Pencil Tool.)

Note: The Tolerance (in the Tool Options Bar) is very important when using the Color Replacement Tool. A low tolerance value will only replace color that is very similar. In order to replace a wider range of color from either side of the original color, you must increase the Tolerance setting.

You now have a choice of replacing a color with another color in your image by sampling it and pressing the **Alt/Option** key, or by selecting a new color via the Color palette.

Select a color with the **Color Replacement Tool** and make sure that in the Tool Options Bar the Mode is set to **Color**, the Limits is set to **Contiguous**, and the **Sampling Once** icon (the second of three Eyedropper icons) is selected. These settings will give you more control in preventing color spilling.

Note: If you choose Sampling Once in the Tool Options Bar, the tool will replace only the color that was directly below it in the image at the start of the stroke. Only that single color will be replaced until you stop painting. If you choose the option Sampling Continuous, the color below it will be replaced at any point within your stroke.

3 Set the Brush Preset Picker Settings.
In the Tool Options Bar click on the arrow next to the brush to open the Brush Preset Picker and make sure the Size is set to **Off** instead of Pen Pressure or Stylus Wheel.

4 Replace the Color.
Now start painting over the color you wish to replace. In this example I painted the color red over with blue. By using the Sampling Once mode, all subsequent guesswork by Photoshop will be done where you first click.

Notice how the Color Replacement Tool does not cover all the red; it leaves some areas untouched. You can alter the Tolerance in the Tool Options Bar to adjust the color replacement as desired.

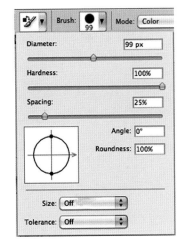

the final
Sylvie Covey, *Moth I*, digital print, 16 x 24 inches

REPLACING COLOR WITH THE REPLACE COLOR COMMAND

This second method works on selections that can be added and subtracted with an Eyedropper Tool from the Replace Color window. Furthermore, the hue, saturation, and lightness of colors are changed by moving sliders, rather than choosing a new color and painting with a brush.

1 **Select Your Image.** Open your start image again and duplicate the "Background" layer [**Layer** > **Duplicate Layer**]. With that duplicate "Background" layer active go to **Image** > **Adjustments** > **Replace Color**.

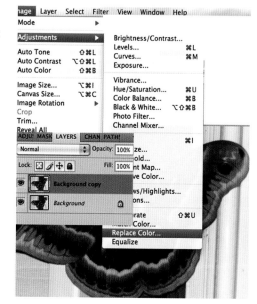

2 **Add or Subtract a Selection.** Check on **Selection** in the Replace Color dialog box. The Eyedropper tools and the Fuzziness slider will determine the area and the amount of color to be replaced. Use the Eyedropper Tool to select an area of the image in the Monochrome preview box. The more you click with the Add to Sample Eyedropper Tool, the more color will be replaced in that area. Also try the Subtract from Sample Eyedropper Tool to reduce the effect of color replacement.

3 **Change the Color Settings.** Once the color areas to be replaced are shown in the Monochrome preview box, move the **Hue, Saturation,** and **Lightness** sliders to choose the replacement color and watch your image change accordingly. If the selection does not look good, simply move the **Fuzziness** slider or use the **Add to Sample Eyedropper Tool** or the **Subtract from Sample Eyedropper Tool** to add or subtract on your selection.

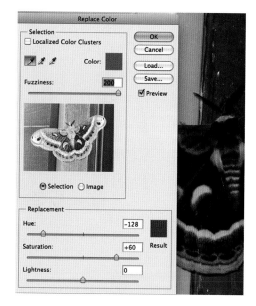

4 Select with the Lasso Tool. You can also
select areas of an image with the Lasso Tool and then replace
the colors. Select the regular **Lasso Tool** from the Toolbox. Make a
rough selection with it; then go to **Image** > **Adjustments** > **Replace
Color.** Move the **Hue** and **Saturation** sliders and tweak the **Fuzziness**
slider to replace color.

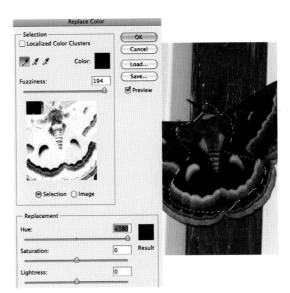

5 Select and Replace More Colors.
Select another area with the **Lasso Tool** and repeat the
Replace Color process using different hues.

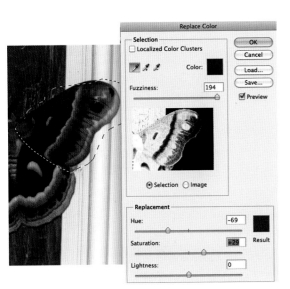

6 Save Your File. The result is an image where the original
color has been replaced with multicolored areas.

☑ the final
Sylvie Covey, *Moth 2*, digital print, 16 x 24 inches

REPLACING COLOR MANUALLY USING ADJUSTMENT LAYERS

This third method demands a careful selection of an area using any selection tool of your choice, depending on your image, followed by the use of an Adjustment layer to replace the color. Remember that the most detailed way of selecting is to use the Pen Tool as a path.

1 Select Your Image. Open an image in Photoshop. I chose a photograph of a house in Northern California.

START IMAGE Sylvie Covey, *Californian House*, digital photograph

2 Select an Area. Choose the **Quick Selection Tool** from the Toolbox to select the area where the color will be replaced. Switch back and forth from the **Add to Selection** and the **Subtract from Selection** in the Tool Options Bar to add or subtract as needed until your selection is complete.

Note: You can also use the Magnetic Lasso Tool to make your selection, or use the Pen Tool to create a path to make a manual selection. Make sure the path's mode is selected in the Tool Options Bar as opposed to the Shape Layers mode. Click point-by-point until the selection is complete; then in the Path window click on the little arrow on the upper right and choose **Make Selection**.

With your selection active go to **Select > Modify > Feather** and adjust the Feather Radius to **1 pixel**.

3 Add an Adjustment Layer.

From the Layer menu choose **New Adjustment Layer > Hue/Saturation**. Keep the **Colorize** option unchecked in the Adjustments dialog box. This will ensure that all the colors in the selection are modified separately. Move the **Hue** and **Saturation** sliders until you find the result adequate.

4 Add Another Adjustment Layer.

From the Layer menu choose **New Adjustment Layer > Curves** and add luminosity and contrast to your image by using Curves in a slight S-shape.

5 Add Final Touches.

I used the Curves to lighten the sky on the horizon. The result is a sharp and crisp image of a house with a new color range.

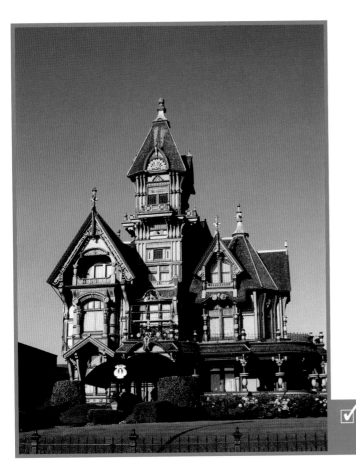

☑ the final
Sylvie Covey, *Californian House*,
repainted digital photograph

Hand Coloring Photos

Before color film photography was invented in the mid-twentieth century, dyes or other paints were traditionally applied to the surface of fiber-based photographic prints to create the illusion of color. Cotton swabs or brushes were used to hand color a black-and-white photograph. This was a time-consuming and delicate process. Hand-coloring, or hand-tinting, is the term given to the process of adding color to a monochrome photograph.

Today, using digital imaging and Photoshop has made it possible to re-create the effects of hand-coloring, and this technique has seen a revival in numerous commercial and artistic venues. The result is similar to the atmospheric hand-tinted photographs of the past. A big advantage of this technique is that it is chemical free, completely adjustable, and reversible. There are several methods for digitally hand-coloring a photograph.

HAND-COLORING WITH THE COLOR BLENDING MODE

This first method is the simplest, using selected areas of the image and painting on separate layers with the Blend Mode Color, which allows the photographic image to show through the color.

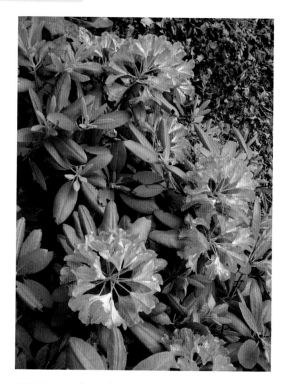

1 Select Your Image. In this first method, hand-coloring works best on strong compositions with simple shapes and open details. I chose this close-up shot of rhododendrons from Northern California. Open a similar color photo in Photoshop.

START IMAGE Sylvie Covey, *Rhododendrons*, digital print.

2 Convert from Color to Black and White.
Duplicate the "Background" layer [Layer > Duplicate Layer]. Convert it to black and white by going to Image > Adjustments > Channel Mixer. In the Channel Mixer window click on the Monochrome checkbox. Your image is now black and white.

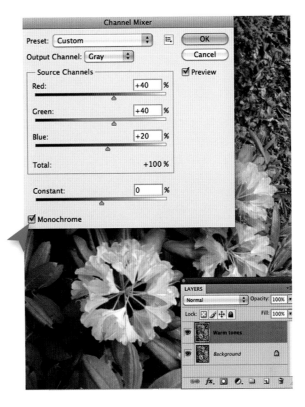

3 Add a Hue/Saturation Adjustment Layer.
I decided to cool down this layer, so from the Image menu I chose Image > Adjustments > Hue/Saturation and in the Hue/Saturation window I clicked on the Colorize checkbox to activate it. I then set the Hue to 200 and the Saturation to 20. These settings can be changed to your taste.

4 **Choose a Color.** Create a new layer above the tinted layer to add color to the image [Layer > New > Layer]. Name the layer according to what element of the image you decide to paint. Change the Blend Mode of this layer to **Color** and choose a color from the Color Picker or from the Color Swatches and select a brush from the Brush Tool palette. I prefer soft brushes for this process. Start painting with a soft brush on the areas you decide to colorize in your image. You can adjust the Color and the Opacity of your brush in the Tool Options Bar, and the layer's Opacity in the Layers palette according to your needs. You can also use the Eraser Tool to erase color if necessary.

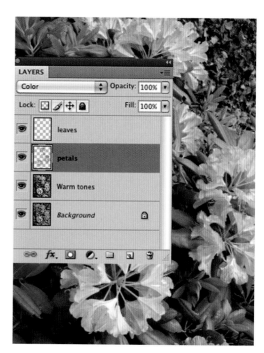

5 **Add a New Layer for Each Color.** Create and name a new layer for each area you decide to paint. For each layer you add, always change the Blend Mode to **Color** and name your new layer accordingly. Color each element of your image on a separate layer for greater flexibility. Change colors and adjust the opacity of both your brush and your layer.

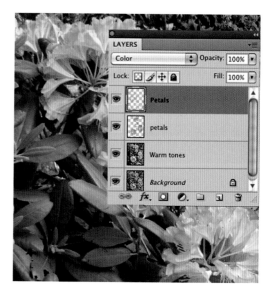

6 **Add a Hand-tinted Effect.** I used one pale orange tint for the petals and three different very pale blue-purples for the leaves in this image. Traditionally, photographic dyes were translucent. Leave some areas unpainted to achieve the look of an antique hand-tinted photograph.

7 **Save Your File.** When you are satisfied with the result, flatten and save your image as a TIFF file. You can also save a version in a PSD format.

☑ the final

Sylvie Covey, *Tinted Petals*, digital photograph

HAND-COLORING WITH GRADIENT MAPS

This method uses Gradient Map Adjustment layers with two shades of color to introduce tints into the areas to be colored. Gradient Maps have a mask that can be filled with black to hide the gradient color on the rest of the layer. Painting with white on the black mask will reveal the tint on your chosen areas.

1 Select Your Image in RGB Color Mode.
Open a black-and-white photo portrait in Photoshop. Although the image is monochrome, make sure the image mode is in RGB Color so that we can access colors [Image > Mode > RGB Color]. I chose a portrait of a Nepalese mother and son by photographer Marguerite Garcia.

START IMAGE Marguerite Garcia, *Mother and Son in Nepal*, digital photograph

2 Choose a Tint.
Decide what you are going to tint first. I decided to leave the skin color for last, and to start coloring the jacket of the mother. For this I clicked on the **Foreground Color** swatch in the Toolbox to open the Color Picker and selected a light orange. Then I clicked on the **Background Color** swatch and selected a darker shade of orange.

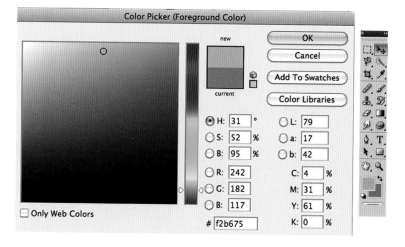

PHOTOSHOP FOR ARTISTS

3 Add a Gradient Map Adjustment Layer.
From the Layer menu choose **Layer** > **New** Adjustment Layer > **Gradient Map**. The selected foreground color and background color are automatically loaded into the Gradient Map Adjustment layer. If the image is negative, check on the **Reverse** box to turn it into a positive.

4 Change the Blend Mode.
Change the Blend Mode of the "Gradient Map" layer to **Overlay** to let the "Background" layer show through the Gradient Map.

5 Hide the Gradient Map.
With the mask active in the "Gradient Map" layer, from the Edit menu go to Fill and fill the mask with black to hide the Gradient Map colors [**Edit** > **Fill** > **Black**]. The mask is now black.

6 **Paint on the Mask.** Select the **Brush Tool** from the Toolbox. Choose a round hard-edged paintbrush from the Brush Picker and make sure that white is selected as the foreground color. With the brush Opacity set at **100%**, zoom in with the Navigator and start painting. Adjust the size of your brush for detailed areas. If you go overboard, switch to black as a foreground color to eliminate the color. Remember, to paint color, use white on a black mask; to remove color, use black on a white mask.

7 **Add a New Gradient Map for Each Color.** To tint the rest of the elements repeat steps 2 to 5, each time choosing a different combination of color shades and creating a new Gradient Map Adjustment layer.

PHOTOSHOP FOR ARTISTS

8 **Add a Gradient Map for the Skin Tones.** To color the skin tones, choose two shades of light and dark and create a new Gradient Map Adjustment layer. Fill the mask with black and start painting the skin tones.

9 **Add Another Gradient Map.** Adjust each layer's Opacity to your taste. Finally, for the background I decided to create a new layer and add a gadient color. Select the **Gradient Tool** from the Toolbox. I chose the **Linear Violet/Orange** gradient from the Gradient Picker and reduced its Opacity to **70%** in the Tool Options Bar.

10 **Save Your File.** The final image is a hand-colored old-fashioned photograph.

✓ **the final**
Sylvie Covey/Marguerite Garcia, *Nepalese Portrait*, digital photograph, 20 x 22 inches

HAND-COLORING WITH COLOR FILL
AND LAYER MASKS

With this method we will give an antique look to a color image by turning it into sepia, filling whole layers with different colors, and revealing each color by painting selected areas with white on a black mask in each layer. This is a rich and more controlled way to achieve hand-coloring with a photograph. Notice that, as in the first method, each layer must be in the Blend Mode Color.

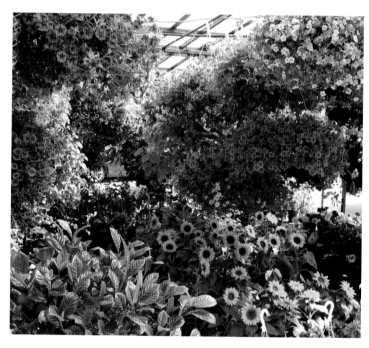

1 **Select Your Image.** Open an image to colorize in Photoshop. I chose a picture of a nursery.

START IMAGE Sylvie Covey, *Nursery Flowers*, digital print

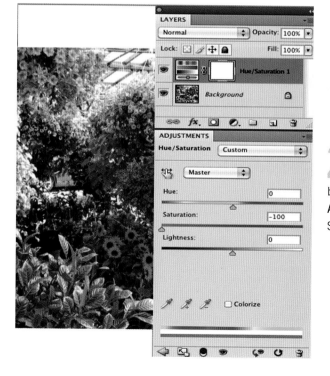

2 **Convert the Image to Black and White.** To convert to black and white, at the base of the Layers palette click on the **Create a New Fill or Adjustment Layer** icon and choose **Hue/Saturation**. Slide the Saturation slider to **−100.**

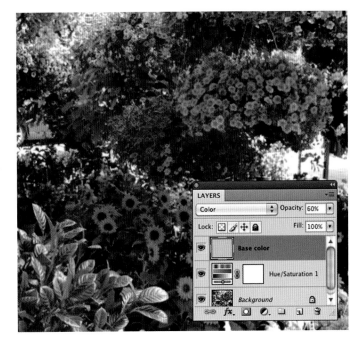

3 **Create a Base Color.** To create a base color, like an initial wash in a watercolor painting, create a new layer [Layer > New > Layer] and name it "Base Color." Choose a beige color from the color swatches as a foreground color, and from the Edit menu choose **Edit > Fill > Foreground Color.** The "Base Color" layer is now filled with beige. Change this layer's Blend Mode to **Color** and reduce its Opacity to **60%**. Your image is now toned with a warm sepia.

4 **Hide the First Color with a Mask.** To create a new layer, go to **Layer > New > Layer** and fill the layer with a bright color. To start with yellow, for example, choose a yellow from the Swatches palette as the foreground color. From the Edit menu go to **Edit > Fill > Foreground Color.** Set the Blend Mode of this layer to **Color.** The yellow color now covers the whole image. Select this layer, and from the Layer menu select **Layer > Layer Mask > Hide All.** This should add a black mask next to the yellow-filled layer. Yellow is now hidden.

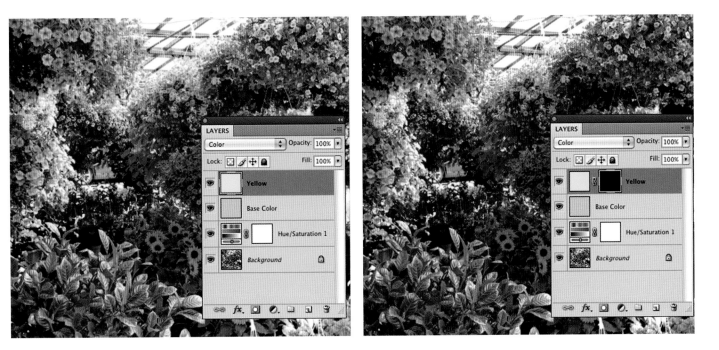

5 **Paint on the Mask.** Set the foreground color to white and select the **Brush Tool** from the Toolbox. Choose a soft paintbrush from the Brush Picker and click on the mask so that it is active. Use the Navigator to zoom in on an area to tint yellow and start painting. The yellow color will appear. Reduce the Opacity of the brush to lighten the paint.

6 **Hide the Second Color and Paint on the Mask.** Go to **Layer > New > Layer** and repeat step 4, but choose a bright red. Paint on the mask with white onto different areas to reveal the red color. To correct an overspill of paint, with the mask selected, hit **X** on the keyboard. This will reverse the foreground and background color swatches. Painting with black on the black mask will correct and hide the red.

PHOTOSHOP FOR ARTISTS

7 Add More Colors.
Repeat step 4 with a new color for each area to paint. Vary the Opacity of the brush. Each time you change and add color, create a new layer filled with the new color. Change its Blend Mode to **Color**, add a layer mask, and paint with white on the mask to reveal the color.

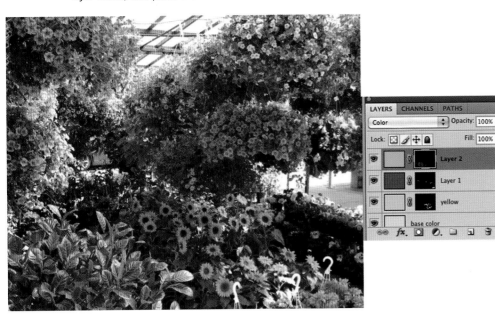

8 Apply Final Touches and Save Your File.
Finally, select the individual Adjustment Fill layers and adjust the Opacity of each until the colors are subtly blended together (around **50%**). You can also go back and forth to add some colors by activating the layer color needing adjustments. When you are satisfied, flatten your image and save it as a TIFF to print.

✓ the final
Sylvie Covey, *Nursery Flowers*,
tinted digital photograph

Applying Halftone Patterns

The halftone printing process has long been favored commercially by newspapers and magazines for its effectiveness and economical quality. The halftone process simulates continuous tone in printed matter with a screen that renders an image as a collection of dots. The dots are of various sizes and shapes, depending on the screen settings, and reproduce optically the tones of the image.

Today, many artists such as Roy Lichtenstein, cartoonists, and graphic designers use halftones to produce art. With Photoshop's tools we can produce halftone images with powerful graphic effects.

ADDING A HALFTONE IN BLACK AND WHITE

In this first method, a Halftone filter is used in combinations with various Adjustment layers to create a modern image with strong impact. Here are examples by New York–based artist Tobias Batz, who photographs models and uses a Halftone filter and Adjustment Thresholds to transform his images into striking graphic statements.

EXAMPLE Tobias Batz, *Tub 5*, digital print

EXAMPLE Tobias Batz, *Cyberesque*, digital print

PHOTOSHOP FOR ARTISTS

1 Select Your Image.
Open a photo portrait in Photoshop. I chose this close-up portrait I took of a friend.

START IMAGE Sylvie Covey, *Patricia*, digital photograph

2 Desaturate.
To keep your original file intact, duplicate the "Background" layer [**Layer > Duplicate Layer**] and desaturate the image [**Image > Adjustments > Desaturate**].

3 Add an Adjustment Contrast.
Increase the contrast according to your image [**Image > Adjustments > Brightness/Contrast**].

4 **Add a Halftone Pattern Filter.** Duplicate this
layer [Layer > Duplicate Layer] and from the Filter menu choose **Filter
> Sketch > Halftone Pattern**. In the Halftone Pattern dialog box, choose
Dot as Pattern Type. I set the Size to **10** and the Contrast to **15**, but feel free
to adjust these settings to your liking.

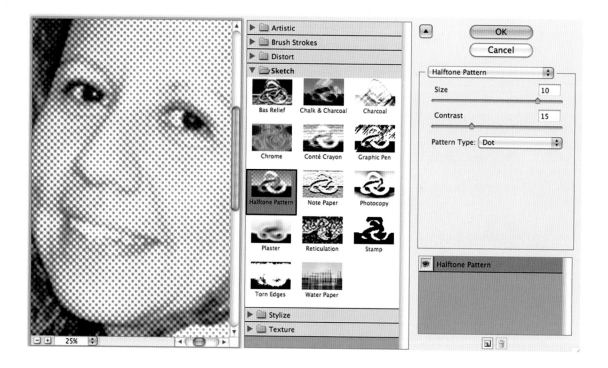

5 **Use Threshold and a Blend Mode.** Duplicate
the "Halftone" layer and from the Image menu go to **Image >
Adjustments > Threshold**. Move the slider to the right to add some black,
and to the left to add some white. Click **OK** and change the Blend Mode of
the layer to **Lighten**.

PHOTOSHOP FOR ARTISTS

6 Experiment with Halftone Options, Blend Modes, and Opacities.

Duplicate the "Threshold" layer and from the Filter menu go to **Filter > Sketch > Halftone Pattern**. This time experiment with the Line pattern and the Circle pattern. Adjust the size and the contrast and experiment with the layers' blending modes and opacities.

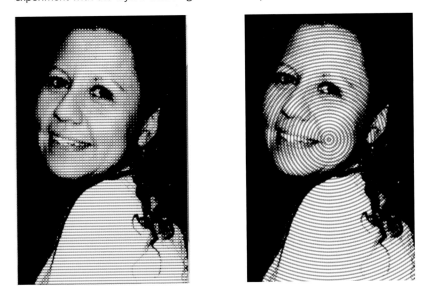

7 Apply Final Touches and Save Your File.

To combine all three halftone patterns I set the top layer's Blend Mode to **Multiply**, the middle layer's to **Lighten**, and the bottom layer's to **Normal**. The result is a graphic halftone image in black and white.

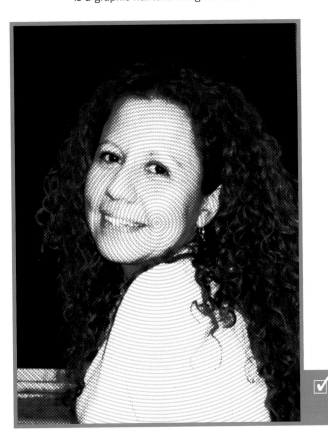

☑ **the final**

Sylvie Covey, *Patricia*, halftone digital photograph, 24 x 16 inches

ADDING COLOR HALFTONES

This method uses the Color Halftone filter and various blending modes to render color graphic images. It is important to note that the Color Halftone filter does not produce different angles for each screen color. For this reason the Color Halftone filter is not used to create halftones for screen-printing, but is a creative and versatile Photoshop tool.

1 **Select Your Image.** Open another photo portrait in Photoshop. I chose this portrait with a simple background. Double-click on the "Background" layer to turn it into "Layer 0."

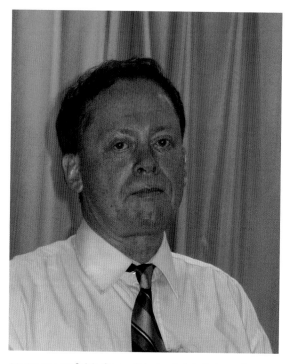

START IMAGE Sylvie Covey, *Sylvain,* digital photograph

2 **Hide the Background.** Cut out the background. Choose the **Quick Selection Tool** from the Toolbox and select the background. With that selection active go to **Layer > Layer Mask > Hide Selection**.

PHOTOSHOP FOR ARTISTS

3 Create a Foreground Color.

Create a new layer [Layer > New > Layer] and drag it under "Layer 0" in the layers stack; then choose a pale color as the foreground color from the Swatches palette. From the Edit menu go to Edit > Fill > Foreground Color.

4 Use Color and Gradient Overlay.

Activate "Layer 0" and click on the Add a Layer Style icon in the Layers palette and choose Color Overlay from the pull-down menu. Click on the color swatch in the Layer Style window to open the Color Picker and choose a color that contrasts with your background. I chose a pale purple. Change the Blend Mode of the Color Overlay to Multiply. In the same Layer Style window select Gradient Overlay and apply a white-to-black gradient to add a boost to your image. Adjust the angle according to your image and change the Blend Mode of the gradient to Overlay. I chose a Scale of 80%.

5 Add a Halftone Background.

To add halftones to the background, create a new layer [Layer > New > Layer] and name it "Halftone Background." Activate the Layer Mask thumbnail in the figure's layer; then from the Filter menu choose Filter > Pixelate > Color Halftone. In the Color Halftone dialog box set the Radius to 100 pixels, and the Screen Angles for Channel 1 to 45, and for Channels 2, 3, and 4 to 100.

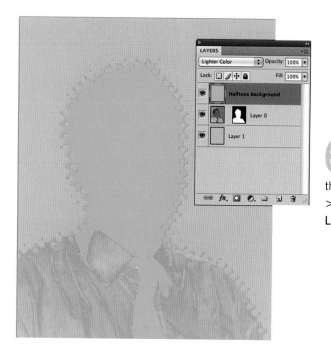

6 **Create a Foreground Color.** Pick a contrasting color from the Color Swatches palette as the foreground color and from the Edit menu go to **Edit > Fill > Foreground Color.** Change the Blend Mode of the layer to **Lighter Color.**

7 **Pixelate the Figure.** Change the Blend Mode of the "Figure" layer to **Pin Light.** Duplicate the layer [Layer > Duplicate Layer] and drag it to the top of the layers stack. Change the Blend Mode of the duplicate layer to **Overlay.** Then with the image thumbnail active, go from the Filter menu to **Filter > Pixelate > Color Halftone,** and this time set the Radius to **20 pixels.**

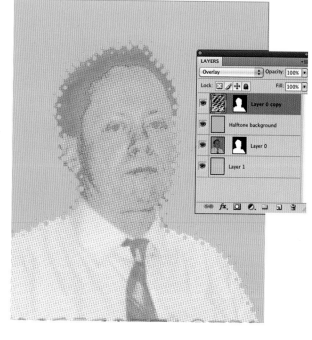

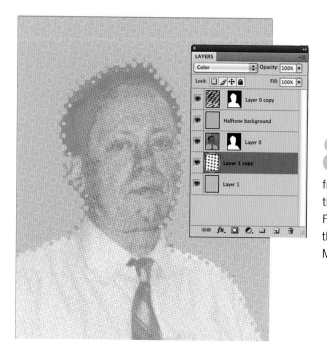

8 **Pixelate Again.** Duplicate "Layer 1," and add a new Color Halftone filter. Activate "Layer 1" and from the Layer menu go to **Layer > Duplicate Layer.** Place the duplicate below "Layer 0" in the layers stack. From the Filter menu go to **Filter > Pixelate > Color Halftone,** and this time change the Radius to **127 pixels.** Change the Blend Mode of that layer to **Color.**

PHOTOSHOP FOR ARTISTS

9 Add a Gradient Overlay and Another Color Halftone Filter.

Duplicate the "Layer 0 Copy" again [**Layer > Duplicate Layer**], place it on the top of the layers stack, and change the Blend Mode to **Multiply**. Add another Gradient Overlay from the Layer Style icon menu in the Layers palette. Then create a new layer and fill it with a new color from the color swatches. Apply another Color Halftone filter [**Filter > Pixelate > Color Halftone**] but this time set the Radius to **50 pixels**. Set the Blend Mode of this layer to **Overlay**.

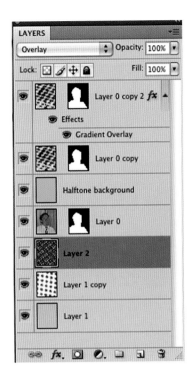

10 Save Your File.

The final image is a color halftone with different dot sizes and colors.

✓ **the final**

Sylvie Covey, *Sylvain*, color halftone
digital photograph, 24 x 18 inches

PART FOUR

Tutorials Combining Photoshop with Printmaking

Printmaking is a series of processes that involve making an image on a plate or surface that can receive ink *before* the surface is printed upon. Traditional techniques in fine-arts printmaking include intaglio-etching; aquatint; lift and soft grounds; engraving; spit bite; mezzotint; relief linocut and woodcut; lithography on stone, metal, or paper plates; silkscreen; and monotypes, to name a few. This book does not cover these basic printmaking techniques, which could easily fill an entire book by themselves.

More recent techniques and materials have improved fine-art media developments. Over the last twenty years I have explored combining photography with printmaking, and I have used exciting new techniques and materials such as solar plates, polymer photo-etching, photogravure, pronto polyester lithography, and photolithography with Fuji plates or Toray waterless plates.

Today, Photoshop is an essential tool used to generate photographic digital imagery for printmaking. These techniques can be used with drawings, paintings, or photographs. Advanced photographic processes in printmaking are an important part of the current developments in graphic arts.

Sylvie Covey, *Performances of the Heart*,
polymer photo-etching on six copper plates,
30 x 40 inches

TUTORIAL 24 Photo-etching

Photo-etching is a sophisticated technique combining photography with printmaking and requires the making of a halftone transparency. Today, the most convenient and efficient way to create a halftone is to use Photoshop. A copper plate is laminated with a light-sensitive polymer emulsion such as Pure Etch or Z*Acryl. The transparency is placed on the laminated plate and exposed to UV light. UV light hardens the emulsion in the non-image areas. When the plate is then developed, the image is formed by collections of dots from the halftone, like an aquatint. The plate is etched in ferric chloride, and the dots "bitten" into the copper retain the ink when they are hand-printed on an etching press.

Plexiglas can also be used to make photo-etched plates, but it cannot be etched in ferric chloride. The emulsion alone retains the ink, so a thicker brand of polymer is recommended such as ImagOn. Below are two examples of photo-etching.

EXAMPLE Beatrice Colao, *On Salzburry Plane*, polymer photo-etching and mixed media, 22 x 30 inches

This image was printed from four photo-etched plates and reprinted with rusted metal pieces rolled with ink.

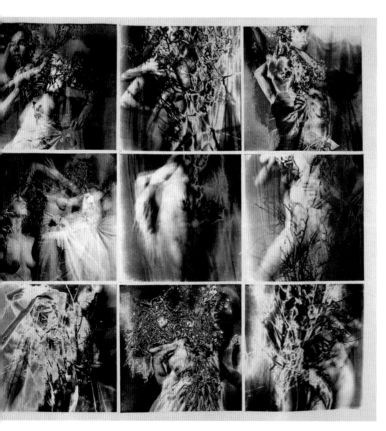

EXAMPLE Sylvie Covey, *Offerings*, waterless photolithograph on fabric, 40 x 40 inches

DITHERS

To enable the printing of photographic types of images in a range of apparent tones, a positive transparency must be created with a laser printer. The pixel-mapped image, however, does not come out of the printer still comprised of pixels, but is converted by the printer software into patterns of dots known as *simulated halftones* or *dither patterns*.

Some printers, particularly inkjet printers, will automatically output images using dithering, which has randomized tiny dots. This can be useful for avoiding the moiré patterns that occur when overlapping regular halftones. Dithering can be created using Photoshop.

From the Image menu go to **Image** > **Mode** > **Grayscale** and then **Image** > **Mode** > **Bitmap**. For Method Use select **Diffusion Dither**. Try this several times with different values of resolution to achieve a varied dot pattern. The diffused dots should not be too small; otherwise, they will not translate on an etching plate. The best type of halftone in my experience is 85-line dot per square inch for photo-etching.

HALFTONES

Using simulated halftones is a more reliable method of producing transparencies that will work for photo-etching. The halftone dots are there to capture information from a pixel-mapped image and to render it with as much detail and accuracy as possible. If the image resolution is low, information will be lost and the quality of the print will be poor. The formula for calculating the relationship between the screen frequency and the image resolution is: Halftone [lpi] = image resolution [dpi] divided by 2.

Each main print process has an optimum range of screen rulings based on the amount of halftone information the plate can hold. For polymer photo-etching the screen frequency can go up to 100 dpi but works best at 85 dpi for the polymer emulsion to develop correctly, and the scan resolution can go up to 300 dpi.

EXAMPLE Sylvie Covey, *Passages*, photopolymer emulsion-etched on four copper plates, 20 x 30 inches

MAKING A HALFTONE FOR PHOTO-ETCHING

A photo-etching is a hand-pulled intaglio print made from a plate (metal or Plexiglas) that is laminated with a light-sensitive polymer emulsion exposed to UV light with the image outputted on a halftone laser transparency. It is then developed in soda ash, etched (if it is metal), and finally printed on an etching press. The heart of the process lies in making a decent and preferably perfect halftone laser transparency image, since the resulting print will depend on the quality of the halftone. If the halftone transparency is done properly, the halftone dots of the exposed plate will develop and retain ink, and the image will render a full tonal range. However, if, for example, the dots are too small or too far apart, the image will suffer a great loss of information. The following method demonstrates how to create a halftone image for monochrome photo-etching.

1 Select and Resize Your Image. Open the
image in Photoshop and select **Image > Mode > Grayscale**; then go to **Image > Image Size**. Set the dpi to **300** and set the Size in inches, according to the final image to be outputted.

2 Add Some Dot Gain. Go
to the View menu **View > Proof Setup > Custom > Profile**. Click on **Dot Gain 25%**.

3 Adjust the Levels. Go
to the Image menu again, and from **Image > Adjust > Levels** double-click on the white dropper in the levels window and set the K box to 5%. Double-click on the black dropper in the Levels window and set the K box to 95%.

4 Sample the Lightest and Darkest Areas.
With the white dropper, select the whitest area of your image and click on it. With the black dropper, select the darkest area of the image and click on it.

5 Lighten the Black Pixels a Bit. In the Levels window select the middle arrow and slide it a little bit to the left to lighten up the black pixels.

6 Reduce the Contrast. Go to the Output Levels (at the bottom of the window) and slide the white arrow on the right. Set it to 254. Slide the black arrow to the left to lighten the dark area but not too much; this is to reduce contrast a bit and open up the black area. Click and save the settings.

7 Adjust Your Image. At this point, make all the adjustments necessary for your image. Once converted to Bitmap, the Levels adjustments will not be possible. If your image has large, black areas, you need to turn them into tones so that those areas will retain ink. You can do this by making your image semitransparent. Double-click on the "Background" layer in the Layers palette to turn it into "Layer 0." The "Background" layer cannot have transparency. It will prompt you to name your layer. You may now use the Opacity slider in the Layers palette to reduce its transparency to between **70%** and **80%**.

From the Image menu go to **Image > Mode > Bitmap**. Select **Halftone Screen**. Set the Frequency to **85 lines/inch** (85 lpi). Select **Round** for Shape and **45 degrees** for Angle. Click **OK**.

8 Output the Transparency. Print with the emulsion side up, on a laser transparency, from a black-and-white laser printer only. If you do not have a laser printer, save your file on a CD and have it printed. Make sure it is a black-and-white laser printer. Below left is a beautiful photo-etching by artist Patricia Acero. Below right is another fine example of photo-etching by artist Kazuko Hyakuda.

EXAMPLE Patricia Acero, *Me*, photo-etching with two plates, 16 x 22 inches

EXAMPLE Kazuko Hyakuda, *YU4*, photo-etching, 8 x 10 inches

Making Color Separations in Lithography

Lithography is a planographic method of printing, which means printing from a flat surface, as opposed to a raised surface as with relief printing, or an incised surface as with intaglio printing. The first principle of lithography is that water repels oil. An image is first drawn with a grease-bearing material or outputted with toner. The surface is then processed, and, when ready to print, is dampened with water and rolled with oil-based ink. The water repels the oil-based ink in the non-image areas. The second principle of lithography is that one stone, or plate, is processed for each chosen color. In photolithography, colors are digitally separated in CMYK (Cyan/Magenta/Yellow/Black) Color mode, exposed, processed, and printed with a careful registration method to reproduce the full-color spectrum of the image. In this tutorial, we will scan a full-color image, make a color separation on four transparencies using Photoshop, and expose and develop Fuji photolithographic plates. The hand-printing process can be achieved either on an etching or a litho press. The lithographic press is essential only when working on stone.

MAKING COLOR SEPARATION TRANSPARENCIES

This color separation technique works for photo-etching as well as for photolithography. You will need laser transparencies and access to a black-and-white laser printer to make these color separations.

1 **Select Your Image to Scan in Photoshop.** Scan your image, and from the File menu choose **Import** to import it into Photoshop. If you are working with a digital file, open the color image directly in Photoshop. I chose this composition I created for its strong colors.

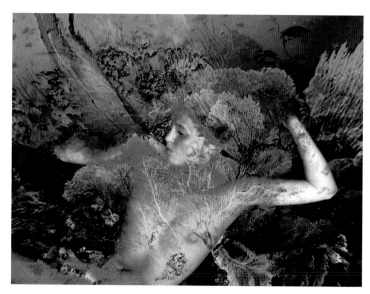

START IMAGE Sylvie Covey, *Into the Sea 4b*, digital photograph

To the right is a picture of an image printed on a clear transparency acetate from a laser printer.

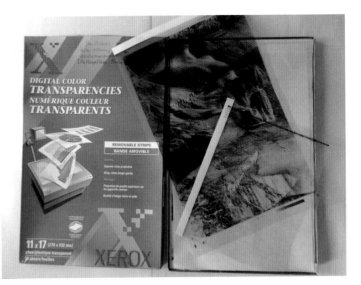

2 Resize Your Image. From
the Image menu go to **Image** > **Image Size**. Choose the image size that fits the printer. In the Document Size window choose the Width and the Height in inches for your image, which should not exceed the size of your transparencies or your printer's capability. Set the Resolution at **300** pixels/inch.

3 Convert to CMYK. From the Image menu go to **Image** > **Mode**
and select **CMYK Color**, which are the process colors: Cyan (blue), Magenta (red), Yellow, and Black.

4 Select the Cyan Channel.
Open the Channels palette from the Window menu. Select the **Cyan** channel only by clicking on it. The other channels are now inactive. From the Select menu choose **Select** > **All**. The Cyan channel is now selected. From the Edit menu choose **Edit** > **Copy**.

5 Create a "Cyan" File. Create a new file [File > New] and
paste the Cyan channel into it [Edit > Paste]. Name this new file "Cyan."

6 Convert the "Cyan" File into a Halftone Bitmap
File. From the Image menu go to Image >
Mode > Grayscale and then Image > Mode >
Bitmap. For photo-etching, choose a Halftone
Screen frequency of **85 lines/inch** (85 ldi) and for
Shape select **Round**. For photolithography, the line
dot frequency can be up to 200, and sometimes
more. I often use the printer's default settings for
photolithography, because it is a planographic
method of printing that does not require etching
around the dot like photo-etching does. The "Cyan"
file is now a black-and-white bitmap file.

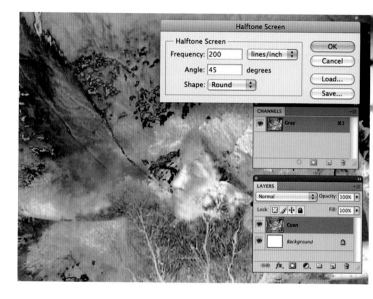

7 Convert the "Magenta," "Yellow," and "Black" Files into Halftone Bitmap Files.
Repeat steps 4, 5, and 6 with the Magenta, Yellow, and Black channels of the
original scanned image. Name each new file according to its color.

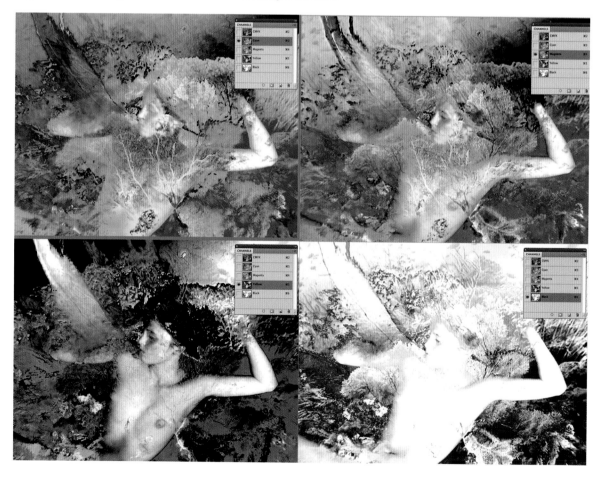

PHOTOSHOP FOR ARTISTS

8 **Print the Files.** Connect your computer to your laser printer. Load the printer with the laser transparencies, one at a time. From the File menu go to **File** > **Page Setup** and check the orientation of your image. From the File menu go to **File** > **Print**. In the Color Management section the printer is already set to Separations. In the Print Window Output section check **Corner Crop Marks** and **Labels**. The Corner Crop Marks will serve as registration marks and the labels will indicate which color transparency it is. This is important because the transparencies are printed in black and white and will not show which color they represent unless the label mentions it.

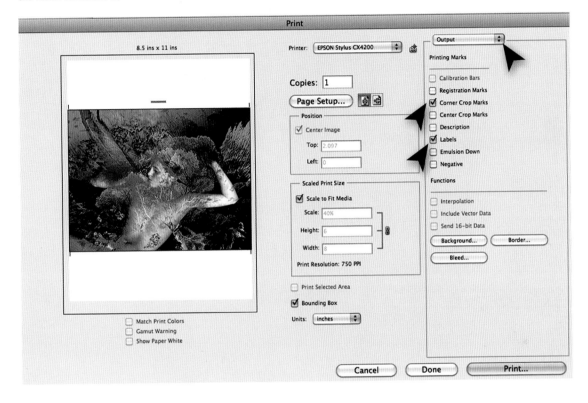

9 **Change the Halftone Settings.** To avoid moiré patterns in the print window, insert the following values when printing halftones in the same dialog box under the Screen button: **75** for Cyan, **15** for Magenta, **0** for Yellow, and **45** for Black. Print the transparencies. Notice that they will come out of the printer in this order: Cyan, Magenta, Yellow, and Black. But when the image is hand printed, the lighter color should always be first, as to not kill the darker ones. Therefore, in printmaking the order is Yellow, Magenta, Cyan, and Black.

MAKING DUOTONE LITHOPLATES

With this method two transparencies and plates are generated from a single image, but they are both positive. One is printed in black, the other with a chosen color to produce a duotone image. When hand printing with ink, several color combinations can also be tried. It is helpful, before outputting the transparency, to give a Curves Adjustment to one of the channels so that it varies from the other. This will accentuate the duotone effect.

EXAMPLE Francisco Feliciano, *Nude*, photolithograph, two plates, 22 x 16 inches.

Here is a beautiful example of a duotone photolithograph by New York artist Francisco Feliciano.

1 Select and Size Your Image.
Open your image in Photoshop. From the Image menu choose **Image Size**. Set the Resolution to **300** and the Size of the image to be outputted in **inches**. The image must be in **RGB Color** mode to start.

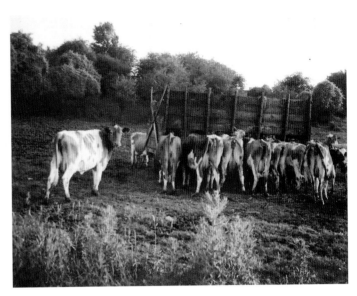

START IMAGE Christie Pavlik-Rosenberg, *Cows*, photolithograph

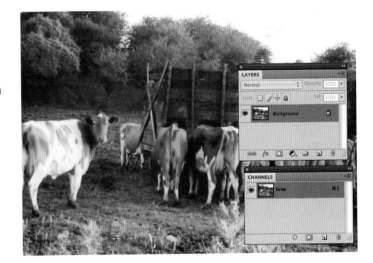

2 Open the Channels Window.
From the Image menu click on **Image > Mode > Grayscale**. From the Window menu click on **Channels** to open the Channels palette.

3 Make Your Image a Duotone.
From the Image menu, click on **Image > Mode > Duotone**.

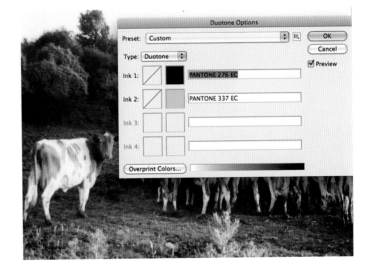

4 Pick a Color.
In the Duotone Options window choose **Duotone** as Type. Double-click on the first color swatch and choose the Pantone Duotones folder and pick a color from either the Color Libraries or the Color Picker. In the image to the right the Ink 1 is shown as black and the Ink 2 is the color chosen. Click **OK**.

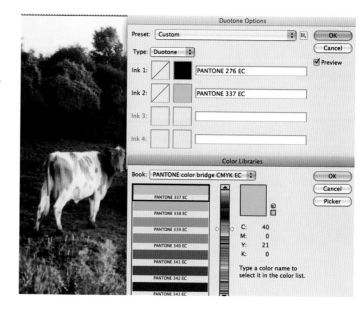

5 Switch to Multichannel.
To view the individual colors of a duotone image, from the Image menu choose **Image > Mode > Multichannel**. In the Channels window the two channels are now displayed, one black, the second with the color chosen.

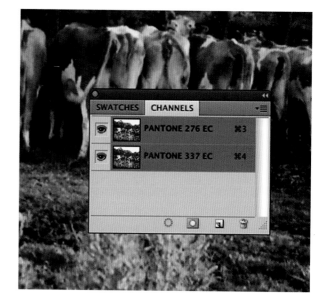

6 Print the Color Channel Transparency.
To make the two transparencies needed for exposing duotone plates, in the Channels window click off the **Eye** icon next to the Black channel. Activate the Color channel [**Select > All**], copy it [**Edit > Copy**], and then paste it onto a new file [**Edit > Paste**]. Print the Color channel on a laser clear acetate with a black-and-white laser printer. Then activate the Black channel back on and click off the Eye icon of the Color channel. Print the Black channel on the second laser acetate.

7 Process the Plates.
Expose two photolithography plates with each transparency. Develop the plates, rinse with water, gum, and buff.

8 Print the Plates.
Use a brayer to roll and ink the black plate with one color and the color plate with another; register and print on one sheet of paper. Try a minimum of three different color combinations, using cold and warm tones.

☑ **the final**
Christie Pavlik-Rosenberg,
Cows, duotone lithograph

TRITONE PLATEMAKING FOR PHOTOLITHOGRAPHY

Photoshop has a Monotone, Tritone, and Quadtone option that can be applied the same as Duotone. To add creativity we can also make a third transparency. This method adds a third plate that is inverted and manipulated with Curves.

1 Create a Duotone. Make duotone transparencies and plates as directed in the Duotones section on pages 260–263.

Open an image in Photoshop and from the Image menu go to **Image > Mode > Grayscale**. Open the Channels palette. From the Image menu go to **Image > Mode > Duotone**. Choose a color and from the Image menu go to **Image > Mode > Multichannel**. Print each channel separately.

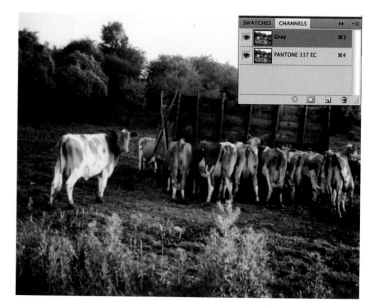

2 Invert One of the Duotone Channels. Pick one duotone image and from the Image menu go to **Image > Adjustments > Invert** to get a negative channel.

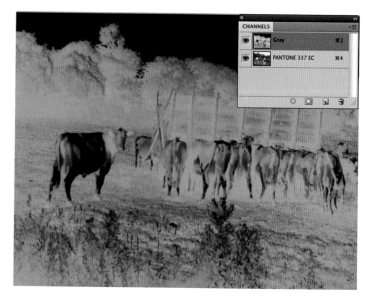

3 Add a Curves Adjustment. From the Image menu
go to **Image** > **Adjustments** > **Curves**. Manipulate the intensity of the
third channel with Curves.

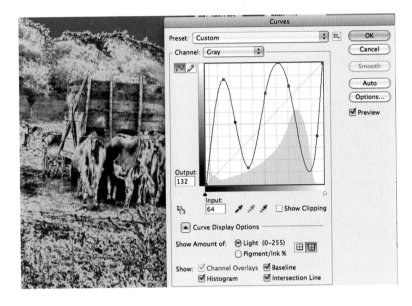

4 Process and Print the Plates. Print it on a
transparency and make a third lithographic plate for creative tritone
lithography. Experiment with all kinds of color combinations.

Christie Pavlik-Rosenberg/Sylvie Covey,
Digital Cows, tritone lithograph

Creating Polyester Pronto Plate Lithography

EXAMPLE Penny Mann, *Doorstep*, photolithograph from pronto plates, limited edition of three, 16 x 10 inches

Polyester lithographic plates were first developed in India as a mean for less-expensive offset printing. Manufactured for laser copiers, where toner is fused to the receiving surface, polyester litho plates can be used to print large quantities of offset lithographs. The late educator and author George Roberts (author of *Polyester Plate Lithography* published by Writers Press) foresaw the interest artists might take in this material.

Although I find printing from a polyester pronto plate less exact and pristine than printing from a Fuji or Toray aluminum plate, this medium offers important advantages to the artist. With polyester there is no need for making a transparency, exposing to UV light, and developing. The image is outputted directly from the computer's printer to the polyester litho plate. The plates are safe to handle and inexpensive. They can be used by young artists with limited technical knowledge and also by advanced, experienced artists interested in small editions and quick output.

Unlike offset printing, however, when an image is hand printed on a printer with a high lpi/dpi (line/dot per square inch) default setting (as most have today), the polyester plate's pores fill up quickly, and as a result a new plate must be outputted after about four prints—unless you lower the printer's lpi/dpi setting.

Polyester lithographic plates are about as thin as printmaking paper and feel like Mylar to the touch. They have the same surface texture as aluminum plates, which are made to receive water dampness, to prevent inking in the non-image areas. Either side of the plate can be used to receive the image. Great care should be taken when handling, as any grease or fingerprints will show on your print.

Waterproof image-making materials, such as toner from a laser printer, or drawing tools, such as a permanent marker or lithographic waterproof crayon, are applied to create the polyester pronto plate. The plate is then dampened with water, rolled with oil-based ink, and hand printed. I prefer to print on an etching press rather than a litho press, but both are good.

The plate should be cleaned after each print to preserve the white areas from filling up. Fountain Solution for polyester pronto plates as well as toothpaste will work. On the left is a fine example of photolithography printed from polyester pronto plates by New Jersey–based artist Penny Mann.

CREATING FOUR-COLOR (CMYK) POLYESTER PRONTO PLATES

This technique demonstrates how to generate pronto plates to print a full-color image from a separation of colors, resulting in four transparencies and plates in cyan, magenta, yellow, and black. Printing and registering the four plates will render the full color range of the image.

1 Select and Open Your Image. Your computer must be connected to a laser printer. Open your image in Photoshop from your computer (or import it from the scanner). If using a scanner, set it to **Flatbed (Reflective), Gray, 300 dpi, 100%.** Click **Scan**. Import in Photoshop. New Jersey–based artist Christie Pavlik-Rosenberg created a digital photomontage to print as a four-colored polyester pronto plate photolithograph.

2 Adjust the Size. Adjust the size of your image according to the polyester pronto plate size and your printer. You need a one-inch margin on each side for the corner crop marks to show. If you are using 8½ x 15–inch plates, your image size should be no more than 6½ x 13 inches, and if you are using 11 x 17–inch plates your image should be 9 x 15 inches or smaller. From the Image menu, go to **Image > Image Size**. In the Image Size window set the Size of the image in **inches** and the Resolution to **300**.

Note: By default, most laser printers print images more than 133 lines per inch (lpi). Lines per inch is the measurement of how many lines of halftone dots are used to create the illusion of a continuous-tone image. The polyester pronto plates were created originally for offset printing, which requires less ink and pressure than hand printing. When inking by hand it may help to lower the lpi to around 75 to 95 lpi so that the ink sitting on the dots does not run together, or "bridge."

START IMAGE Christie Pavlik-Rosenberg, *Hopper's House*, digital print

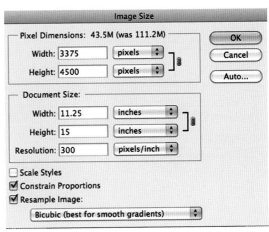

3 Manipulate the Image.

Christie is creating a collage from images of a house, a sky, and railroad tracks. She used the Magic Wand Tool to select and change the Color Balance of various elements of the house.

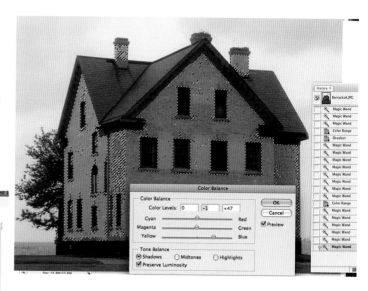

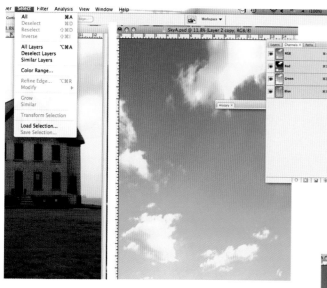

4 Enhance Your Image with Added Elements.

Using the techniques from page 152, a new sky is enhanced, resized, and then added to the original house.

5 Use a Mask.

The third image of the train track is introduced using a mask and techniques described in previous tutorials.

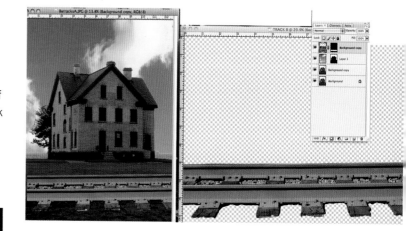

6 Finish Your Composition.

The final image to be outputted for polyester pronto plates is ready.

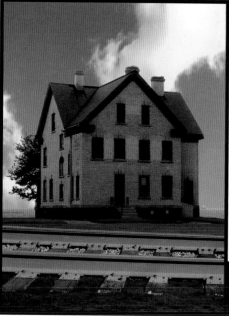

☑ the final

Christie Pavlik-Rosenberg, *Hopper's House*, digital photograph

7 Print the Image on Polyester Pronto Plates.

Load the printer with polyester pronto plates one at a time to avoid jamming the printer. From the Image menu go to **Image > Mode > CMYK Color**. Follow the steps for CMYK separations on pages 256–265. From the Image menu go to **Image > Image Rotation > Flip Horizontal**. The image needs to be flipped so that when hand printed it will be properly oriented. Another way to flip horizontally is to print with the Page Set Up option **Emulsion Down.**

Note: I print my pronto plates on a HP 5000 laser jet printer, which prints at 1200 dots per inch, up to 11 x 17 inches, with adequate heating to fuse the toner. There are many newer printers available today and all have adjustable toner density and heating control for the toner.

8 Prepare the Printer's Settings.

Set up your printer for color-separated polyester pronto plates. From the File menu go to **File > Page Setup**. Choose the orientation of your image. From the File menu again go to **File > Print**. In the Print window, under the Output section check **Corner Crop Marks** and **Labels**. This is important because the plates must be trimmed exactly to the size of the image for registration, and the labels identify each CMYK color.

9 Print the Separations on Polyester Pronto Plates.

In the Color Management section the image is automatically set to **Separations** because it is a CMYK image. Click on **Print**. Load the printer from the back tray with the polyester plates one at a time, but note that your printer will print the four CMYK colors without interruption, so keep feeding the back tray as each color gets printed.

TILING TECHNIQUE FOR CMYK COLOR SEPARATIONS

Tiling is often necessary when creating large prints because the pronto plates must fit in a laser printer. Large-sized printers are not always affordable for most artists. Tiling the image in sections allows printing in larger formats. Here is an example of a beautifully tiled polyester pronto print by artist Dail Fried.

1 Select Your Image and Change the Mode to CMYK. Create and open a color image in Photoshop. From the Image menu, click on **Image > Mode > CMYK Color**. Decide on the final size of the artwork. Usually, the paper size of the final image bears the most importance. A normal, full sheet of printmaking paper is 22 x 30 inches, so that will be this project's size.

2 Flip Your Image. From the Image menu, click on **Image > Image Rotation > Flip Horizontal**. As noted in the previous project, plates to be hand printed must be flipped so that they print back correctly.

3 Size Your Image. From the Image menu, click on **Image > Image Size**. Choose **300** for the Resolution. If the image is horizontal (landscape format) type **21 inches** for the Width. The height will adjust accordingly to the 21-inch width if the **Constrain Proportions** in the Image window is checked. (Both are linked.)

If the image is vertical (portrait format), enter **21 inches** for the Height. Again, the width will adjust to the height if **Constrain Proportions** is checked.

EXAMPLE Dail Fried, *Cortona Window*, tiled photolithograph on pronto plates, 30 x 18 inches

4 Decide on the Paper Size. The image, when printed, will now fit on a 22 x 30–inch Rives BFK paper. However, to make pronto plates that fit in the printer we must tile the images in three sections.

5 Set the Tile Size. From the Image menu click on **Image Duplicate**. From the Toolbox choose the **Crop Tool**. If the image is horizontal, you must divide the width into three. Therefore, type in the Crop Tool's option bar **7 inches** for the Width and the appropriate Height. If the image is vertical, you must also divide the height into three, so type **7 inches** for the Height in the Crop Tool's option bar as well as the appropriate Width.

6 **Create and Save Your Tiles.** With the Crop Tool, carefully crop and save the first section of your image. Name it "#1." Then duplicate your image again and crop and save the section as "#2." Duplicate your image again, crop, and save the section as "#3."

7 **Prepare Your Polyester Pronto Plates.** You are now ready to print all three sections on polyester pronto plates. Because you want to print color separations (CMYK means four colors per section) you need twelve pronto plates (four plates per section of three).

This tiled polyester lithograph is by artist Beatrice Colao. It is interesting because she inverted the place of two tiles by mistake, but it added mystery to the image.

EXAMPLE Beatrice Colao, *Amazing Discover,* tiled photolithograph on pronto plates, 30 x 20 inches

PRINTING INVERTED IMAGES ON POLYESTER PLATES

Printing with white ink on black paper can produce interesting results if the image is first inverted with Photoshop. This project is fun and fast.

1 Select Your Image. Open an image in Photoshop. Make the necessary Levels adjustments; then from the Image menu go to **Image > Adjustments > Invert**. Load your laser printer with a polyester pronto plate and output it. Artist Janet Millstein did a photomontage of this portrait and inverted it.

START IMAGE Janet Millstein, *Rachel Montage*, inverted pronto plate

2 Prepare Your Polyester Pronto Plates. She trimmed the edges of the polyester pronto plate with a cutter.

3 Ink with White Ink. She then dampened the plate with water and started rolling white ink onto the inverted plate.

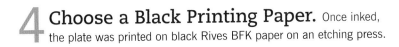

4 **Choose a Black Printing Paper.** Once inked, the plate was printed on black Rives BFK paper on an etching press.

5 **Examine the Final Print.** The result is a positive image on a black background.

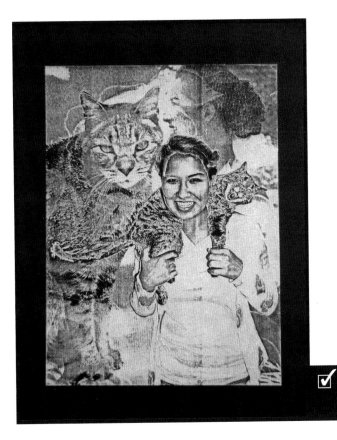

☑ **the final**

Janet Millstein, *Rachel*, photolithograph on inverted pronto plate, 10 x 8 inches

TILING AN INVERTED PORTRAIT

Using Photoshop, create an inverted, grayscale tiled portrait on polyester pronto plates with a laser printer. Hand print on black paper with white or gold ink using an etching press. In this project we will use the tiling method to print an 18 x 26–inch image on black Rives BFK paper that is 22 x 30 inches.

1 **Prepare the Image.** Open a close-up photo portrait in Photoshop. From the Image menu choose **Image > Mode > Grayscale**.

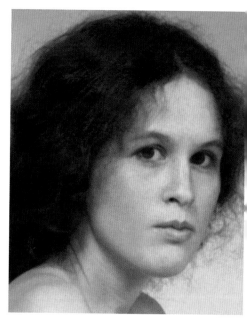

START IMAGE Sylvie Covey, *When You Are Only 20 Years Old*, digital photograph

2 **Adjust the Image.** From the Image menu select Adjustments > **Levels** and make sure the black and white arrows are positioned at the beginning and the end of the histogram to ensure a good level. Click **OK**.

3 **Crop the Image.** Choose the **Crop Tool** and crop the face only; then from the Image menu choose **Image Size**. In the Image Size window make sure **Constrain Proportions** is checked and type the following settings: a Resolution of **300**, a Width of **18 inches**, and a Height of **26 inches**. Click **OK**.

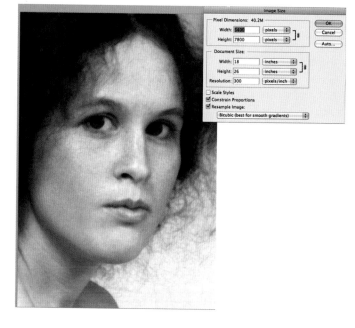

4 Invert Your Image. From the Image menu choose **Adjustments** > **Invert**. The image is now inverted since our goal is to print on black paper with white ink to achieve dramatic effects.

5 Make Tiles Using Guidelines. Because most laser printers are smaller than 18 x 26 inches, we will tile the image in nine pieces, each 6 x 8.66 inches. The tiling will add an interesting effect. From the View menu choose **New Guide**. To divide the width (18 inches) into three parts, in the New Guide window check **Vertical** under Orientation and type **6 inches** for the Position. Click **OK**.

6 Duplicate and Crop. Repeat **New Guide** > **Vertical** and then type **12 inches** for the Position. We now have two guides dividing the width into three tiles that are 6 inches each. Choose **New Guide** again and check **Horizontal** for the Orientation and type **8.66 inches** for the Position. Click **OK**.

Again, select **New Guide > Horizontal** and type **17.33 inches** for the Position. Your image is now divided into nine equal tiles, each 6 x 8.66 inches, to cover the final 18 x 26–inch image.

Note: In order to crop each tile you must remember to first duplicate the image each time before cropping. If you don't duplicate it, you will not be able to crop the next tile. Select the **Crop Tool** and in the Tool Options Bar type a Width of **6 inches** and a Height of **8.66 inches**.

7 **Make the First Tile.** From the Image menu select **Image > Duplicate**. Drag the **Crop Tool** across the first tile on the image duplicate, click **Enter** to apply the Crop, and then save the file as "Tile 1" on your Desktop. Return to the main inverted portrait, duplicate it again, crop, and save as "Tile 2" on your Desktop.

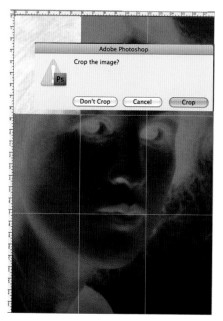

8 **Save Your Tiles.** Duplicate your main image again, crop, and save as "Tile 3," and so on until you have nine tiled and cropped images. Save them in a folder until you can access a laser printer.

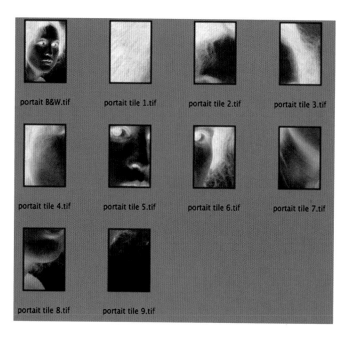

portait B&W.tif portait tile 1.tif portait tile 2.tif portait tile 3.tif

portait tile 4.tif portait tile 5.tif portait tile 6.tif portait tile 7.tif

portait tile 8.tif portait tile 9.tif

9 Imaging the Pronto Plates. When you are ready to print your polyester pronto plates on a laser printer, from the File menu choose **Page Setup,** and in the Page Setup menu choose the printer. Check on **Orientation Portrait** if your image is vertical. Next, in the Print menu check on **Corner Crop Marks** and **Labels.** This is to ensure you can properly crop and register the tiles and identify them.

10 Output the Pronto Plates. Feed the laser printer with one pronto plate at a time to avoid jamming the printer. Right after printing each tile on a pronto plate, mark the number of each with a permanent Sharpie marker on the back of the plate (not in the margin area, since they will be trimmed).

11 Trim the Plates. With a ruler and a sharp cutter, use the crop marks on the pronto plates to carefully cut off the margins. Be precise to ensure a continuous image. You are now ready to print your inverted portrait as a tiled lithograph on black paper.

12 Print the Tiled Portrait. It is a good idea to lay out the nine tiles on your black printing paper first and to mark the appropriate placements of each with a pencil to ensure a good layout with proper margins of your black paper.

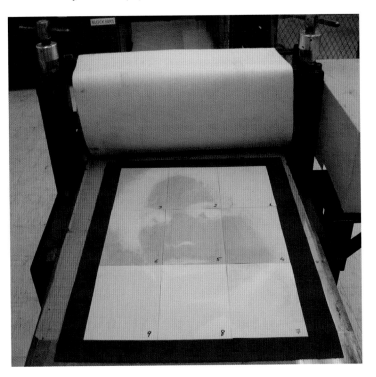

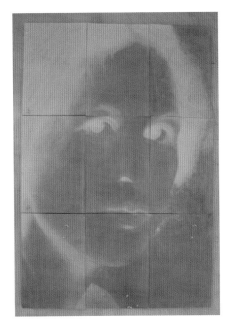

13 Prepare Your Inking Area. You will need a bowl of
water with a clean sponge, some white litho or relief oil-based ink (you
can also experiment with silver and gold litho ink), a brayer, and an etching press.

Sponge the pronto plate with a little water to keep it dampened at all times.
Start rolling a thin layer of ink with the brayer in all directions. In following the
principle of lithography that oil repels water, keep the plate dampened to ensure that
the ink stays away from the non-image area.

14 Ink Your Plates. Keep inking each tile
until they all look even in color; then set up the etching
press with your black paper down and on the bed of the press.
Lay out the tiles with the ink face down on the paper following
their numbers. Cover with clean newsprint and the press
blankets. Make sure the press is set for the right pressure and
run it through.

PHOTOSHOP FOR ARTISTS

15 Examine the final Work.
Peel the pronto plates from the black paper and you will have your tiled portrait. You can re-ink and print the pronto plates three or four times to print a small edition as long as you clean them with pronto plate Fountain Solution, or some toothpaste on a paper towel. This project can be done in a variety of sizes and colors and with various inks. I printed two versions of this portrait, one with gold ink and one with white ink.

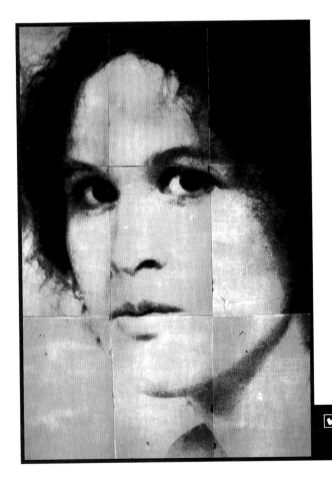

☑ **the final**
Sylvie Covey, *Tiled Inverted White Portrait*,
photolithograph on pronto plates, 30 x 22 inches

Mixed-Media Painting and Printmaking

Mixing techniques is a wonderful way to create rich and sophisticated prints. Today's technology permits photographic imagery to be combined with hand-created works to produce a mixed-media print. Many artists have found ways to integrate digital imaging with traditional print media.

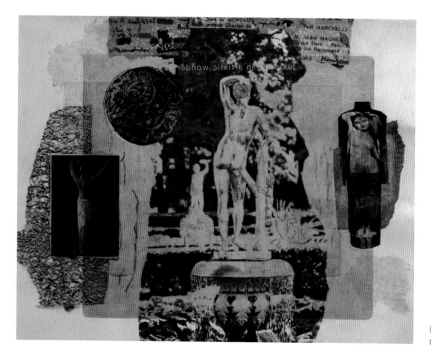

EXAMPLE Sandra Frech, *Fragments of Time III*, mixed media, 22 x 30 inches

EXAMPLE Sylvie Covey, *Old Wall-New Wheat*, photo-etched copper plate with soft ground, 30 x 40 inches

COMBINING LITHOGRAPHY WITH ABSTRACT MONOTYPES

Monotypes are created by rolling or painting inks on a surface. When the surface is printed, usually with an etching press, a one-of-a-kind print is produced, called a monoprint, or monotype. This method shows how combining photolithography with an abstract monotype can result in a vibrant image.

1 Create a Monotype. Artist John
Salvi frequently works in mixed media, inking directly on the etching press. In this example, he started by printing a monotype, brushing and rolling ink on a piece of Plexiglas, and then running it through the etching press on a sheet of Rives BFK paper.

START IMAGE John Salvi, *Untitled*, monotype, 22 x 30 inches

2 Output Pronto Plates with a Color Image Created with Photoshop. After the monotype dried, he
created a new image with Photoshop and color separated it in CMYK on pronto polyester plates. In order to not hide too much of the monotype, he cut the pronto plates in three sections, electing to space out the new image.

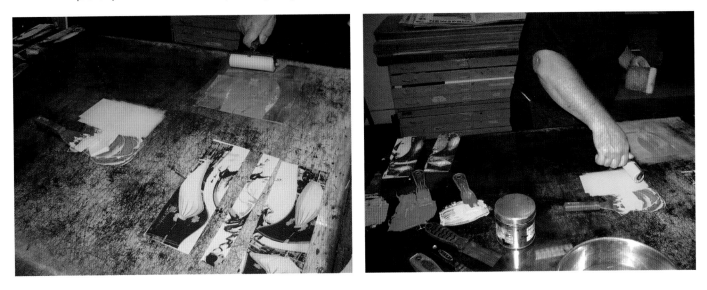

3 Ink the Pronto Plates. John mixed four colors and
printed the pronto plates. Although the image was outputted in CMYK,
he often opts to ink the pronto plates with his own choice of colors. This
time it was yellow with blue for green, and yellow with pink for red.

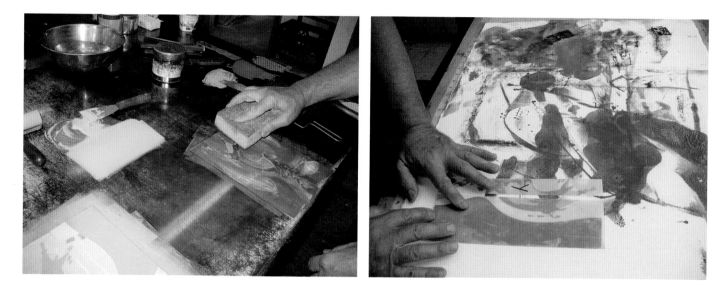

4 Print the Pronto Plates on the Monotype. The
pronto plates are printed on the monotype paper, overlapping and letting the
brushstrokes show through. Balancing the positive and negative spaces is crucial, as
well as layering the inks for the image's composition.

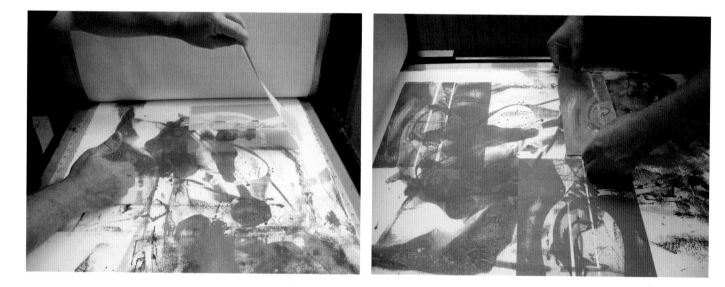

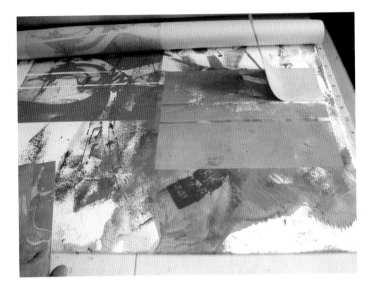

5 **Add Another Plate.** A black pronto plate was also inked and added, as well as more brushstrokes with red and blue ink to link all the elements in the image. Direct painting on the print was also done for the last adjustments. The final print was pulled.

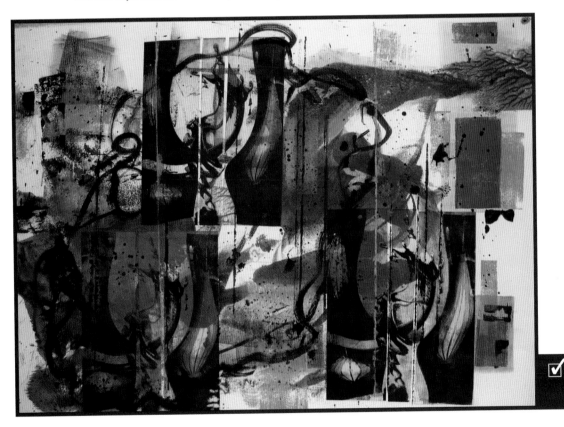

☑ **the final**
John Salvi, *Untitled*,
mixed media, 26 x 32 inches

COMBINING PHOTO-SILKSCREEN WITH SUGAR-LIFT ETCHING

This process is for artists who already have a basic knowledge of both silkscreen and etching techniques. In silkscreen a halftone image on clear acetate is exposed to a screen covered by a photo emulsion. The emulsion hardens in the non-image areas when exposed to UV light. After the screen is washed, the ink is pressed through it with a wide squeegee in the image area only, and the image is printed.

Artist Rena Rubinstein conceived a method of combining photo-silkscreen with the traditional intaglio sugar-lift technique to create multicolored images printed from etched copper plates. Instead of inking the exposed screens, she uses the silk-screen method to pass a solution of sugar lift through the screen onto copper plates. The sugar-lift method is then applied. After the sugar dries, the plate is covered with a liquid hard ground and later soaked in warm water. The sugar melts in the warm water and lifts the ground off the image areas. The plate is etched in ferric chloride and printed on an etching press.

Rena used Photoshop to color separate and output transparencies made to expose the screens, and she mixed a solution of sugar-lift to create her images on the copper.

1 Make the Transparencies for Silkscreen.

Transparencies made for silkscreen have a much lower frequency of halftone setting than transparencies made for photo-etching and photolithography. For silkscreen, the frequency is not higher than 65 dpi. Open your image in Photoshop. From the Image menu go to **Image > Mode > CMYK Color**.

START IMAGE Rena Rubinstein, *Untitled*, digital photograph

Open the Channels palette. Activate one channel at a time. From the Select menu choose **Select > All** to select the channel and copy it on a new file by creating a new file [**File > New**] then copying the channel [**Edit > Copy**] and then pasting the channel [**Edit > Paste**].

From the Image menu go to **Image > Mode > Grayscale**.

From the Image menu go to **Image > Adjustments > Levels** and adjust the levels. Levels cannot be adjusted from the Bitmap mode.

From the Image menu go to **Image > Mode > Bitmap**. In the Bitmap dialog box, for Output Resolution type **300** and select **Halftone Screen**.

In the Halftone Screen dialog box select a Frequency of **45** and for Shape select **Ellipse**. Change the angle for each color transparency to avoid a moiré pattern. If using four colors, choose these angles: Cyan=**105 degrees**, Magenta=**75 degrees**, Yellow=**90 degrees**, and Black=**45 degrees**. If using three colors only choose Cyan=**45 degrees**, Magenta=**75 degrees**, and Yellow=**105 degrees**.

Print the transparencies on clear acetate from a laser printer.

2 Make the Silkscreens. The three screens below show the
different density and texture captured by the separation from each color
channel, cyan, magenta, and yellow.

Coat your screens with the appropriate silkscreen photo emulsion.

Determine the proper exposure time in the light exposure unit and expose the
screens to UV light to emulsion. The transparency emulsion should be face down on
the screen so that your image will print in the correct orientation.

To protect your image carefully wash the screens without using too much
pressure. Test print your screens to make sure the image is correctly exposed.

PHOTOSHOP FOR ARTISTS

3 Make the Sugar-lift Solution.
There are several recipes in etching techniques to mix sugar-lift solutions, and each one gives a different result. Some sugar-lifts are made to give a textured result; some are made to gain better control in the painting of the sugar for better details. The following recipe is recommended for this particular technique.

SUGAR-LIFT RECIPE

Mix 2 cans of sweetened condensed milk with the following:
½ cup Karo syrup
5 to 10 drops India ink (to tint the solution)
2 drops glycerin (to slow the drying process)
The sweetened condensed milk will begin to dry after the first pass but can be rinsed out with warm water.

4 Set Up the Screens and the Copper Plates.
If you are doing multiple etching plates, set up a jig to ensure registration. The jig, however, should not be thicker than the plates. If the jig is thicker, the contact with the plate will not be firm and accurate enough for a good result in the image transfer through the screen.

Set up the screen and place the clean copper plate in the jig. Taping the plates carefully along the filed edges ensures that the screen won't pull up the plate after you have passed the sugar-lift through the screen.

5 Pass the Sugar-lift Through the Screen.
Degrease the copper plate with rubbing alcohol. Place a generous strip of sugar-lift solution at the bottom of the screen. Flood the screen with an even and moderate pressure; then, using an even printing pressure, pull the sugar-lift through the screen at a 30-degree angle.

Once you have achieved a successful deposit, allow adequate drying time. If you are not satisfied with the sugar deposit, you can wash it off the plate with warm water and try again. When the copper plate has received the sugar-lift, let it dry thoroughly.

6 Etch the Sugar-lift.
When the sugar is dry, use a foam brush to cover the copper plate with a thin layer of liquid hard ground. Keep the layer thin to allow the sugar to lift. Let the hard ground dry for about twenty minutes.

Note: You will have more successful results if you lift the ground the same day.

Place your plate in a tray of warm water and let it sit. The hotter the water, the faster the sugar will lift. If it lifts too fast, however, you might lose some details. If the lift is too slow, you can tickle it with a soft paintbrush.

When the sugar has melted and lifted the ground off the image areas, the plate can be etched as an open bite in a solution of ferric chloride for forty-five minutes to an hour. If the image has large, open areas, the plate should be aquatinted before etching.

7 Print the Copper Plates.
Depending on how many copper plates are made, printing can be done with a straight CMYK ink process, as covered in Making Color Separations in Lithography on pages 256–265, or with made-up color combinations and numbers.

In the example below Rena elected not to use the CMYK process colors but to print her three plates in a variety of made-up color combinations with different orders of plate inking and printing. The chart she made identifies her three plates as A, B, and C, and indicates in which colors and order the plates were printed and which were surface-rolled or printed as intaglio. This body of work explores the idea of microscopic images of skin as a kind of human landscape. The gridded system is meant to suggest a periodic table—a useful framework to classify, systemize, and compare all the many different forms of chemical behavior. By using a similar configuration, it allows tracking of the process and comparing the different orders of colors and printing techniques.

☑ the final
Rena Rubinstein, *Untitled*, silkscreen/sugar-lift, limited edition of four

EXAMPLE Rena Rubinstein, *Untitled*, silkscreen/sugar-lift, multiple prints

			This 3 plate etching is sequentially identified by letters A, B, & C.	
A^I_{Bl}	B^I_{Bl}	C^I_{Bl}	ABC^I_{Bl}	
A^I_G	B^I_P	C^I_{Gr}	ABC^I_{GPGr}	
A^S_P	B^S_G	C^S_R	AC^S_{PR}	ABC^S_{PGR}
A^I_R	B^I_Y	C^I_B	CBA^I_{BYR}	ABC^I_{RYB}

A^I_{Bl} B^I_{Bl} C^I_{Bl} ABC^I_{Bl}

A^I_G B^I_P C^I_{Gr} ABC^I_{GPGr}

A^S_P B^S_G C^S_R AC^S_{PR} ABC^S_{PGR}

A^I_R B^I_Y C^I_B CBA^I_{BYR} ABC^I_{RYB}

This 3 plate etching is sequentially identified by letters A, B, & C.

Printing Process:
I = INTAGLIO
S = SURFACE

Colors:
Bl = BLACK
G = GRAY
P = PURPLE
R = RED
Gr = GREEN
Y = YELLOW
B = BLUE

Rena Rubinstein, detail of table chart from *Untitled* (above)

Making Digital Transfers

Digital image transfer is the process of transferring a digital image from its printed surface onto another receiving surface, or substrate. The receiving surface can be two- or three-dimensional, such as printmaking or watercolor paper, fabric, wax, wood, glass, stone, or metal. Artists have been trying to make color transfers long before the 1980s, when color copiers became prevalent. Technological changes these past few years have opened a whole new world of possibilities.

EXAMPLE Sylvie Covey, *Into the Sea 11*, dye transfer on fabric mounted onto aluminum, 8 x 12 inches

MAKING WET INKJET TRANSFERS

Inkjet printers use water-based dye, or pigment inkjet, and are readily available to artists. Dye inks have a larger color range than water-based pigment inks, but are less resistant to fading. Some brands of ink are marketed as archival and some perform better than others. Pigment inks are recommended for transfers, but dye-based ink may work for some techniques. It is always best to use inks that are matched by the printer manufacturer, such as Epson, HP, or Cannon.

The process of creating ink jet transfers from digital images is usually fast, easy, and fun. With this first method, the idea is to create and transform images with Photoshop, print them on a non-absorbent surface, and, while the ink from the printer is still wet, transfer the images onto a new hosting paper with an etching press.

1 Assemble Your Materials.

You will need:

- Paintbrush
- Bowl
- Hair dryer
- Paper towels
- Water tray
- Watercolor pencils
- Transfer paper
- Substrate surface (receiving paper)

The transfer paper must be waxy and non-absorbent like the back of a label sheet. Those work well because they are the right size to run through the printer. You can also use the back of contact paper as a release surface, or paper palette, which is also waxy. Another solution, courtesy of artist Jacinthe Battaglino, is to coat a polyester pronto plate with a thin acrylic medium, let it dry, and print with an inkjet printer. The pronto plate can be wiped and reused for other images repeatedly.

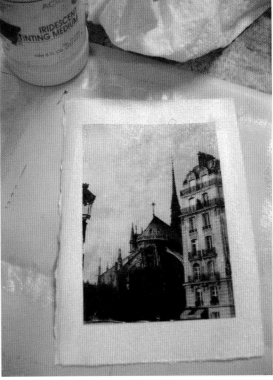

EXAMPLE Jacinthe Battaglino, *Notre Dame*, transfer on coated board, 8 x 10 inches

2 Prepare the Substrate Surface. The best receiving
paper is hot-pressed printmaking paper. The smoothness allows the ink
to transfer evenly. Some of my favorites include Rives BFK, Arches Cover, and
Somerset etching. Watercolor papers have a texture that interferes with the transfer
image. Watercolor paper is sized, meaning a coat of glue, gelatin, rosin, or starch is
added to make the paper resistant to water, while printmaking paper is usually not
sized, or if so, very lightly.

3 Prepare Your Image. The best transfers are generated by
high-resolution TIFF files. Open your image in Photoshop and adjust its
sharpness and contrast.

4 Set Up the Inkjet Printer. Remove the labels from the label
sheet and load the inkjet printer with the waxy label paper, shiny side up.
Epson inks work better than Canon for this transfer method.

5 Boost Up the Image. Adjust the image on you computer screen
with a Curves Adjustment layer so that it is around 20% darker and 5% higher
in contrast than a normal print would be [Image > Adjustments > Curves] and
[Image > Adjustments > Brightness/Contrast].
 The image must be flipped horizontal to print the right way [Image > Rotate
Canvas > Flip Horizontal].

6 Print the Image. Print the image with the highest-quality print
mode. The print comes out of the printer wet with droplets of ink, due to the
waxy paper backing. Immediately place it face down on your printmaking paper and
go to the press. Run it through with tight pressure.

7 Add Final Touches. The image transfers on the receiving paper.
You can use a brush to blend the inks to get a watercolor effect. Manipulate
your image with watercolor pencils and pastel chalks.

Note: If you do not have access to an etching press, wet your printmaking paper in
a water tray and blot it with paper towels. Place the transfer image face down on
the dampened paper and hold it firmly with one hand to hold it in place and avoid
smudging. Rub the transfer backing until the image is transferred and then carefully
lift it off.

8 Dry the Print.

Use the hair dryer to dry the ink, or let it air dry on a rack. If the transfer image is too light, adjust the image settings on the computer. The colors might look muted when the initial image comes out of the printer, as if there were no color. When the inks get transferred onto the printmaking paper the image gets darker. If the image has a dot pattern, the receiving paper was probably too wet and should be drier.

In the example below I made an inkjet color transfer and then reprinted the image with a monochrome sepia photolithographic plate.

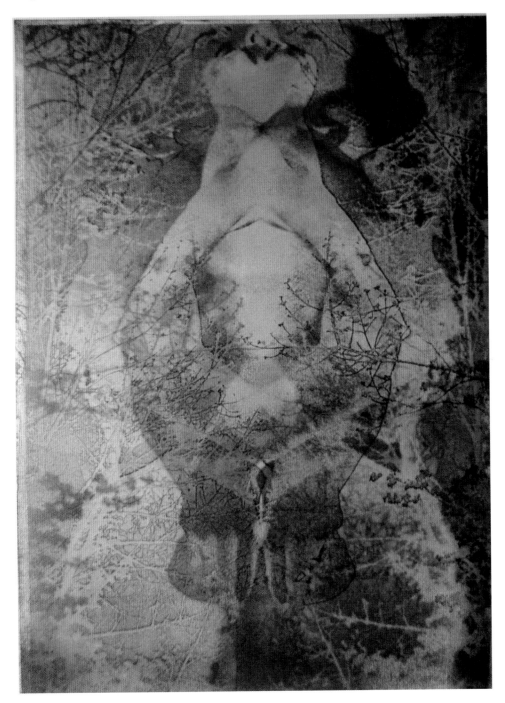

EXAMPLE Sylvie Covey, *Dream*, inkjet transfer on paper with photolithograph, 20 x 16 inches

MAKING LAZERTRAN INKJET DECAL PAPER TRANSFER

With this second method we will use Lazertran transfer decal paper. Lazertran is a market brand that makes several kinds of great transfer papers, in particular Lazertran Inkjet, Lazertran Regular for laser printers, and Lazertran Silk. More information is available at *www.lazertran.com.*

Note: The Lazertran Inkjet transfer decal paper is a relatively new product that gives an end result very much like the older Polaroid emulsion transfer method, but is easier to handle. I have used the technique described in this lesson extensively to transfer digital images onto copper and aluminum plates as the substrate surface. The color of copper shows through the image and becomes part of it. Note that this decal paper will not work on fabric. Use Lazertran Silk for transferring to fabric.

1 **Select an Image for Transfer.** Open your color image in Photoshop, make the necessary image adjustments, and load your inkjet printer with a sheet of Lazertran Inkjet transfer decal paper.

2 **Set Up the Inkjet Printer.** If using an Epson printer choose the **Plain Paper** setting, then **Custom > Advanced,** and set the dpi to **1440.** Click off **High Speed.** For HP printers choose the **Draft** setting. To lessen the ink output and avoid bleeding, check the **Gloss or Film** setting in the printer's dialog box. I have a Canon 9000 Inkjet printer and it also worked with this method.

3 **Print on the Transfer Paper.** Print your image onto the smooth, white side of the transfer paper. The backside is slightly colored.

4 **Let Dry Thoroughly.** Let the print dry for one good hour so that the inks dry and become waterproof. This is crucial because the decal transfer will be later soaked in water.

5 **Coat with Varnish.** Depending on your image and the receiving surface, you must decide if you want the background to be transparent or opaque. A transparent background will show the color and texture of the substrate surface, such as wood, metal, or ceramic. If both the substrate and the image are dark, the transfer will fade in and you might need an opaque (white) background. However, if your image is strong and your substrate surface blends well with it, you should coat it now with varnish so that the background will be transparent. Use exterior polyurethane clear gloss varnish, or Plasti-kote Fast Dry Enamel, or Vitrail, made by Lefranc & Bourgeois, for an even and thick coating. If you want some

selected areas of the image with a white background use acrylic matte medium.

Note: Oil-based varnishes will turn the white areas of the inkjet transfer transparent, while acrylic varnishes will retain the white background permanently. The oil-based varnish can be applied later on the substrate surface to protect the ink and turn the background transparent, but areas coated with acrylic varnish will retain permanently their white background.

6 **Lift the Image.** When the transfer decal is totally dry, soak it in warm water to release the backing paper. Use a water tray so that the image floats on the water surface and the backing paper peels off. If you are transferring on paper, gently lift the image, let the water drip, and place it on your substrate surface.

7 **Apply the Transfer.** If your substrate surface is other than paper, like a metal plate or an object that can be soaked, for example, you can place the receiving surface in the water container prior to soaking the transfer. Once the paper backing is off the transfer, gently lift the receiving surface to catch the transfer image floating on the water.

8 **Remove the Air Bubbles.** If the receiving surface is flat, gently push out any air bubbles and water from underneath the image transfer with a rubber squeegee. However, if the receiving surface is rough or three-dimensional, you might have to press out the air with a pinhole. Be creative in case the image tears.

9 **Let Dry Thoroughly.** Let your transfer dry overnight. If the decal inkjet print was not previously coated with varnish, do it now—oil-based for transparent background, acrylic-based for white background. Two even coats may be applied after drying time is allowed between coats.

Note: When transferring on candles, let the transfer dry overnight and apply two coats of candle varnish such as Exagon.

EXAMPLE Sylvie Covey, *Living with Trees*, Lazertran transfer on copper plate, 12 x 9 inches

EXAMPLE Sylvie Covey, *Bryce Canyon*, Lazertran transfer on three mounted copper plates, 26 x 12 inches

MAKING SOLVENT TRANSFERS

The principle of solvent transfers is that the solvent dissolves the toner from the laser print or the ink from the inkjet printer and transfers on the substrate surface when pressure is applied. The use of a printing press is usually necessary, but in some cases a handheld brayer roll will work.

I have used Citristrip, Citra-Solv, and wintergreen oil to make laser and inkjet transfers. Citristrip is a gel made to strip paint. Wear gloves when using Citristrip. The advantage of this product is that it does not smell, so there is no danger of inhalation, but skin *must be* protected. Citristrip can be found in hardware stores.

Other solvents I prefer for transferring laser and inkjet prints are Citra-Solv and wintergreen oil. Both are housecleaning products.

Recently, after reading Bonny Pierce Lhotka's book *Digital Alchemy* (New Riders Press), the latest solvent transfer with Inkjet I have used and liked is simply using gel alcohol made for hand sanitation. The brand she recommends is Purell, but really any pure gel alcohol with a 65% alcohol content will work.

For this newer technique, print your image with an inkjet printer on a inkjet film acetate. Make sure you flip your image horizontal before printing it [**Image > Rotate > Flip Horizontal**] so that when transferred it reads the right way. It is not always relevant to some imagery, but it is important to read an image the right way when the image contains letters or numbers. Note that laser acetates will not work with this process. Some inkjet film acetates work better than others. Bonnie Pierce Lhotka has developed her own line of products, including a transfer film, that will definitively work (www.digitalartstudioseminar.com). Just experiment with what is available to you.

Note: Use caution when working with solvents. A solvent is a substance that dissolves other substances. Good ventilation is extremely important when using solvents. Printmakers in the past have used acetone to transfer laser prints, but today artists want to avoid working with toxic materials when possible. Acetone is a carcinogen. Although all solvents are somewhat toxic, it is possible to use them safely when taking precautions. Use gloves and a mask, keep the containers closed, and do not eat and drink while working.

1 **Prepare the Paper.** Saturate your printmaking paper with gel alcohol, using a brayer to spread the gel on both sides of the paper. The gel alcohol will evaporate on your skin, so do not use your hands to spread the gel.

2 **Apply the Transfer.** When the paper is saturated with gel alcohol, lay down the inkjet film acetate image, pigment side down, on the paper, and use a brayer to transfer the inks to the paper. After a couple of minutes, peel off the film acetate from the paper.

Other Solvent Transfers Method
Note that due to the changing printing industry and newer photocopiers, it is not always possible to achieve a solvent laser transfer. Some copiers have a higher fusion system and will not permit the release of the toner.

1 Select and Adjust Your Image.
Open an image in Photoshop and manipulate it. If you are using a photocopier, it is advisable to darken the image and add saturation to help the transfer. From the Image menu go to **Image > Adjustments > Curves** and bring the middle of the Curves line slightly down toward the darker tones. Next go to **Image > Adjustments > Hue/Saturation** and move the Saturation slider to **+35**.

2 Copy Your Image.
Make a photocopy of your image or print it on a laser printer. If you are using an inkjet printer, chances are the ink might run a little, so use less solvent. Aside from Photoshop-generated imagery, transfers can also be done from some color magazines or newspapers cut in pieces and layered, but not all will transfer. Wax-coated magazines do not transfer well.

3 Apply Your Transfer.
Place your fresh photocopy face down on the receiving paper. Use a wide brush to coat the back of the copy with Citra-Solv.

4 Print the Transfer.
Cover the transfer with several layers of newsprint and run it through the etching press.

5 Compose Your Images with Multiple Transfers. Here are two good examples of color laser transfers made with cut-out elements.

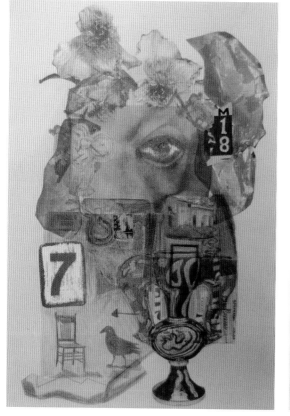

EXAMPLE Ann Winston Brown, *Untitled*, solvent transfer on paper, 30 x 22 inches

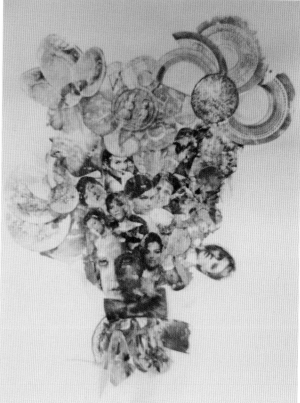

EXAMPLE Kyung Min Kang, *Bridal Bouquet*, solvent transfer on paper, 30 x 22 inches

OPPOSITE Sylvie Covey,
Tree Hands 3, digital print

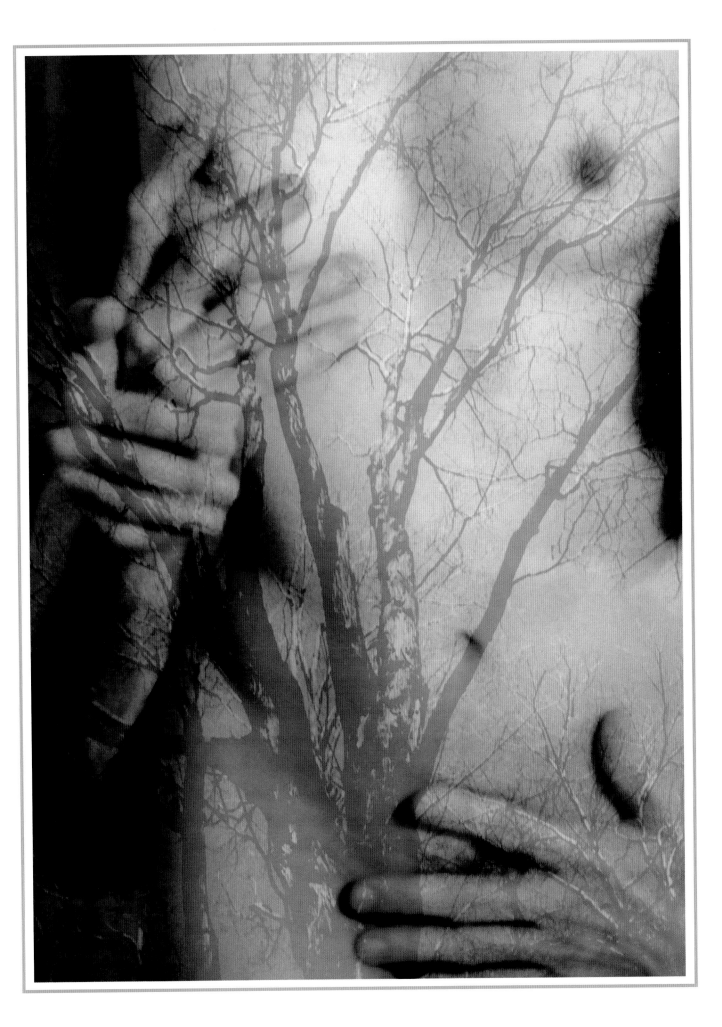

Contributing Artists

PATRICIA ACERO was born in Columbia and came to the United States in the mid seventies. She studied printmaking at the Art Students League of New York and works as a graphic designer at Underline Communications in New York.
Contact: anaid.p@gmail.com
Website: artistsunite.ring.com/profile/patriciaacero

JACINTHE BATTAGLINO studied printmaking at the Art Center of Northern New Jersey and now works at her printmaking studio in Warwick, New York. She frequently travels all over the world with her husband John, an accomplished photographer, to gather inspiration for her artwork.
Contact: jjbat@optonline.net
Website: www.battaglinoimaging.zenfolio.com

TOBIAS BATZ sees his work as a hybrid of fashion photography and street art, reflecting the urban landscape of New York City and its inhabitants through the celebration of the female form.
Contact: batz@tobiasbatz.com
Website: http://tobiasbatz.com

ANN WINSTON BROWN was a textile artist and weaver for many years before she turned to painting and printmaking. She studied Photoshop and printmaking at the Art Center of Northern New Jersey and frequently exhibits her prolific work in New York and New Jersey.
Contact: awbartist@verizon.net

BEATRICE COLAO grew up in New Zealand and traveled widely while acquainting herself with the mediums of photography and printmaking. From intaglio to monoprints, photo-etching, photolithography, and Photoshop, she continues to explore and seek new art forms.
Contact: beacolao@aol.com

MOIRA FAIN is a fine artist, illustrator, and published author of children's books. She lives and works in New York City.
Contact: moirafain@gmail.com
Website: www.moirafain.com

FRANCISCO FELICIANO was born in the Philippines and received an MA from Columbia University in 1993. He is a prolific artist and printmaker living and working in New York City.
Contact: fs1@mac.com

SANDRA FRECH is a multimedia fine-arts artist living and working in New Jersey.
Contact: sjfrech@hotmail.com

DAIL FRIED, a graduate of Boston University, is a professional artist working as a painter, sculptor, and printmaker who frequently exhibits her work throughout the United States and Spain. Her work is inspired by her extensive traveling, in which she strives to capture her inner landscapes.
Contact: dailart@aol.com
Website: www.dailfried.com

MARGUERITE GARCIA has lived and worked in Europe, the Americas, the South Pacific, Southeast Asia, and Africa. She is a humanitarian worker for the United Nations Peacekeeping Operations, the European Union, and the Organization of American States. She photographs people around the world and uses her Facebook page to stay in touch.
Contact: garciamarguerite@hotmail.com

KYUNG MIN KANG was born in South Korea and studied fine arts at the School of the Art Institute of Chicago and at the Fashion Institute of Technology in New York. Her work reflects inner wounds that have been carved into her soul, and she uses art as medicinal healing. She lives and works in New York City.
Contact: rudals1201@hotmail.com

KAZUKO HYAKUDA was born in Tokyo, Japan, and lives in New York City. The subjects of her photography are streets, women, and water surfaces, from which she derives the fragments of time she experiences. Her artwork has recently been concentrated in photo-etching.
Contact: kaztny@aol.com
Website: http://kazukohy.blogspot.com

PENNY MANN has painted for forty years and started experimenting in printmaking twenty years ago. She creates vignettes and combines elements that make statements about major events of our time.
Contact: Mtinpanalley@aol.com
Website: www.pennymann.com

JANET MILLSTEIN works in communication design as a creative director, art director, and graphic designer. She is also a printmaker and creates hand-pulled prints by merging photography, digital media, and traditional printmaking techniques. She lives and works in New Jersey with her family. Visit her Facebook page under Janet Millstein Art & Design.
Contact: janetmillstein@hotmail.com

MARC PICOT is a professional film photographer who lives and works in Paris, France.
Contact: picotmarc75@gmail.com

CHRISTIE PAVLIK-ROSENBERG is a graduate of Rhode Island School of Design with a degree in illustration. Her artwork mainly concentrates in etching and photolithography.
Contact: christieprintsii@facebook.com

RENA RUBINSTEIN is a printmaker based in Brooklyn, New York. She studied at the Art Students League of New York and attended the Tamarind Institute in 2011. She is the recipient of many awards and grants— the Kuniyoshi Award being the most recent—and experiments and combines different print techniques to achieve her artistic vision.
Contact: renarubinstein@gmail.com
Website: www.renarubinstein.com

JOHN SALVI is an abstract expressionist painter and printmaker who lives and works in Monmouth Beach, New Jersey. His four-color lithographs and mixed media works combine traditional printmaking with digital imagery.
Contact: johnsalvi@msn.com
Website: www.johnsalvi.net

BERT G.F. SHANKMAN is a professional artist and photographer who works exclusively with flowers, which he grows in his garden to allow him to record their lifecycles in all kinds of weather and light. His objective is to create images that are a reflection of his feelings. He prints his own work in limited editions of twenty-five, using carefully chosen archival materials. "Flowers contain the essence of life."
Contact: bertgf@cameraflora.com
Website: www.cameraflora.com

RICHARD TURCHETTI is a digital photo-artist living and working in New York City.
Contact: turchetti222@gmail.com

DAN WILLIAMS is a graphic designer living and working in New York City. His artwork fuses manipulated digital photography with printmaking, balancing traditional processes with the digital world.
Contact: fiveflightsupdesign@yahoo.com

NORA WINN is a watercolor artist living and working in Northern New Jersey. She specializes in children's portraiture and occasionally ventures into Photoshop to find inspiration.
Contact: nlwinn@optonline.net
Website: www.norawinn.com

Index